VE Sept 13

10643682

IMAGES FROM THE LIKENESS HOUSE

DAN SAVARD

ROYAL **BC** MUSEUM

Victoria, Canada

Designed by Chris Tyrrell, RBCM.
Edited, formatted and typeset by Gerry Truscott, RBCM.
Typeset in Bembo Std (11.5/13, body).
Digital imaging by Kim Martin and Carlo Mocellin, RBCM.
Front-cover photograph by J.W. Jones or T.M. Jones, about 1897
 (see page 155 for the description).
Back-cover photograph by Frederick Dally, 1868: "Salmon caches"
 on the Fraser River, near Yale. Original card-mounted photograph.
 PN 6006.

Printed in Canada by Friesens.

See page 194 for credits and permissions.

Library and Archives Canada Cataloguing in Publication

Savard, Dan, 1948-
 Images from the Likeness House / Dan Savard.

 Includes bibliographical references and an index.
 ISBN 978-0-7726-6150-0

 1. Native peoples – British Columbia – Social life and customs – 19th century – Pictorial works. 2. Native peoples – British Columbia – Social life and customs – 20th century – Pictorial works. 3. Indigenous peoples – Northwest Coast of North America – Social life and customs – Pictorial works. 4. Documentary photography – Northwest Coast of North America. 5. Native peoples in art. 6. Indigenous peoples in art. 7. Photography in ethnology. 8. Royal BC Museum – Photograph collections. I. Title.

E78.B9S28 2010 778.9'93058970711 C2009-906767-6

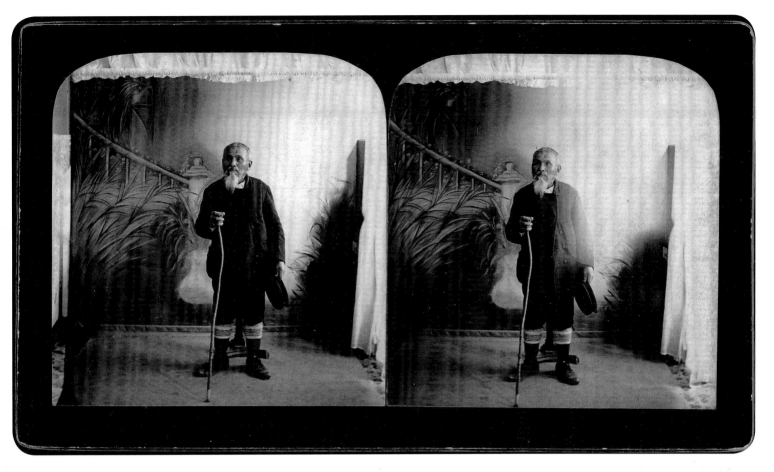

Arthur Wellington Clah.
Richard Maynard or Arthur Rappertie,
December 9, 1889 (possibly).
Stereograph. RBCM PN 4325.

In the late fall of 1889, Tsimshian Chief Arthur Wellington Clah went to the Maynards' photography studio in Victoria to have his portrait taken. Clah wrote about this visit in his diary: "Rebekah ask if I going likeness house. so I go. to give myself likeness. Rebekah stand longside me. the man making likeness to me. ill finished. Next Friday [Dec 13] at $2.50 per half a doz cars [cards]." Given the date, the cards he refers to are probably stereographs like this one.

Although this is not the photograph that Clah refers to, it may have been taken during the same visit. The photographer – either Richard Maynard or Arthur Rappertie, a studio employee – used a 5×7-inch dry-plate negative. He used an iron stand to help Chief Clah remain stationary during the long exposure time required to take his portrait; the base is visible behind Chief Clah's feet.

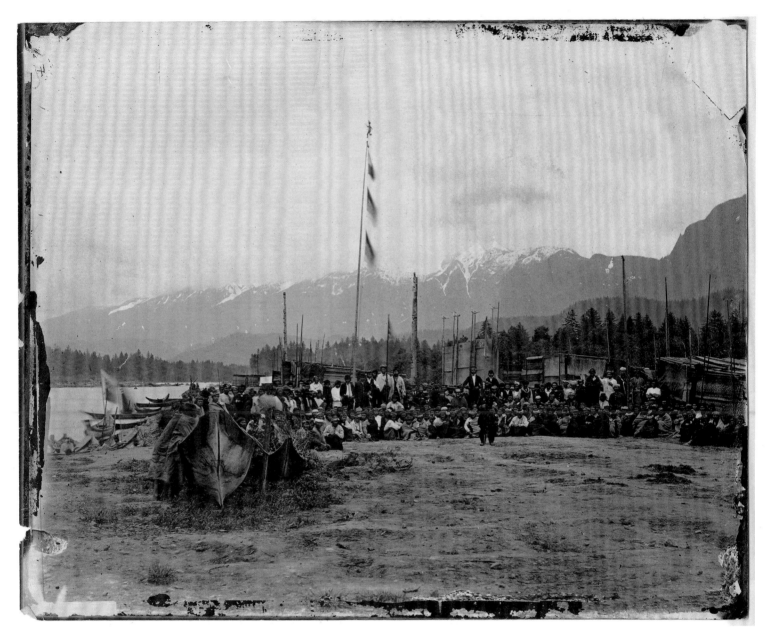

Chief Wakash and the villagers of Dzawadi.
Richard Maynard, June 3, 1873.
Original photograph. PN 2291-B.

The Dzawadi villagers and Chief Wakash assume their rightful place in this group portrait and in the visual history of First Peoples. Dr Israel Wood Powell, British Columbia's first federal superintendent of Indian Affairs, visited Dzawadi, Knight Inlet, in June 1873. Officers of HMS *Boxer,* as well as Dr Powell and other members of the official party, pose in the background.

To the First Peoples whose images, art, technology, crafts and villages appear on its pages and to future First Nations scholars who will conduct further research in this field. This is a small measure of repayment for the privilege I have enjoyed in being associated with these photographs for 35 years.

**Winter and Pond's store
in Juneau, Alaska.**
William H. Case, February 3, 1918.
Copy negative. ASL-P39-0541.

This photograph epitomizes the theme
of this book: a First Nations icon stands
beside one of the most recognized icons of
the photo industry. A model, based on the
Raven pole of Chief Shakes of Wrangell
(but missing several carved figures), stands
outside Lloyd Winter and Percy Pond's
store. As the "KODAKS" sign indicates,
when this photograph was taken, the
partners were merchandising photographic
supplies to the growing number of amateur
photographers in Alaska.
 The photographer, William Case, was
one of Winter and Pond's competitors.

Contents

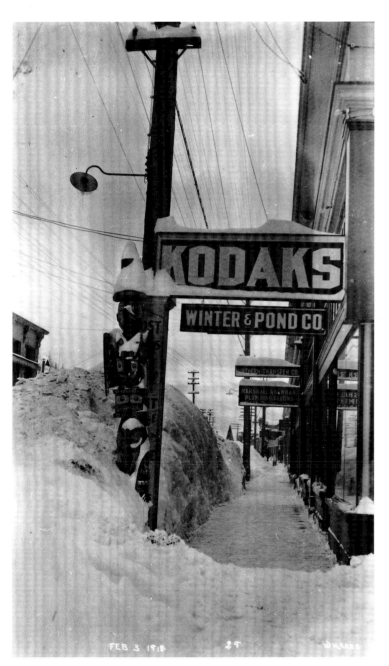

Locations of the places named in the photograph captions.

Preface

This book is an outsider's analysis of the first six decades (1860–1920) of interactions between photography enthusiasts and the First Peoples living along the coast of North America from the Olympic Peninsula to the Gulf of Alaska and in the interior of British Columbia. It is not a discourse on colonialism, although some of the photographs certainly document colonialism. Neither does it presume to be the voice of those whose images appear on these pages – their portraits speak for themselves. I have avoided speculation on motive, presentation and purpose, electing instead to restrict my comments on the body of work generated during this era to those that can be supported by empirical evidence. This book is a personal and subjective interpretation of this interplay, and I have tried to make it respectful to the people and cultures shown on its pages.

I hope to reveal the wealth of First Nations historical photographs housed in the collections of museums, archives and libraries throughout North America. Although these images are becoming more accessible as they are digitized and brought online, many remain in print form only and can be accessed solely by visiting cultural institutions. This book is one means of showing these images to a wider audience.

The photographs printed in this book were created by professionals and amateurs, including: Carlo (Charles) Gentile, Naitesket, Frederick Dally, Benjamin Haldane, Hannah and Richard Maynard, George Hunt, Oregon Columbus Hastings, Edward Dossetter, William Case and Herbert Draper, George Thornton Emmons, brothers Edward and Asahel Curtis, James Teit, Charles Frederic Newcombe, Lloyd Winter and Percy Pond, Elbridge Merrill, R. Z. Tashiro, Valient Vivian Vinson, Frank Swannell and Julius Stenberg.

Photographs may present a culture as it really is or as the photographer perceives it to be. Through their use in print, exhibition, video and cine film, the images created primarily by photographers of the late 19th and early 20th centuries continue to influence national and international perceptions of First Peoples. Although this book focuses on the First Nations in British Columbia, it also includes the works of photographers in Alaska who have documented Tlingit and Kaigani Haida peoples, and those Washington photographers whose Makah subjects share cultural relationships with the Nuu-chah-nulth of Vancouver Island.

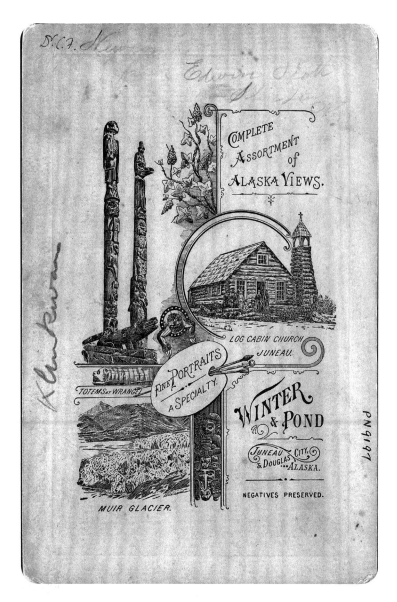

Back of a boudoir card.

The back of this boudoir card (the front is shown on page 162) advertised Lloyd Winter and Percy Pond's photography and curio business in Juneau, Alaska. Its graphic images capture three of Alaska's four identifying characteristics at the time: its natural beauty, the rich First Nations cultures and the pioneering Euro-American community. (Missing is a reference to Alaska's Russian history.)

In addition to selling prints of their field and studio photographs of Tlingit and Kaigani Haida people and villages (the Alaska State Library has more than 500 of these), Winter & Pond also sold "Indian curios" from their store. Other notable Alaskan commercial photographers, such as William Case and Herbert Draper in Skagway, and Elbridge Merrill and Edward De Groff in Sitka), also sold curios.

Many photographers in British Columbia operated another commercial enterprise in the same building as their photographic studio. In Victoria, Hannah and Richard Maynard had a shoe store, and in Quesnel, C.D. Hoy ran a dry-goods store.

Introduction to the Photographs

My research for this book focused on the historical photographs housed in the Anthropology Department of the Royal BC Museum, a collection that I am intimately familiar with. Available to the casual and serious researcher, this collection of primary source material includes some 25,000 *cartes de visite*, stereographs, cabinet cards, Victoria cards, snapshots, printed and real-photo picture postcards, large format photographs and lantern slides that document the life-ways of the First Peoples of British Columbia and those culturally related peoples of northwestern Washington and southeastern Alaska. The collection has grown through the generous donations made by individuals and families, as well as the purchase of about 7,000 reference photographs from other cultural institutions in North America and Europe.

The still and moving images that survive in museums, libraries and archives provide First Nations elders, social historians, anthropologists, curriculum developers, traditional land-use study researchers, museum curators and many others with a rich visual legacy of the past 150 years. They record changes in human geography, house construction and monumental carvings in coastal villages, as well as the ceremonies and distribution of goods associated with potlatches. They communicate visual evidence of casual, everyday clothing and of ceremonial dress and record First Peoples participation in a burgeoning cash economy. They document material culture collected by museums in the context of everyday use and are invaluable in assisting museum curators in identifying and authenticating pieces in their collections. A field photograph of a wooden screen in situ (such as the one shown below) can be extremely valuable to a museum conservator in monitoring the deterioration of a particular object over time.

**"Salt Water Chief" screen
at the Nisga'a village of Angidah.**
Charles F. Newcombe, May, 20, 1913.
Direct duplicate negative. PN 666-B.

Anthropologists and collectors sometimes photographed the objects they collected on location. Such photographs are important cultural records, and invaluable visual aids for research; they also help conservators monitor the deterioration of artifacts.

Charles Newcombe photographed this carved and painted yellow-cedar screen that he purchased for the Provincial Museum of Natural History (now the Royal BC Museum). For many years on exhibition in the museum's *First Peoples* gallery, this screen will be transfered to the Nisga'a Lisims government under the terms of the 1998 Nisga'a Final Agreement.

Repairing a canoe at the Kwakw<u>a</u>ka'wakw village of 'Y<u>a</u>lis (Alert Bay).
Charles F. Newcombe, April 1913.
Direct duplicate negative. PN 629.

This close-up of the inside of a canoe documents the technique used to repair cracks in the wood. Anthropologist Franz Boas describes the procedure in his book, *The Kwakiutl of Vancouver Island* (1909):

> When large cracks are to be closed, where considerable amount of pressure is needed to bring the sides of the board together ... holes are drilled straight through the wood on each side of the crack, and a stout withe [cedar branchlet] is pulled through.... After it has been closed, a wedge of cedar-wood ... is driven in, and in this manner the sides of the crack are drawn together ... [then] holes are drilled [along the length of the split ... and] grooves ... are cut into the surface of the board, connecting the drill-holes; so that after sewing, the surface of the board represents a smooth surface, and the stitches [of twisted cedar-twigs] are protected against injury by friction or cutting.

Researchers and curators working with First Nations consultants use these photographs to elicit additional information about traditional and transitional aspects of their cultures. Exhibition designers create a sense of an earlier time by enlarging panoramas of people and villages to mural size.

In this book, images trump words. Rather than choose photographs to supplement the text, I have searched for written documentation that helps explain what was recorded by the camera's lens. For example, why did Charles Newcombe photograph the inside of a canoe at the Kwakw<u>a</u>ka'wakw village of 'Y<u>a</u>lis (above) in April 1913? When I first saw this image many years ago I wondered what had motivated him to take it. Closer examination revealed that Newcombe was documenting several methods of repairing cracks in one of the canoe's sides. I include this photograph not only because there are few images documenting First Nations technology but because it exemplifies what motivated me to write this book: I had a photograph – I needed to determine why it was taken.

I selected the photographs based on three criteria: (1) the image had to be ethnographically significant or (2) important to the history of photography of this region during the 60-year period covered by this book, and (3) it had to exist as a high-quality positive or negative, because the amount of information that can be gathered from a photograph often depends on its quality.

Acquired in 1961, the Newcombe Collection has become an important part of the Royal BC Museum's holdings. This massive collection, assembled between 1895 and 1933 by Dr Charles Frederic Newcombe (1851–1924) and his son, William Arnold Newcombe (1900–61), includes material culture, photographic prints and negatives, lantern slides, diaries and reports.

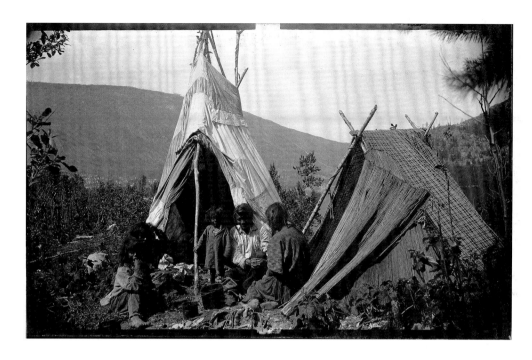

Family portrait.
Unidentified photographer;
location and date unknown.
Dry glass-plate negative. BCA I-68923.

The photographer used a large-format,
dry glass-plate negative to record this
family camping somewhere in the interior
of British Columbia. Like so many
other historical photographs in museum
collections, any information once attached
to it has been lost. The size of the negative
(5×8 inches) suggests that prints made
from it may have been intended for sale as
boudoir cards.

The images in this book have not been digitally altered or enhanced to improve their appearance (except for one, on page 121, to remove graffiti). Neither imperfections nor evidence of degradation has been digitally removed from any negatives, prints or lantern slides. For some, the contrast has been adjusted to improve the image, but none of the elements have been altered or deleted. Nothing has been removed from nor added to the images. Whenever possible, the photographs have been reproduced as they were originally presented for sale to the public. This was done to emphasize the differences in the medium of photography today and that of the two previous centuries.

Each photograph's caption includes a comment about the image's relevance to the theme of the publication, the names of the people (if known) whose likenesses appear in the photograph, the location, the photographer's name and the date of the photograph and the source from which the image was scanned. The caption also notes any digital adjustment or cropping of the original.

The photographs in this book belong to the school of "documentary realism" (Bant and Hinsley 1986:40): clear and sharply focused, meant to convey the reality of life as perceived by the photographer at a point in time.

Documentary realism contrasts with "pictorialism", the dominant movement in art photography from about 1891 to 1910 (Hannavay 2008:1126). Pictorialism became popular among professional photographers after the invention of hand-held, inexpensive cameras made for the general public. Now that anyone could take a picture, pictorialists re-established their professional status by substituting camera and negative for paintbrush and canvas. While an admirable movement in art photography, pictorialism contributes much less to studies in visual anthropology. Only one of the photographers published in this book was a pictorialist. Edward Sheriff Curtis took many of his photographs using soft focus to give a slightly out-of-focus, "dreamy" quality to his images. As a researcher whose interests lie in the ethnographic content of the image, I am less interested in the aesthetics of Curtis's photographs than their subject matter. Yet I cannot dismiss his considerable contribution to the visual history of First Peoples in this region simply because of his photographic style.

One of the challenges working with historical images is the lack of accompanying documentation. Many surviving images from the time period covered by this book have no textual information. Some record the date of the photo-

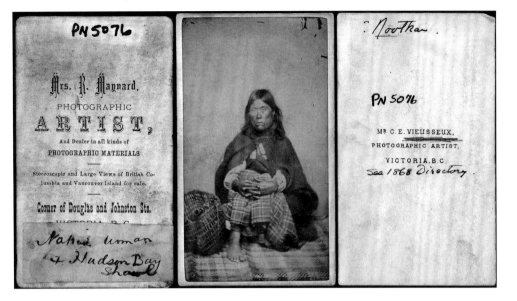

Unidentified woman, Victoria.
Hannah Maynard or Charles E. Vieusseux, about 1868.
Cartes de visite. PN 5076.

The photographer of a *carte de visite* can often be identified by the border design on the card's face, the photographer's imprint on the reverse side and the quality of cardboard. But these are not infallible indicators. Occasionally, after a studio closed, the owner of a rival gallery would purchase the card stock.

This studio portrait is framed by the backs of two *cartes de visite*, each bearing the same image. The imprints indicate that either Hannah Maynard or Charles Vieusseux made the photograph. Both claimed to be a "photographic artist", but only Hannah Maynard was a professional photographer. Charles Vieusseux, a French anarchist and political exile, was a teacher at a private school for boys in Victoria.

Another *carte* with Vieusseux's imprint carries a field photograph known to have been made by Richard Maynard (see page 88). This suggests that Hannah Maynard made this studio photograph and mounted it on stock once owned by Charles Vieusseux; but we cannot say for certain that this is a Maynard photograph.

As with many historical photographs in the Royal BC Museum collection, the catalogue information relating to this image is minimal. The unidentified woman may be a Nuu-chah-nulth peddler. The basket beside her has an open-weave that would allow for drainage, suggesting that it was used for carrying clams or fish.

graph, the name of the person who appears in it or where this person is from, but little else. Location can sometimes be determined by comparison with other photographs from other institutions' collections. Sometimes the same image is claimed by two photographers (as shown above).

A great disparity exists between the number of extant photographs of coastal and interior First Peoples – a ratio of at least 20:1 in favour of the coast. This book reflects that imbalance. Access to coastal villages was facilitated by the marine waterways that connected them to the city of Victoria and the Royal Navy based at Esquimalt, both located at the southern end of Vancouver Island. Victoria was a centre of trade and government in the region; more importantly, it was home to many of the photographic galleries in the colony and, later, the province of British Columbia. The Royal Navy provided transportation to colonial and dominion government authorities and these coastal field trips were conducted in comparative ease and with more frequency than journeys inland.

In the 1800s, British Columbia lacked an inland network of roads, making travel by freight wagon or pack horse difficult. In 1868 Victoria photographer Richard Maynard spent 22 days travelling by steamer and wagon to Barkerville in central BC. Even in the early 20th century it was difficult to get to places in the interior. River and lake transportation by paddle steamer, scow or canoe had limited reach, and then you had to travel overland by stage coach, freight team, foot

"A view at 19 mile post, Fraser River", Cariboo Wagon Road.
Frederick Dally, 1867 or 1868.
Original card-mounted photograph.
BCA A-03866.

The principal road to BC's interior was the Cariboo Wagon Road. When construction finished in 1865, the road connected the gold mining town of Barkerville with Yale, the farthest interior town on the Fraser River accessible via paddle steamers.

During the summers of 1867 and 1868 Frederick Dally used the Cariboo Road to transport his photographic equipment to Barkerville where he made pictures of the mines and miners of the area. Many of his photographs of wagons being pulled by ten-mule teams over this roughly built road have been used to illustrate books on the history of British Columbia. This photograph shows two wagons in the distance, and more importantly, in the lower right corner, Dally's horse-drawn, two-wheeled carriage that he used to transport his photographic equipment. The dark rectangle at the back of the wagon is probably his portable dark-tent.

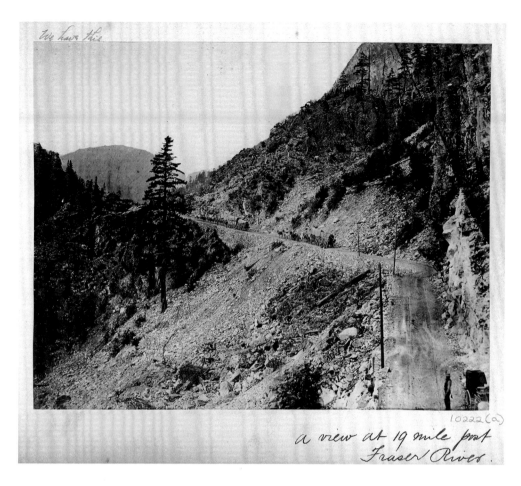

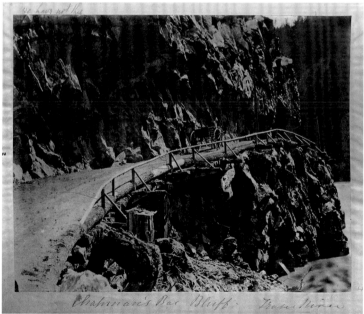

Chapman's Bar Bluff.
Frederick Dally, 1867 or 1868.
Original card-mounted photograph.
BCA B-07284.

Identified in Frederick Dally's handwriting as "My horse and trap", this light, two-wheeled carriage carried his fragile photographic supplies and equipment. It's understandable that Dally would not entrust his cameras, tripods, chemicals, glass plates and portable darkroom to the rough handling of a freight wagon.

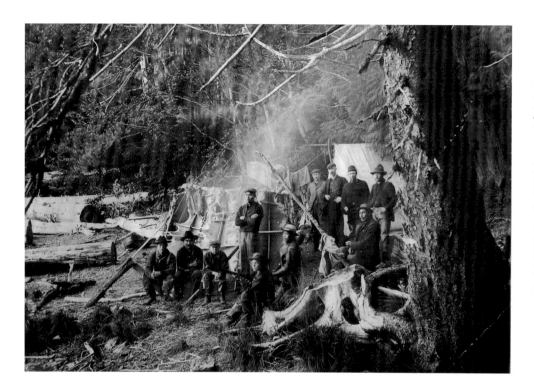

Men drying meat and preparing skins at Kasaan Bay, Alaska.
Julius Sternberg, September 23, 1901.
Original photograph. PN 5421.

Many First Peoples come to the Royal BC Museum to view the collection of historical photographs. Their knowledge of community has enhanced the collection's documentary value because they sometimes recognize the people who appear in photographs. In August 1975, M. Lawrence identified the men on the far left as Peter John, Joseph Jones and Louis Jones.

or the automobile service that began in the Cariboo in 1910 (Sherwood 2004:48). You could photograph it if you got there, but you still had the arduous task of getting there.

It's easy to fall into the trap of interpreting the motives of photographers working in the late 19th and early 20th centuries through what Jamie Postman (2001) called a 21st-century "prism of understanding". Few written accounts exist describing interactions between First Peoples and photographers during this era (some diary entries, official government reports, hand-written notes and newspaper entries). In the absence of clear empirical evidence it is impossible to say with certainty what motivated a photographer to take a particular image.

A more important point to consider, as you continue through this book, is that most of the photographs from this era remaining in public institutions were produced by outsiders who knew little about the cultures they recorded. The decisions about what to photograph and how to compose it were made by someone other than those whose images and cultures were fixed on glass and film negatives.

The significance of this cannot be overemphasized, and although it diminishes, it does not dismiss the value of the photographs.

Is this the photographic account that First Peoples would have chosen to leave of themselves? Almost certainly not, but this is the public record that survives in archives, museums and libraries. I suspect that more personal collections dating onward from the second decade of the 20th century exist in private hands within First Nations communities. Further research by indigenous scholars from these communities will bring an insider's perspective and understanding to the existing corpus of public ethnohistorical still photographs and cine film. I hope this book will encourage such commitments.

Several years ago, during a visit to a commercial photographic laboratory that printed public requests for photographs from the Royal BC Museum's collection, the technician remarked, "Everybody picks the same negatives." I've tried to break this trend by selecting photographs that I hope will be somewhat less familiar.

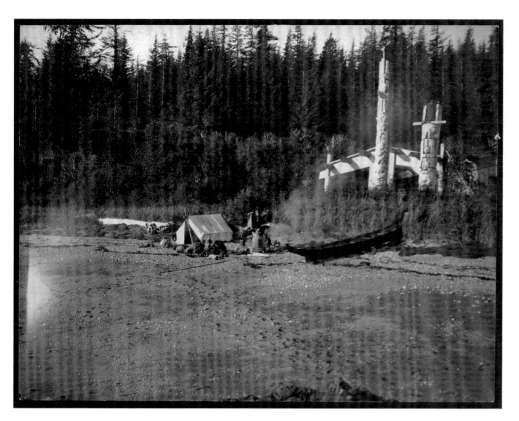

The Haida village of T'anuu 'Llnagaay (Tanu).
Herbert Carmichael, September 1901.
Original photograph. PN 332.

Although marine waterways gave greater access to coastal villages, photographers visiting these places faced many challenges. Travelling on the open ocean by sailboat or canoe, such as the one drawn up on the beach in this photograph, could be dangerous. The tent set just above the high water line probably belongs to the photographer's party. By the time this photograph was taken at T'anuu 'Llnagaay, many of its inhabitants had moved to Hlragilda 'Llnagaay (Skidegate).

Crossing an icy river.
Percy Pond, about 1897.
Black-and-white recent contact print from a dry glass-plate negative. ASL-P87-0665.

This photograph shows the challenges associated with field photography in Alaska during the 1890s. The caption reads: "Photographer's equipment on sleds, crossing an icy river, ca 1897. Lloyd Winter (centre) and two unidentified native men pulling two loaded sleds across a crude log bridge in snowy valley."

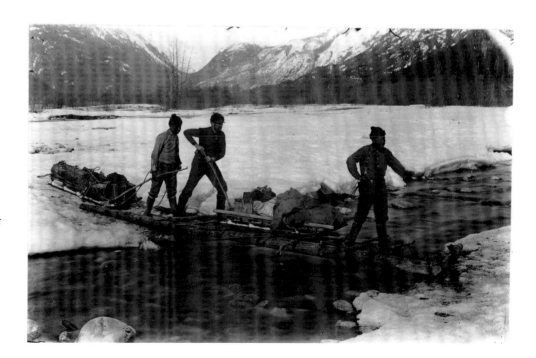

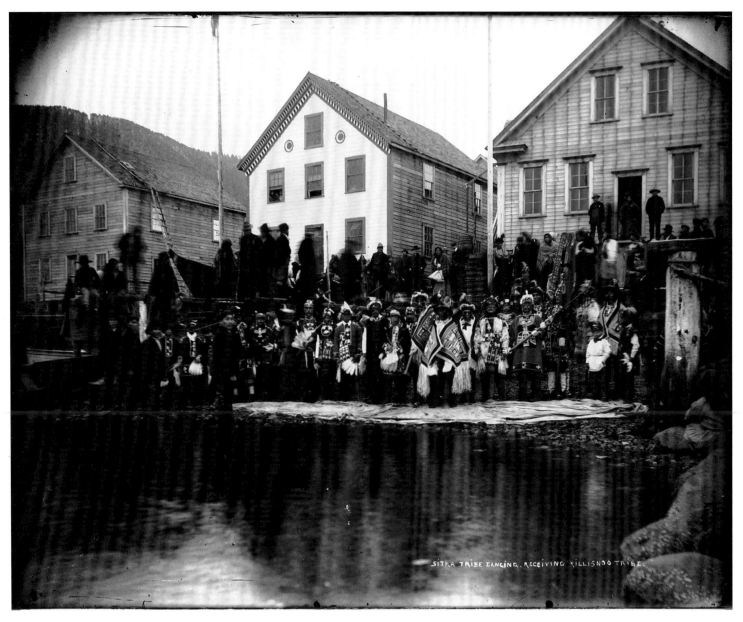

SITKA TRIBE DANCING, RECEIVING KILLISNOO TRIBE.

"Last potlatch", Sitka, Alaska.
Elbridge W. Merrill, December 23, 1904.
Copy negative. SITK 3767.

In 1904, members of Sitka's Tlingit
Christian community decided that
potlatching had become a fundamental
impediment to becoming a modern
society. Alaska's Governor John Brady
supported their initiative and suggested

that Sitka's Kaagwaantaan clan host a "last
potlatch" so that the Tlingit from across
southeastern Alaska could gather to discuss
their future and, presumably, renounce this
cultural institution (Preucel and Williams
2005:12). But the traditionalists won the
day and potlatching continued.

In this photograph, the hosts, dressed
in their dancing regalia, assemble on the
beach at low tide in front of a clan house

to greet guests from Angoon. Photographer
Elbridge Merrill, himself a long-time Sitka
resident (1899–1929) called this group
portrait "Sitka Tribe Dancing, Receiving
Killisnoo Tribe". He used an 8×10-inch
dry glass-plate negative. Because the
resolution of this negative is so fine, it
can be enlarged enough to clearly see
the people's faces and the details of their
costumes.

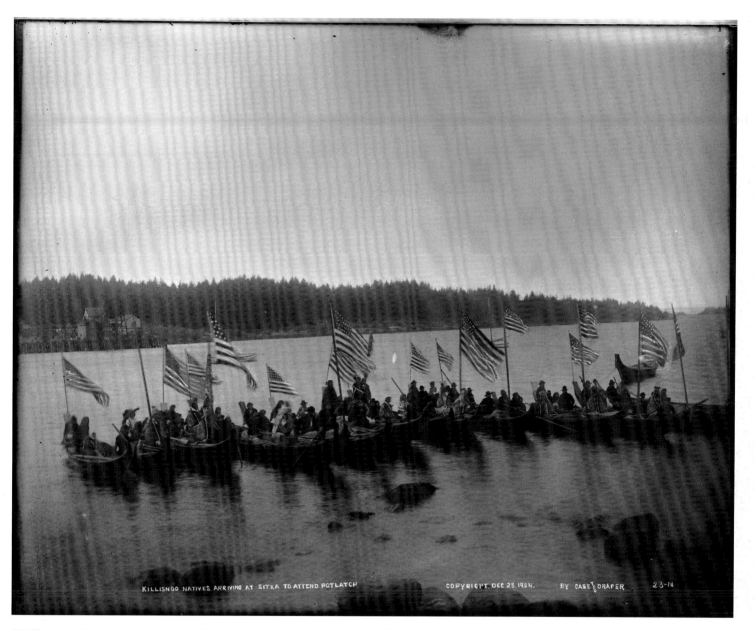

KILLISNOO NATIVES ARRIVING AT SITKA TO ATTEND POTLATCH COPYRIGHT DEC 23 1904. BY CASE & DRAPER 23-N

"Killisnoo Natives Arriving at Sitka to Attend Potlatch."
William Case and Herbert Draper,
December 23, 1904.
Copy negative. ASL-P39-0015.

Case and Draper travelled from their studio in Skagway to record this event. They used a nitrate film negative measuring 3.5×4.4 inches. This photograph with Merrill's on the facing page offer a unique opportunity to experience the perspectives of potlatch guests and hosts.

Potlatch hosts often decorated their canoes with flags when delivering an invitation to a neighbouring village and guests reciprocated in similar fashion when travelling to the potlatch.

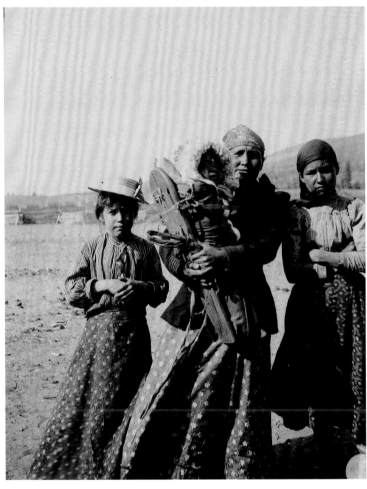

**Mother with children,
Nicola River valley.**
Charles F. Newcombe, 1903.
Direct-duplicate negative. PN 322.

A mother holds her infant in a carrying
pouch attached to a wooden cradleboard.
The girls may be her daughters.

Clo-oose woman?
Skene Lowe, 1889–92.
Original card-mounted photograph.
PN 5061.

This studio photograph is a classic example
of poor documentation associated with
many historical photographs of First
Peoples. We know the name of the
photographer and where the photograph
was taken, because the studio's name and
address are embossed on the card mount.

But who is this woman and where is she
from? The only clue to her identity is
"Clooose 1900" written in pencil on the
back of the card. Is this woman a native of
Clo-oose or was the photograph merely
collected there? The Royal BC Museum
benefits from the help of First Nations
elders who come in to look at photographs
in the collection and add information to
them; unfortunately, we do not know this
woman's identity.

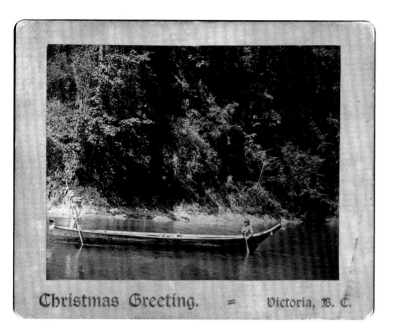

Christmas Greeting. = Victoria, B. C.

Two men in a Nuu-chah-nulth-style canoe on the Cowichan River.
Unidentified photographer, about 1895.
Original card-mounted photograph.
PN 1452.

During the 1890s, field and studio photographs of First Peoples were mounted on cards printed with seasonal greetings. Today, the sale of these might be considered eccentric and inappropriate, but enough examples exist in the Royal BC Museum collection to suggest that this was an accepted practice at the end of the 19th century. Even so, this photograph seems incongruent with Christmas celebrations.

**Nuu-chah-nulth people
at Muchalat Inlet, Nootka Sound.**
Edgar Fleming, summer 1896.
Black-and-white recent contact print from a nitrate negative. PN 11440-B.

The woman in the back row seems completely at ease with the camera as she rests her elbow on her companion's shoulder. The man in the peaked cap holds a paddle in his mouth – perhaps a feat of strength? A net for trapping ducks and the framework of a fish weir are visible in the background.

 Two things diminish the value of this photograph: the names of the people were not recorded, and the nitrate negative has deteriorated along both sides.

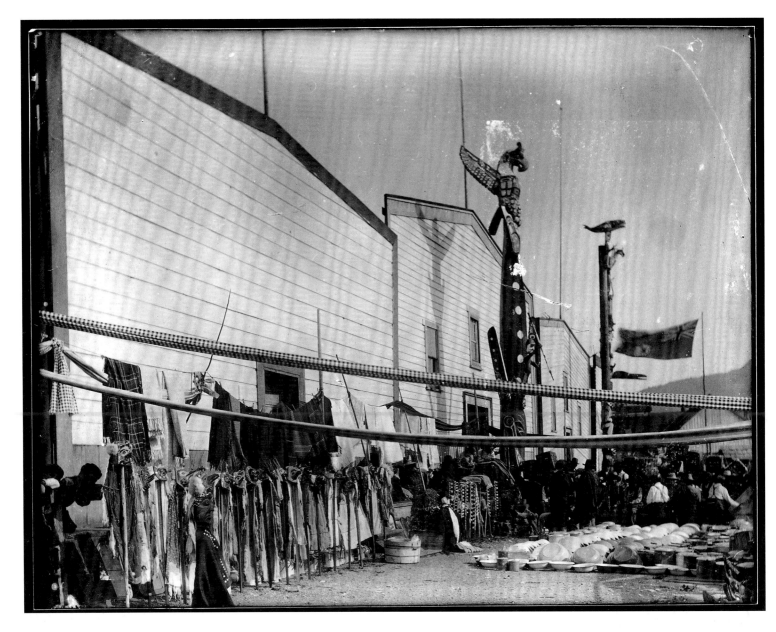

Potlatch at the Kwakw<u>aka</u>'wakw village of 'Y<u>a</u>lis (Alert Bay).
William Halliday, about 1907.
Black-and-white recent contact print from a dry glass-plate negative. PN 10628.

This photograph shows the vast quantity of property distributed at a potlatch: store-bought goods including bolts of calico cotton cloth, woollen blankets fastened by clothes pegs to lines, basins, pots, a wooden wash tub, sea chests, large framed photographs and a mound of Hudson's Bay Company blankets, all displayed alongside more traditional Kwakw<u>aka</u>'wakw items, including 20 dancing headdresses complete with their ermine trains mounted on stakes (right foreground), a pile of cedar ropes and 100 or more carved bracelets of silver or gold tied to stakes (centre). Men are drumming and singing in the background.

William Halliday, the agent responsible for administering the Kwawkewlth Agency in the Department of Indian Affairs, took this and other photographs, presumably to be used as evidence in prosecuting violators of the 1884 legislation that prohibited holding potlatches.

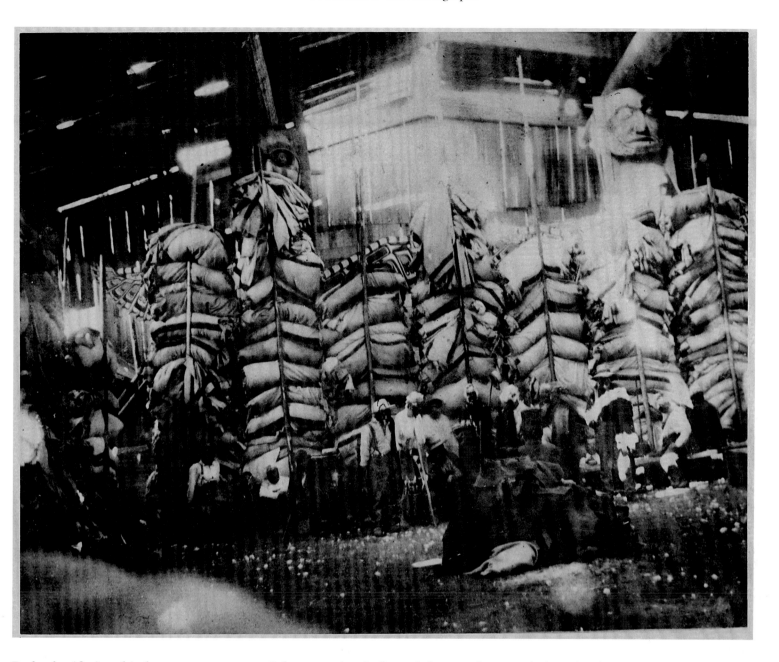

Potlatch gifts in a big house at 'Yalis (Alert Bay).
Unidentified photographer, about 1900.
Copy negative. AMNH 22861.

Massive stacks of Hudson's Bay Company blankets obscure the carved house posts inside a Kwakwa̲ka'wakw big house.

Other more sharply focused photographs show smaller quantities of blankets ready for distribution, but this one dramatically illustrates the material wealth required to hold a successful potlatch.

The photographer used the light entering the big house through the smoke hole in the roof, the gaps between wall planks and perhaps the open front door. The reduced light would have necessitated the use of a tripod to steady the camera.

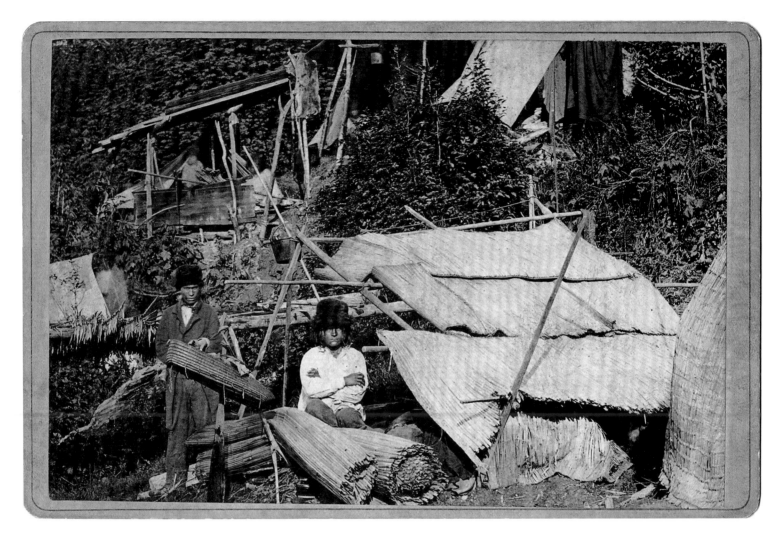

Fishing camp on the Fraser River.
Frederick Dally (probably), 1867 or 1868.
Cabinet card. PN 1419.

The back of this cabinet card bears the name "Mrs R. Maynard, Photographic Artiste, Douglas Street, Victoria, V.I., B.C." – but Frederick Dally probably made this photograph. Sometime after Dally left Victoria in 1870, Hannah and Richard Maynard acquired many of his glass-plate negatives and then marketed some of his photographs on cards advertising their gallery. They had to crop Dally's photograph to fit the image on a cabinet card. It's important for researchers to know that complete views may be available on the original negatives.

This temporary fishing camp has rush mats covering an A-frame fashioned from thin poles, built to last for the duration of the eulachon run that occurred every April and May in the Fraser River. Rows of eulachon hang from drying sticks. These small oily fish (sometimes called candlefish) continue to be an important food in the diet of First Peoples.

The blurred figures in the background are two children and an adult who moved during the time that the wet-plate negative was being exposed.

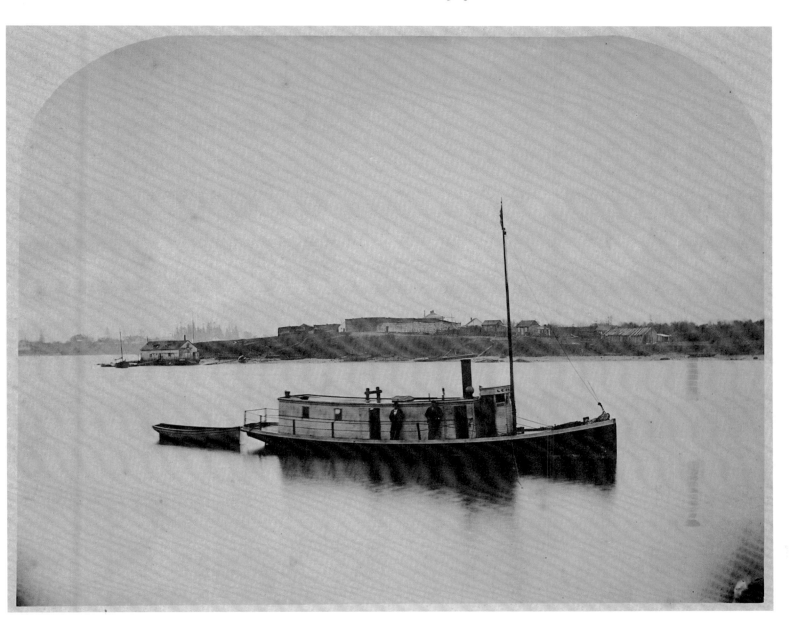

Victoria harbour, Songhees village.
Unidentified photographer, 1877.
Original card-mounted photograph.
BCA F-04584.

A photograph's background is sometimes more important than its subject: this one features the *Leonora* at anchor in Victoria's harbour, but the Songhees village on the far shore commands the research value of this image for anthropologists.

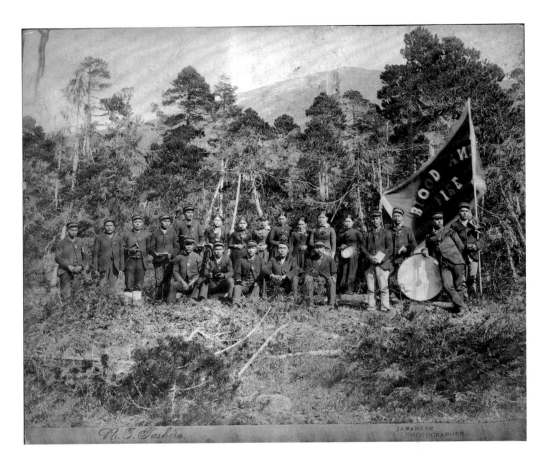

Salvation Army band.
R.Z. Tashiro, about 1895.
Original card-mounted photograph.
PN 4795.

This photograph also has little documentation associated with it. Who were these people? Where and when was the photograph taken? Photo researchers often are presented with these challenges of content, context and origin.

The picture itself offers some clues. The presence of a tambourine, bass drum and uniforms indicate a band, probably a brass band, because First People often joined such groups (Duff 1997:143). The motto on the flag, "Blood and Fire", identifies the men and women as members of the Salvation Army. Although the location is unidentified, it is likely that these people are either Coast Tsimshian or Gitxsan, because the Salvation Army was active along the coast and Skeena River (Duff 1997:143). Supporting this hypothesis is the name of the photographer stamped beneath the image, "R.Z. Tashiro, Japanese Photographer". Tashiro was active at Claxton and Port Simpson from 1892 to 1900 (Mattison 1999).

Two men in the Alberni area.
Carlo Gentile (probably), about 1864.
Original photograph. PN 5072.

This photograph drew my attention because I thought that the man on the right was wearing a cedar-bark blanket. If so, it would be the only photograph in the Royal BC Museum collection not taken by Edward Curtis that showed a person wearing cedar-bark clothing. It would be an even more impressive find as this photograph pre-dates Curtis's fieldwork among the Nuu-chah-nulth by perhaps 50 years. My exuberance was tempered by skepticism. A high-resolution scan of the original photograph enabled me to examine the details. Disappointment prevailed – the man's blanket was clearly not made of cedar bark. I sent my observations to colleagues at the Canadian Museum of Civilization who replied, "Even though the blanket isn't cedar bark, those of us who looked at the photo here weren't disappointed at all."

Others received the photograph with enthusiasm, even though weavers and ethnologists cannot determine the nature of this garment. My colleagues at the CMC reported that it may be a woven, twined, hand-spun Salish or Nuu-chah-nulth wool blanket or it may be a quilt blanket "made by a Nuu-chah-nulth or Salish seamstress or even a male sewer … worn in the same manner as the HBC blanket. [Regardless, it] is a wonderful photo, and very important, as a quilt or a weaving, for Salish blanketry".

Both men, who may be Tseshaht from the west coast of Vancouver Island, wear cloth shirts and the man on the left wears a Hudson's Bay Company point blanket. These garments illustrate the transition to non-native clothing that was beginning to take place among the Nuu-chah-nulth by the early 1860s. Both carry bags or perhaps quivers slung across their chests; the man on the right is carrying an arrow in his right hand and part of one in his left. One man wears a headdress made of cedar bark, dyed alder and a feather; the other appears to wear a feathered cap. They pose in front of an outside house wall made of overlapping split-cedar planks.

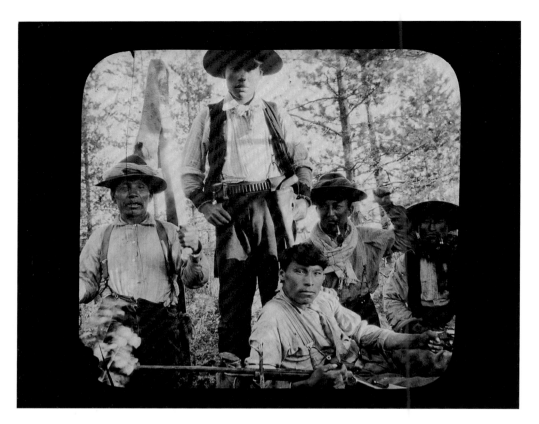

**Men of Stony Creek,
Nechako River valley.**
Frank Swannell, 1908.
Lantern slide. PN 14214.

Staff at the Royal BC Museum examined about 3000 lantern slides in the Anthropology Department's collection searching for images that had not survived in either print or negative format. They copied these slides using a large-format camera to produce 4×5-inch copy negatives and prints. The prints now reside in the reference collection of historical photographs.

This image, one of those in the duplication project, has the characteristic outline of a lantern slide. Charles Newcombe recorded this image in *Newcombe's 2nd Register of Negatives and Lantern Slides* with a short comment: "Carrier Indians, men of Stoney Creek Band, Nechaco Valley, FCS1908." The men remained unnamed until 1996, when researchers at the Yinka Déné Language Institute identified four of them (left to right): Seymour Sagalon, Alex McKinnon, Belnar Sagalon and possibly Wasa Leon; the man on the far right remains unidentified.

The photographer remained a mystery until I recently came across the same image on the BC Archives website. The original picture, called "Indian axemen", was taken by Frank Swannell, a licensed land surveyor who photographed many First Peoples while surveying in central and northern BC in the early 1900s.

Advancements in Technology
1851–1900

The early photographers of the northwest coast of North America packed their extensive equipment on board Royal Navy, US Navy, US Revenue Service gunboats and, later, private steamers that plied the sheltered marine waterways. Most of the ethnohistorical photographs before the mid 1880s were produced using a technology called the wet-plate process. This type of photography used glass-plate negatives that, once sensitized, had to be exposed while still wet, or the emulsion (the part of the negative that captured the image) would lose its sensitivity to light. Unlike the pre-sensitized, flexible film used today, the glass negative had to be prepared just before the photograph was made, whether in the studio or in the field.

The wet-plate process was long and cumbersome. In the field it might require an hour or more to set up equipment, prepare, expose and process the first negative. A large, wooden view camera had to be mounted and fixed on a heavy wooden tripod that had been set and levelled. The camera required the sturdy tripod to keep it steady during the film's lengthy exposure, which could take 20 seconds to five minutes. The photographer then removed the lens cap and ducked his head under the black focusing cloth to compose and focus the image on the ground-glass viewing screen at the back of the camera. He replaced the cap and then prepared the negative in a "dark-tent", a portable darkroom (shown in both photographs on the following page), on a sturdy support, usually a tripod, to prepare the negative.

Outside the dark-tent, the photographer took a clear glass plate from a carrying box and coated it with collodion, a syrup-like solution used to bind the emulsion to the glass. Then, inside the dark-tent, he coated the plate with the emulsion, placed it in a light-tight plate-holder (also called a plate carrier) and carried it to the camera. The camera's hinged viewing screen allowed the plate-holder to be inserted in its place.

Now the photographer removed the plate-holder's dark-slide, which made the negative ready for exposure to the sun's light. He removed the camera's lens cap for the length of time required to make the exposure. The exposure time depended on the available sunlight, the photographer's experience and the capacity of his pocket watch to keep time. Time up, he put the lens cap back on and slid the dark-slide into place, then pulled out the plate-holder and quickly returned to the dark-tent to develop and wash the negative.

After developing the negative, he brought it outside again to fix and wash it a second time, then dry it in the sun. When dry, the side of the glass plate carrying the emulsion could be coated with a protective covering of varnish, dried and finally replaced in its slotted wooden box for safe storage and transportation back to the photographer's gallery.

The photographer depended completely on the limited supplies that he took with him into the field, carefully returning excess chemicals to their containers throughout the procedure. Positive paper prints were usually made after he returned to his gallery, since they required additional chemicals as well as a printing frame. To make a print, the photographer placed sensitized paper in direct contact with the negative in a printing frame and exposed it to the sun; he washed and toned the print, then fixed and washed it a second time.

Until the 1890s, photography was by-and-large the specialized practice of those men and women who held both the technical expertise and financial means to make photographs. Because the production of wet glass-plate negatives was intricate, lengthy and cumbersome, I use the verb *make* (not *take*) throughout this book to describe photographs created from them.

Studio photography during the wet-plate era was almost as daunting, and it clearly intimidated everyone who arrived at a gallery to have her or his photograph made. Surviving portraits of First Peoples present them as stiff and unsmiling. This was due to the long exposure times required to produce photographs in the 1860s and 1870s. To assist their customers and subjects in holding still, photographers

Indian camp burial ground

Dark tent on a beach near Old Metlakatla or Tsaxis (Fort Rupert).
Richard Maynard, about 1880.
Stereograph. PN 8708.

This photograph is one of the few showing the photographic apparatus used to make a wet glass-plate photograph in the field. Richard Maynard's dark-tent stands at the base of the rocks (right). His slotted wooden box, used to transport glass plates, and a chest containing chemicals and other sundry equipment sit on the beach nearby.

Dark tents "... were usually perched on legs, so the photographer had his materials at waist level, and apart from darkness they provided compartments or shelves for chemical bottles and a surface on which to work, and had a tinted panel or window to shield against the harmful rays of light. Water was usually brought in the tent through a tube connected to a container set on top of the tent." (Spira 2005:48.)

The Kwakwaka'wakw village of 'Yalis (Alert Bay).
Richard Maynard, September 14, 1874.
From a wet-plate negative. BCA G-05843.

The people of 'Yalis seem comfortable with the camera as they pose for their group portrait. Richard Maynard made this photograph when he accompanied British Columbia's first federal superintendent of Indian Affairs, Dr Israel Wood Powell, on a tour of inspection of coastal villages around Vancouver Island in 1874. Powell, wearing a pill box cap, stands in front of the entrance to the house on the right.

Maynard's dark-tent (portable darkroom) sits on its tripod on the left. Every photograph printed from this negative shows an incomplete image, because the emulsion that Maynard applied in the field either did not cover the entire glass plate or it has disintegrated over time.

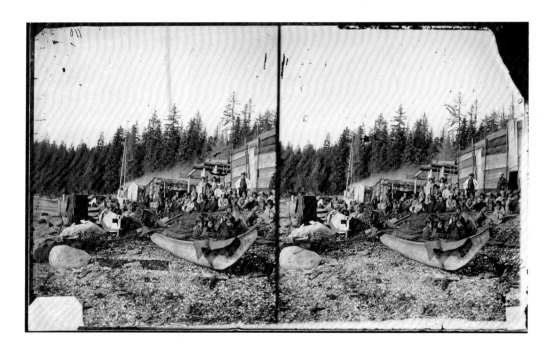

Winter and Pond's studio in Juneau, Alaska.
Lloyd Winter and Percy Pond, no date. Black-and-white recent contact print from a dry glass-plate negative. ASL-P87-0991.

This photograph, probably taken after 1900, shows the array of props and furnishings used to produce commercial portraits: a cushioned swivel stool with adjustable back rest; adjustable iron stand with neck brace; a large rectangular plain backdrop; multiple larger backdrops affixed to a chained pulley system (a painted garden scene is visible); an outside wall of high windows, bringing natural light into the studio; a large pleated-bellows stand camera, probably capable of accommodating 8×10-inch glass plates; a rug made of various pelts, possibly to convey the Alaskan wilderness; several smaller stools; a small table; a rustic chair; and a large wall mirror that would have been used by clients for grooming and perhaps by Winter or Pond to reflect additional light onto the sitter. The glass-plate negative used to take this photograph measured 7½×9½ inches.

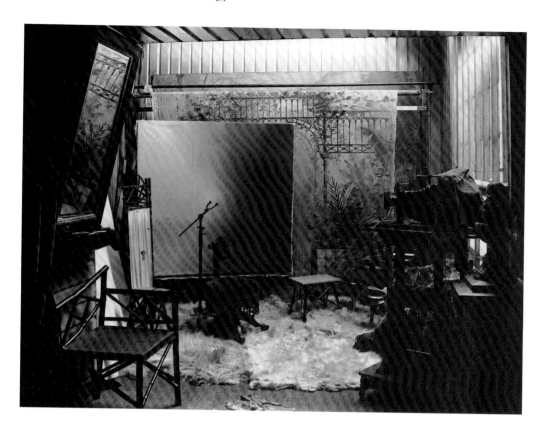

used a variety of supports: an iron stand, a wooden balustrade, a chair or perhaps a small table to lean against. One photographer in England used a "posing machine ... [with] separate controls for the back, arms, sides and head, allowing the photographer to contort the subject into a variety of 'natural' poses, and then immobilize the body to hold in that position.... This was truly the iron instrument of torture." (Sandweiss 1991:64)

Towards the end of the 19th century, the many technological advances in photography resulted in an exponential increase in the taking of photographs. Dry glass-plate (or dry-plate) negatives coated with a presensitized emulsion were introduced in England in 1871. Since these negatives did not require on-site processing it was no longer necessary to transport a dark-tent, chemicals or a supply of water into the field. The disadvantage of using early dry-plates was that they required a longer exposure time to capture an image. This shortcoming was overcome seven years later with the Bennett dry glass plates that reduced the exposure time to a tenth of that required wet glass plates. The introduction of these rapid gelatine dry-plates was not immediately embraced by commercial wet-plate photographers comfortable using a technology they understood and had invested a great deal of time and money in. Because of this, a photograph dated 1881 could have been made from either a wet-plate or dry-plate negative (example above).

"You press the button, we do the rest." This 1888 Eastman Dry Plate and Film Company slogan announced a photo-finishing service to owners of the first Kodak box camera. These first Eastman negatives were roll film on a paper backing. Once all 100 exposures were taken, the photographer sent the camera to the Eastman factory in Rochester, New York, where the negatives were processed and printed. The camera was then re-loaded and returned

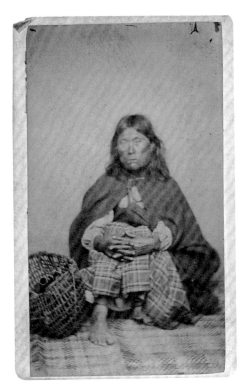

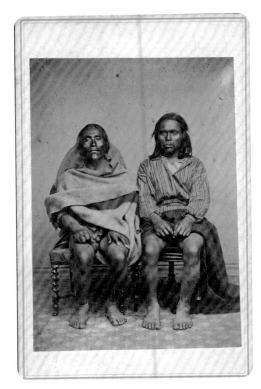

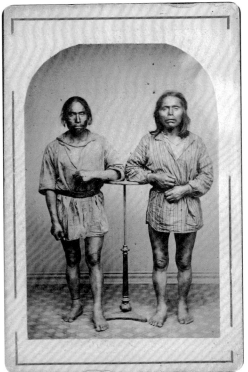

Studio portraits made in Victoria.

Studio photographs in the 1860s and 1870s required lengthy exposure times. If patrons moved, their portraits were blurred. To help people remain still, photographers posed them sitting on the floor, sitting on high-back chairs or leaning on iron stands. Clockwise from top left:

Unidentified woman.
Hannah Maynard or
Charles E. Vieusseux, about 1868.
Carte de visite. PN 5076.
(see page 14).

**Two Huu-ay-aht men
from Barkley Sound.**
Frederick Dally, about 1866.
Carte de visite. PN 4703.

**Kwakwa̲ka'wakw chief
from Tsa̲xis (Fort Rupert).**
Hannah Maynard, 1865–72.
Carte de visite. PN 8736-B.

**Two Tseshaht men
from Barkley Sound.**
Frederick Dally, about 1866.
Carte de visite. PN 4813.

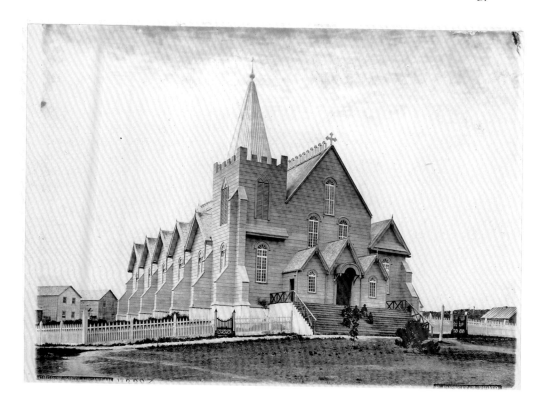

St Paul's Church
at the Tsimshian village of Metlakatla.
Edward Dossetter, June 30 to July 3, 1881.
Black-and-white recent photograph.
AMNH 42293.

Anglican lay missionary William Duncan
and his Tsimshian converts established
the industrial Christian community
of Metlakatla in British Columbia in
1862 under the auspices of the Church
Missionary Society. In 1887, after a falling
out with Reverend William Ridley,
Anglican Bishop of Caledonia, Duncan and
many villagers moved to Annette Island
in Alaska where they established New
Metlakatla.

Metlakatla's St Paul's Church could
seat more than a thousand people and
was reputed to be one of the largest
churches west of Chicago and north of
San Francisco (Usher 1974: 69). Besides
the uniformly designed houses visible
in the background, the village included
a museum, jail, sawmill, salmon cannery,
brick yard, courthouse, store and school.

In a letter dated August 13, 1881, to
Dr Israel Wood Powell, British Columbia's
superintendent of Indian Affairs (Canada
1881:148), Duncan wrote: "We have not
forgotten to cultivate the arts peculiarly
Indian. I am encouraging the Indians
to keep up their ancient carving, and
our village hall (now being erected) is
to be almost entirely Indian in style and
structure."

Edward Dossetter made this
photograph when he accompanied
Dr Powell on a tour of coastal villages.
Although prepared dry glass-plate negatives
were available to Dossetter, he chose to
employ the more challenging wet-plate
process to photograph this view of St
Paul's.

to the owner with the processed prints. In the following
year, Eastman introduced the No. 2 Kodak camera. It had a
rudimentary viewfinder "… placed so that the photographer
held the camera at waist or chest level and looked down into
it. Yet it was difficult to see clearly with the tiny viewfinder.
One photographer characterized it as a 'dimly lit one-inch
square'." (Greenough and Waggoner 2007: 13). Perhaps tak-
ing a photograph wasn't as easy as George Eastman's slogan
suggested.

Eastman also introduced cellulose nitrate roll film
in 1889 (Coe and Haworth-Booth: 1983:22). This major
advancement was everything that glass negatives were not:
light, compact, flexible and non-breakable. Roll film helped
make possible the invention of user-friendly hand-held box
cameras, with a shutter speed of 1/25th of a second, enabling
users to capture spontaneity. The affordable Kodak "Brownie"
box camera, launched in 1900, retailed for $1.00 and enjoyed
sales of between 150,000 and 250,000 cameras in its first
year. These technological advances released the practice of
photography from the arms of the well-to-do professionals to
the welcoming hands of amateurs around the world.

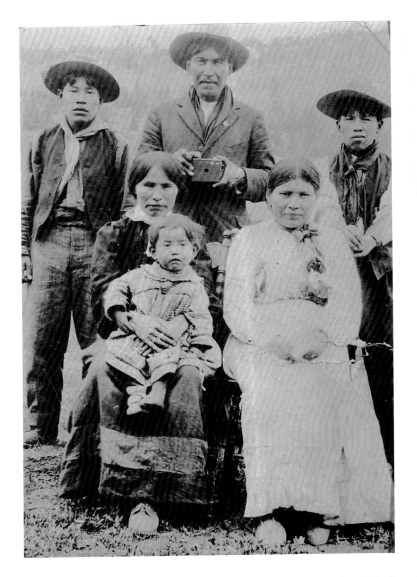

Making the Exposures
Instantaneous Exposures
"Snapshots"

THE shutter of the No. 2 or the No. 2A Brownie Camera is released by pushing the lever either to the right *or* left with the thumb. Push the lever *slowly* and in one direction only.

Fig. I.

If the lever stands at the right end of the slot simply push it to the left, or if it is at the left end of the slot push it to the right—*one movement only.*

11

A page from the Canadian Kodak Company's *Picture Taking with the Nos. 2 and 2A Brownie Cameras* instructs users how to take snapshots – quick and easy photographs (RBCM PN 23907).

"Snapshot" originally described the firing of a gun without taking careful aim. The Eastman Dry Plate and Film Company applied the term to its first Kodak camera that did not have a viewfinder, but had sighting lines etched into its top to indicate the field of view. Of course, the lack of a viewfinder left photographers with some doubt about the accuracy of their shot. "Snapshot" has remained a common term to describe an informal photograph.

People in the Tsilhqot'in village of Tl'etinqox (Alexandria).
Unidentified photographer, about 1910.
Copy negative. PN 14048.

By 1910, the use of box cameras was commonplace, resulting in an exponential increase in the number of photographic prints. This proliferation of photographs did not improve the documentation that came with them. The Royal BC Museum borrowed this photograph in the early 1980s, but the people in it remained unidentified until 2003. In May of that year the photograph was shown in Quesnel, where the man holding the camera was identified as Joseph Bobby and the woman in white as his wife, Josephine. Faith Moosang mentions Josephine in her biography (1999:142) of "Quesnel's first professional photographer", Chow Dong Hoy: "Josephine (Alexander) Bobby, from Alexandria, was a Tsilhqot'in woman who sat for Hoy on at least 15 occasions."

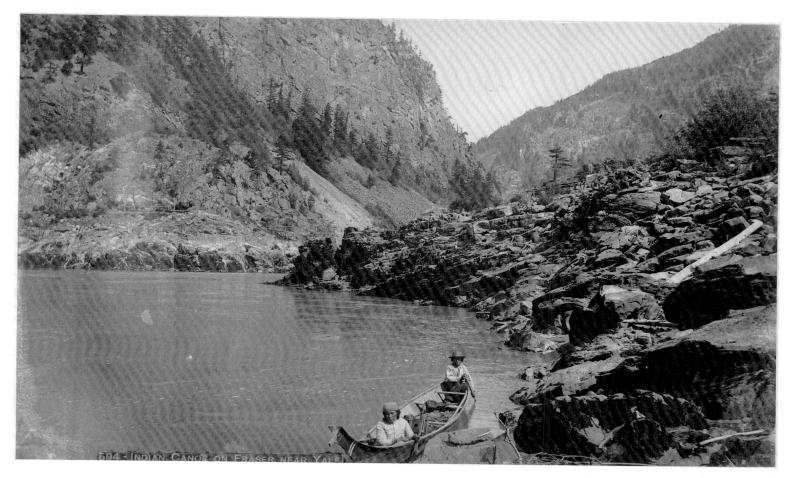

"Indian Canoe on Fraser near Yale."
Charles Bailey, June 21, 1888.
Black-and-white recent print. VPL 19955.

Charles Bailey, of Vancouver, used a
5×7-inch glass-plate negative to take this
photograph. He framed the image to
include not only the Nuu-chah-nulth-style
canoe in the foreground but also the fish-
drying racks on the far bank. His second
large-view camera rests behind the woman
sitting in the front of the canoe. Bailey's
cameras, tripod and glass-plate negatives
would have occupied a considerable share
of the canoe's space. Field photography
in the late 19th century posed challenges
far removed from the convenience of
21st-century digital photography.

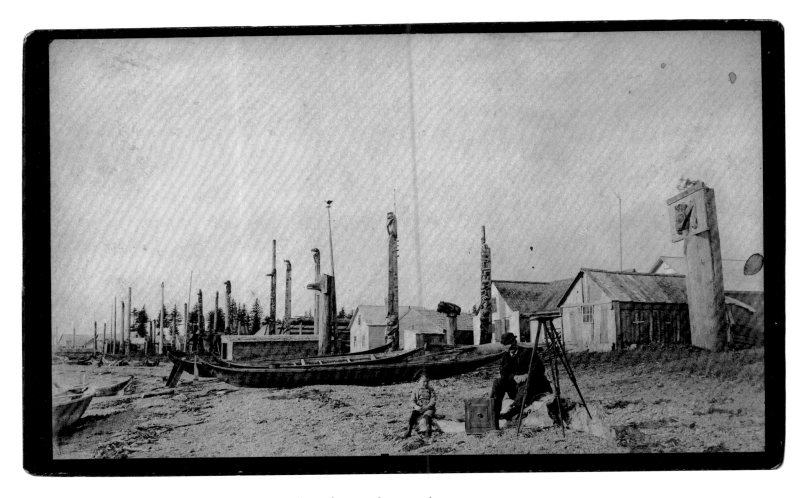

The Haida village of Rad Raci7waas (Massett).
Robert Reford, October 1890.
Boudoir card. PN 23906.

The tripod gives a sense of the size of some 19th-century cameras: the larger the camera, the larger and more sturdy the tripod required to support it. It's not surprising, then, that so many more photographs were taken at coastal villages, because it was easier to carry this equipment from ship to village than by freight wagon or pack horse through the interior of British Columbia. The man sitting beside the camera is Charles Macmunn, a professional photographer based in Victoria who also worked for the Canadian Pacific Railway. This photograph was taken using a dry-plate negative and the view camera seen on page 105.

"Chauffeurs in camp",
possibly at Chimney Creek, Cariboo.
Unidentified photographer, July 1914.
Original photograph from a photo album.
PN 12559.

This photograph appears in an album
prepared for J.A.J. McKenna, a member of
the Royal Commission on Indian Affairs,
1913–16. The man in the centre stands
behind a portable folding-bellows pocket
camera mounted on a tripod. Folding
pocket cameras (perhaps a misnomer due
to their considerable size) were used to
produce many photographs during the
first two decades of the 20th century.
They accepted a cartridge containing
prepared roll-film, eliminating the need to
load the camera in a darkroom. Compare
this compact, easy-to-use, daylight-
loading camera with the cumbersome
photographic apparatus that Richard
Maynard used in 1874 (see page 30, top).

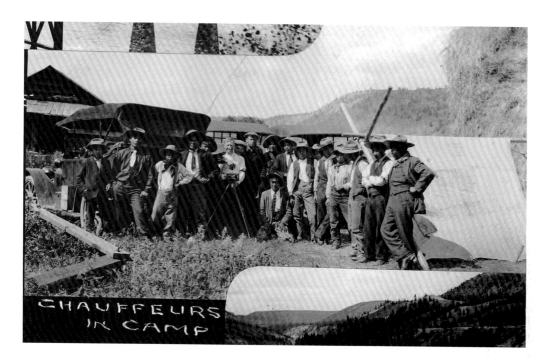

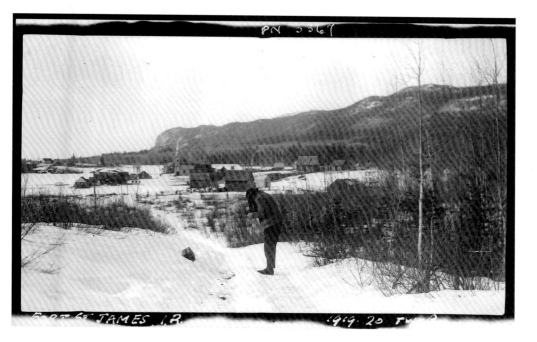

Photographing the Dakelh village
of Nak'azdli, near Fort St James.
Thomas W.S. Parsons, 1919–20.
Black-and-white recent contact print
from a nitrate negative. PN 3367.

Anthropological field photographs in
British Columbia showing photographers
at work are uncommon for the early
20th century and non-existent before the
1890s. In this photograph, an unidentified
photographer looks into the focusing
hood of his camera; the hood prevented
unwanted light from interfering with
focusing the image. He is taking a picture
during the winter, a rare occurrence.

The photographer, Thomas Parsons,
was not an anthropologist, but a police
officer (he later became the chief
superintendent of the British Columbia
Provincial Police). Researchers appreciate
the care he took to document his images
by printing the location, author and date
on his negatives.

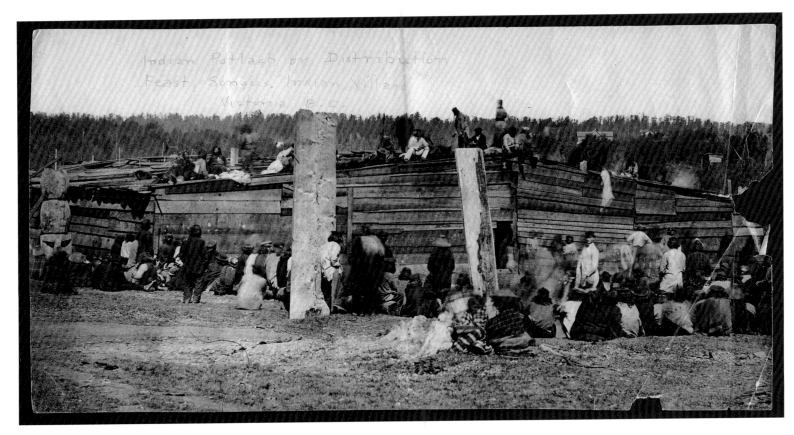

Despite the efforts that photographers took to avoid breaking their glass-plate negatives, accidents sometimes happened:

ACCIDENT – As Mr Dally was coming down the steep pitch at the four-mile canyon, near Jack of Clubs lake, his horse slipped, and one of the wheels running over a high piece of rock in the road, upset the trap and precipitated both horse and wagon into the ravine below, some thirty feet, and damaging a good many of his chemicals. During the day a pack train passed and assisted him out of his difficulty. He says it would have made a good picture, but he was not in the humor to take it. At the same place a similar accident occurred last fall.
 – *The Cariboo Sentinel*, vol. 5,
 Barkerville, Sunday, July 26, 1868.

Potlatch in Songhees village, Victoria. Frederick Dally (probably), 1866–70. Original photograph. PN 6805.

The long exposure times required when using wet glass-plate negatives made field photography especially challenging. Depending on the amount of daylight and the quality of the lens, the photographer had to expose the negative for 20 seconds to 5 minutes. This scene of a potlatch in the Songhees village shows how difficult it was to record movement. Many of the assembled guests and people preparing to throw blankets from the roof are blurred, some even to the extent of being transparent "ghost figures".

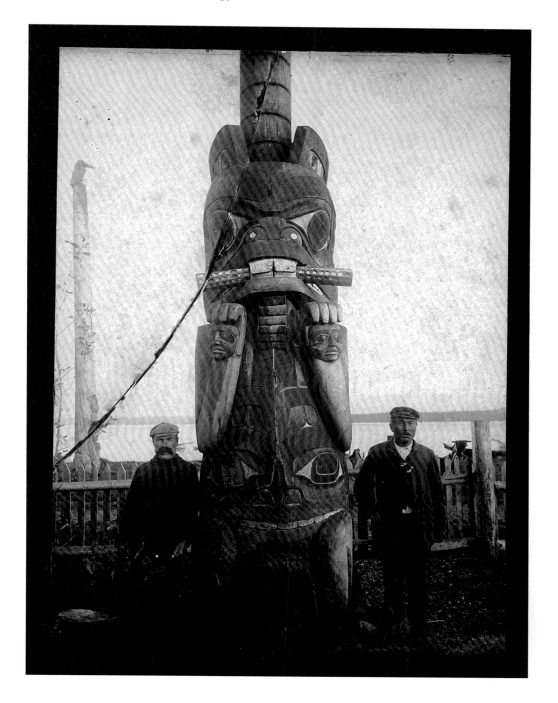

Chief Wi:ha's interior pole at the Haida village of Rad Raci7waas (Massett).
Charles F. Newcombe, September 1900.
Original card-mounted photograph.
PN 9096.

Unlike the flexible plastic films used in cameras today, glass-plate negatives were fragile and susceptible to breakage. Many photographs printed from these types of negatives have chips or cracks running the length of their images.

Charles Newcombe took this image using a presensitized dry glass-plate negative measuring 4¾×6½ inches. He may have included the two unidentified men (one could be Harry Wi:ha, Chief Wi:ha's nephew) to provide a sense of the pole's height (5.5 metres). This pole, which originally stood inside Neiwans (Monster House), is now on exhibition in the Grand Hall at the Canadian Museum of Civilization in Gatineau, Quebec.

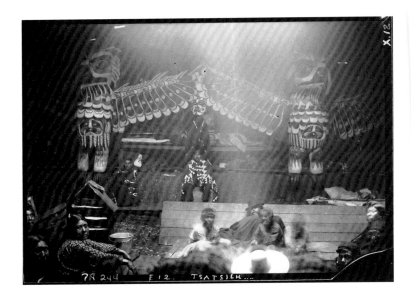

Interior of a big house at the Kwakwa̲ka̲'wakw village of T'sadzis'nukw̲aame' (New Vancouver), Harbledown Island.
Charles F. Newcombe, 1900.
Black-and-white recent contact print from a dry-plate negative. PN 244.

This is one of the few surviving photographs of the interior of a traditional 19th-century Kwakwa̲ka̲'wakw big house. The glass-plate negative has a chip in the lower right corner. The exterior of this house appears in the photograph shown on pages 43–45: it has a sculpin's face painted on its front. The three children in the foreground could not sit still long enough to avoid being blurred during the lengthy exposure time.

The house may have been illuminated by a combination of natural light from the smoke hole in the roof and artificial light made by burning magnesium (a slow-burning ribbon or powder spread on a metal tray). Flash photography at this time was problematic: the magnesium could easily explode, and it was difficult to set off the flash at the same time as the opening and closing of the camera's shutter. A viable, safe method of lighting indoor photography did not arrive until the 1930s with the introduction of flash-bulbs.

Secwepemc *kekuli* in the Nicola River valley.
Charles F. Newcombe, May 17, 1903.
Black-and-white recent contact print from a dry-plate negative. PN 1000.

Newcombe rarely made references to his photographs in his diaries, but his entry for May 17, 1903, reads: "AM, photos of Indians, one wearing dentalium headdress, after lunch changed plates in camera and right away for Nicola Lake at 3:15 pm took photo ... of kekuli ... house near Armitage's place. Could not take interior, too dark."

A *kekuli* is a semi-subterranean winter house used by the Secwepemc and other interior First Peoples. The dirt excavated to form the pit of the house covers a structure of wooden posts, poles and bark. The primary entrance is at the top via the log notched with steps.

Captain Jack's house in the Nuu-chah-nulth village of Yuquot.
Ernest W.A. Crocker, about 1920.
Black-and-white recent contact print from a dry-plate negative. RBCM PN 11682.

Although flexible film was available in the late 1880s, professional photographers continued to use dry glass plates for portraiture in their studios. As late as the 1920s, Ernest Crocker took large-format (6½×8¼ inches) presensitized glass-plate negatives into the field. He used one to photograph these finely carved house posts inside Captain Jack's house at Yuqout.

The poles were collected some 40 years later by the BC Provincial Museum. Master carvers Tim Paul and Ki-ke-in (Ron Hamilton) made new carvings of the poles in 1995 and the museum returned these to the Mowachaht-Muchalaht First Nation. They stand at the back of the church in Yuquot, which is now the tourist centre.

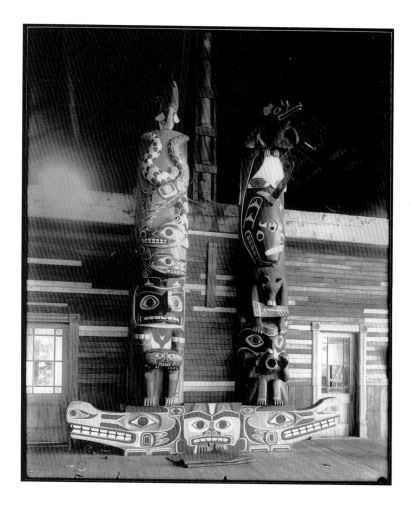

This story will tax the credulity of those who practice kodakery [Kodak-camera enthusiasm] in its simplest form. To people who make pictures by aiming quickly, firing quickly, heading for the corner drug store and waiting eight hours it will seem that truth has strained a ligament. But Mr. J. Savannah, who has been in the photographic business since the days of the wet plate, the head rest, and the solidified smile, vouches for the facts.

"As to interiors, I remember the time we photographed the interior of the old iron church on Douglas Street [Victoria]. We set up the camera, focused it, removed the cap from the lens – no shutters in those days – and went home to lunch. When we returned about an hour later, replaced the cap and developed the plate, we found that we had obtained excellent results."
– *The Daily Colonist*, Victoria,
 Sunday, July 27, 1924, page 13.

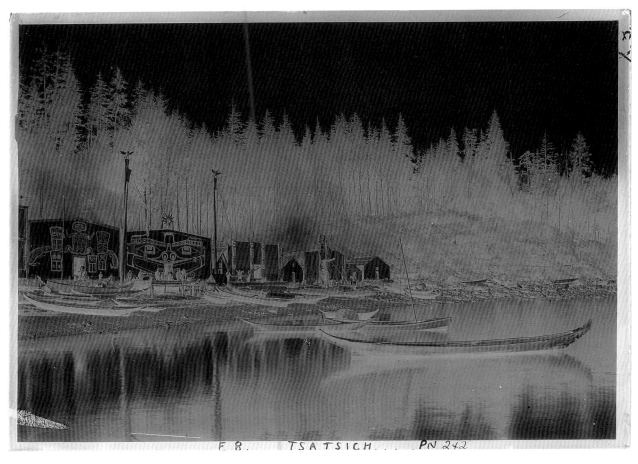

F.B. TSATSIGH PN 242

Negatives a century apart.
PN 23878.

Compare this 2007 single frame 35-mm colour negative and the 4¾×6½-inch black-and-white dry glass-plate negative from 1900. The older negative is 14 times larger than the modern negative, enabling researchers to more easily study the details.

The following three pages show an example of enlargement. But the most dramatic examples of enlarging photographs taken with glass-plates can be found in Dr George MacDonald's *Haida Monumental Art* (1983).

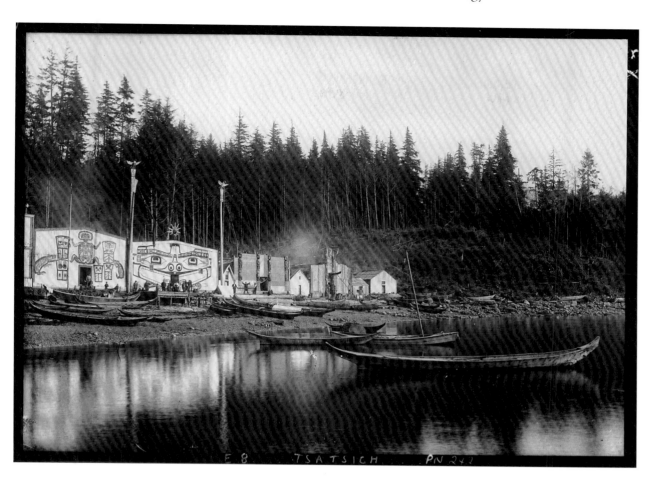

Positive full-size image of the Kwakwa̱ka̱'wakw village of T'sadzis'nukwa̱ame' (New Vancouver), Harbledown Island.
Charles F. Newcombe, 1900.
Black-and-white recent contact print from a dry glass-plate negative. PN 242.

This contact print is the same size as the original glass-plate negative on the facing page. It may tell us something about how familiar the photographer and villagers were with the technical limits of photography at the turn of the 20th century. The people posing in front of the houses most likely expected to be recognizable in this photograph, but the distance separating subject and camera was too great, even for a large-format glass-plate negative.

Kwakwa̱ka'wakw village of T'sadzis'nukw̱aame' (New Vancouver), Harbledown Island.
Charles F. Newcombe, 1900.
Enlargements of PN 242.

When Charles Newcombe took this photograph in 1900, T'sadzis'nukw̱aame' consisted of a combination of traditional 19th-century big houses, smaller, transitional houses with steeply pitched, gabled roofs, and one single-family, Euro-Canadian house.

The traditional big house on the left features a painting of the first man or chief of Dzawadi, Knight Inlet. On either side are painted Grizzly Bears and five coppers (shield-like plates adorned with painted faces that signify great wealth, prestige and social standing). The adjacent big house has a Sculpin's face painted on it and, above, a carving of a Sun crest with its rays expanded.

Both big houses were built using split-cedar planking, but the façade of the third big house was made of milled lumber, some of which is arranged in both horizontal and vertical herringbone patterns. Four carved and painted columns, each consisting of *Dzunukwa* (Wild Woman of the Woods) standing atop a chief who is holding a copper and standing on what may be another copper, are affixed to the house front. Some time later, the owners added the carvings of a *Sisiyutl* (a supernatural double-headed serpent with human face in the centre) and a bird (shown on page 62).

The remaining big house was constructed of split-cedar planks. Its rectangular entrance is framed by two columns, each consisting of a Grizzly Bear and three men in succession, and the prow of a canoe that projects outward; above the canoe is a large painting of a chief topped with a carving of a *Huxwhukw* (Cannibal Bird).

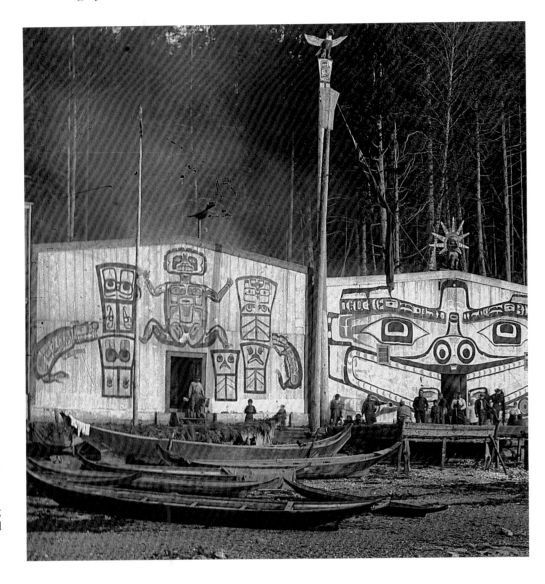

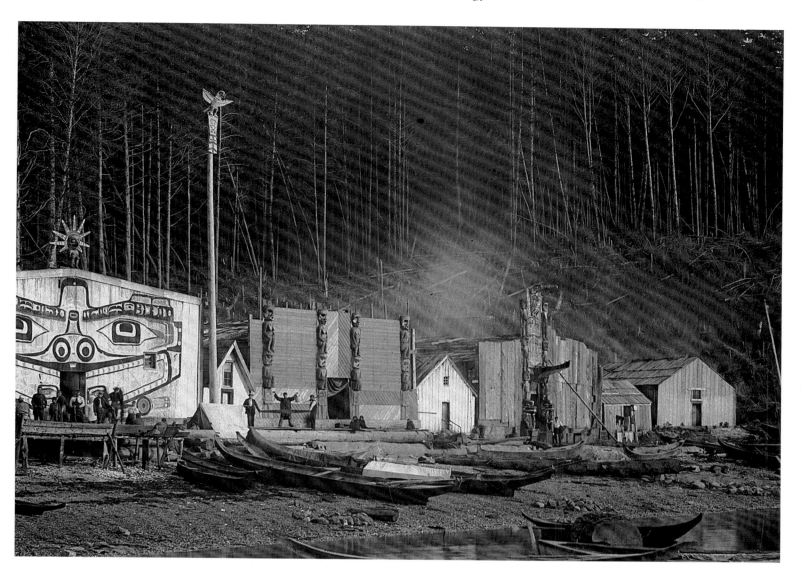

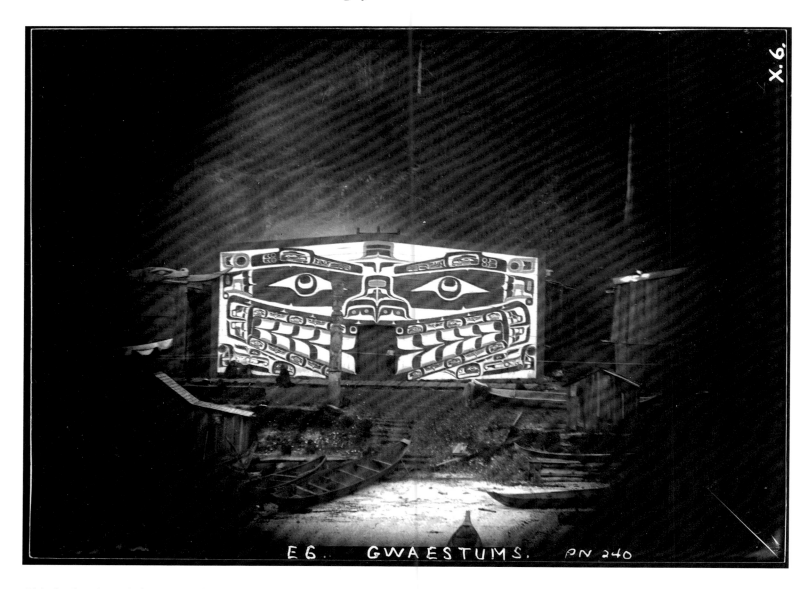

Chief John Scow's house at the Kwakwaka'wakw village of Gwa'yasdams.
Charles F. Newcombe, November 1900. Black-and-white recent contact print from a dry-plate negative. PN 240.

Newcombe's note about this photograph in his *Register of Negatives and Lantern Slides* reads "enlarged by telephoto". It is the only photograph in the Royal BC Museum's ethno-historical collection that was taken with the use of a telephoto lens. It shows the design of a Sea Monster painted on the front of Chief Scow's house in Gwa'yasdams, on Gilford Island.

Photographic Formats

Because of technological advancements in photography and changing styles of presentation, photographers produced images in several formats over the 60 years covered by this book. The caption for each photograph notes the format from which the printed image was scanned, as defined on the following pages. Each of the card-format photographs and the two types of lantern slide have been reproduced to actual size to help you identify similar items in your personal collection. Simply place your collection piece against the example. Dimensions are in inches, because people in this region used Imperial measurements at the time the photographs were made.

Negatives

Original Negative
The negative in the camera when the photograph was either made (wet-plate process) or taken (dry-plate process, flexible nitrate sheet or roll film) is the original.

Direct Duplicate Negative
If an original negative is fragile, in disrepair or likely to degrade, then a direct duplicate negative can be produced by placing duplicate negative film in direct contact with the original. Because the image on a direct duplicate negative is laterally reversed, care must be taken when printing or scanning it to make certain the image is oriented correctly. Direct duplicate negatives used in this publication measure 4×5 inches and were made from nitrate negatives of equal or smaller size in the Royal BC Museum's Anthropology Department's collection.

Copy Negative
When the original negative no longer exists, a copy negative can be produced from a positive image (print or lantern slide). If the image has survived in print or card format, then it is placed on a copy stand and photographed. In lantern slide format, the slide is place on a light table to illuminate the image and then photographed. Copy negatives used in this publication measure 4×5 inches.

Wet-plate Negative
Most of the ethnohistorical photographs made before 1885 were produced using the wet-plate process. It was so named because the glass-plate negative had to be exposed while still wet otherwise the emulsion would lose its sensitivity to light. See page 29 for a description of this process.

Dry-plate Negative
Dr Richard Leach Maddox invented dry glass plates in England in 1871 (Spira 2005:69). He pre-sensitized the plates with a gelatine emulsion that contained light-sensitive silver salts. The photographer no longer needed to transport darkroom and chemicals into the field, because the plates could be processed after returning to the photographic gallery. (An example of a dry-plate negative appears on the next page.)

Nitrate Negative
The first flexible plastic developed to support the gelatine emulsion, the part of the negative that contains the image, was cellulose nitrate (celluloid). It was introduced in 1888 in sheet-film format by John Carbutt of Philadelphia and the following year by George Eastman as roll film (Coe and Haworth-Booth 1983:19,22). (An example of a nitrate negative appears on page 49.)

**"Cache and house frame",
Nicola River valley.**
Charles F. Newcombe, 1903.
Dry-plate negative (4¼×6½ inches)
and black–and–white recent contact print
(actual size). PN 23900.

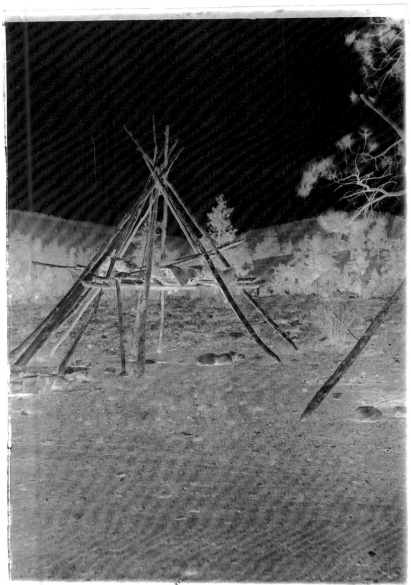

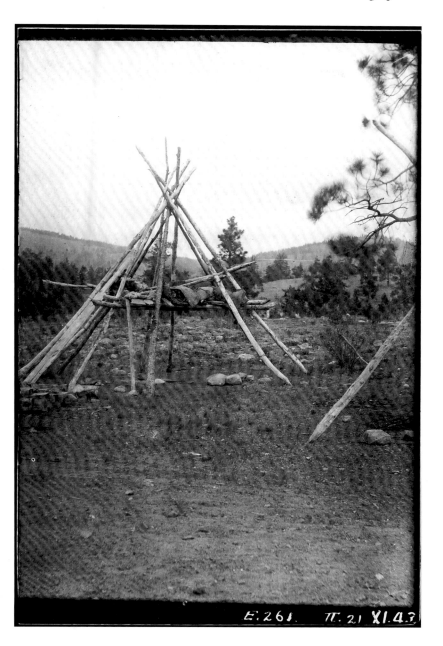

"Rock fort", Nagas, Haida Gwaii.
Charles F. Newcombe, June 7, 1901.
Nitrate negative, 4×5 inches. PN 23910.

Photographic Prints

Original Photograph
An original photograph was printed using the original negative and on the type of paper contemporaneous with the original negative (example below).

Contact Print
A contact print (example on page 49) is made by placing the negative and photographic printing paper in direct contact with each other and then exposing the negative. It can be used to determine the size of the original negative if the negative no longer exists. Careful examination of a contact print may also reveal whether the negative was glass or film.

Enlargement
An enlargement is a print larger than its negative (examples on pages 44–45).

Black-and-White Recent Print
Any print produced from either the original negative or a copy negative within the last 25 years I call a recent print. It is one of the least desirable formats to scan from because it can be several generations removed from the original negative.

Card-Mounted Photographs

Carte de visite
A *carte de visite* is a card photograph made by mounting a photographic print on cardboard measuring 2½×4 inches. One of the earliest forms of card photography, it originated from the idea that one's image should adorn a calling or visiting card. But there is some doubt that *cartes de visite* were used for the purpose their name suggests.

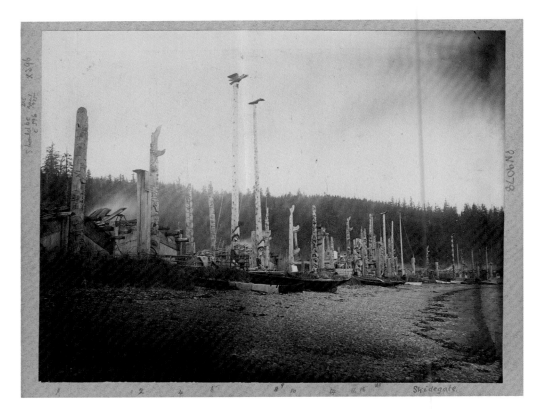

The Haida village of Hlragilda 'Llnagaay (Skidegate).
Richard Maynard, 1884.
Original card-mounted photograph.
PN 9078.

In the late 19th century many Haida villages could boast a forest of totem poles. Closer examination reveals ropes running from the ground to the tops of some poles. Flags affixed to the ropes added motion and colour to the village. Visitors approaching by water must have been awestruck by the vista before them.

This glossy gelatine printing-out paper print shows the warm purple-brown hues from it being toned with gold-chloride to help stabilize the image's surface.

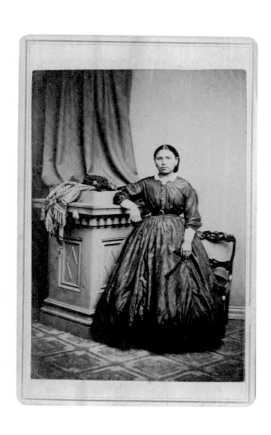

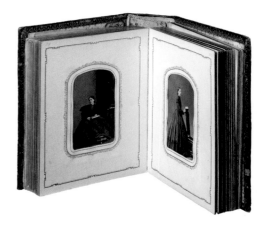

"Stato, Queen Charlotte Island."
Frederick Dally, 1866–70.
Carte de visite (actual size). PN 7561.

Frederick Dally made this image in his
Victoria studio and produced it as a *carte
de visite*. A notation on back of the card
identifies the young woman only as "Stato"
from Haida Gwaii.

***Carte de visite* album.**
PN 23901 (BC Archives acc. no. 198904-10).

Albums like this were used to store *cartes
de visite* purchased from studios and
galleries during the 1860s and 1870s. Two
cartes could be slotted into the cardboard
pages and displayed as shown here. This
album, measuring 6¾×5½×2½ inches,
accommodated 100 *cartes*.

Early business card.
Carl Günther, 1886.
Carte de visite. PN 23747.

This *carte* shows how some of Carl
Günther's photographs were copied and
used in Victoria. *Indian Bazaar*, a store
owned by Jacob Isaac, advertised its
products on the *carte* format using the
striking image of the nine Nuxalk men
who went to Germany with Adrian and
Fillip Jacobsen in 1885. The back of the
card features Haida argillite carvings of
three model poles and a chest.

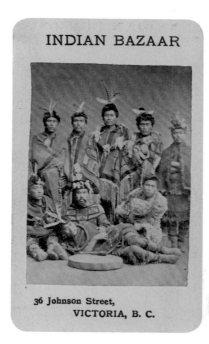

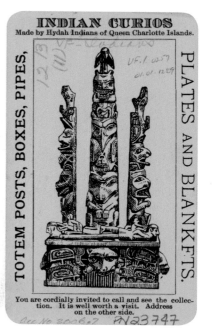

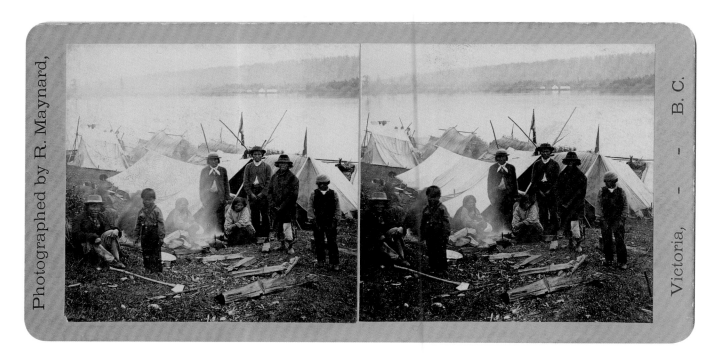

Photographed by R. Maynard,

Victoria, - - B. C.

Coast Salish camp on a bank of the Fraser River, New Westminster.
Richard Maynard, about 1870.
Stereograph and *carte de visite*. PN 5974.

Look closely at the almost identical images in the stereograph, above, and you'll see that everything in the print on the right is shifted slightly more to the left of its equivalent in the print on the left. Offsetting one image from the other simulates the three-dimensional view of a stereograph. (You may also see fingerprints on both prints, a reminder to wear cotton gloves when handling original photographs.)

The stereoscopic camera produced side-by-side images that were laterally reversed: the photographer had to transpose the prints before mounting them onto the cardboard support (Hannavy 2008:257).

Sometimes photographers marketed the same image in two card formats. The Maynards sold this photograph as a *carte de visite* (right) and as a stereograph.

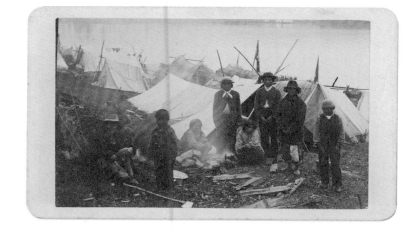

As with all card photographs, the cardboard mount provided firm backing for the image, which was printed on very thin paper. The photographer's name and gallery location usually appear on the back of a *carte de visite* (see page 67). Its convenient pocket size and low cost made it the most popular type of card photograph in 1860s British Columbia. People collected *cartes* showing images of friends, famous people and exotic scenes, and placed them in albums specially designed to hold them (page 51). Because of this, *cartes de visite* were also called album cards (Bogdan and Weseloh 2006:21).

Stereograph Card

The stereograph consisted of two almost identical photographic prints glued on card stock usually measuring 3½×7 inches. Most photographers produced stereographs by using a single, stereoscopic camera containing two lenses set about 2½ inches apart, approximately the same distance between one's pupils. It was also possible to produce a stereographic image with a single-lens camera, by quickly making two images of the same scene (Sexton 1980:20); but single-lens stereographs have different looking backgrounds or noticeable differences in the positions of the subjects. A photographer could also make a stereograph by using two cameras (Spira 2005:34).

A stereograph gave the illusion of three dimensions to an image when viewed through a stereoscope; the viewer slid the card along the stereoscope's track to bring the pair of two-dimensional images into a single three-dimensional perspective. The stereograph made it possible for people in the Victorian era (1837–1901) to experience a 19th-century form of virtual reality by being transported visually to such exotic places as the pyramids in Egypt, Niagara Falls or Yosemite Valley.

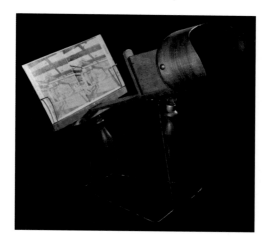

Stereoscope.
PN 23881.

A stereo card has been inserted into a holder that rests on a sliding bar of the stereoscope. The operator uses the bar's handle to slide the holder along a track until the image is three-dimensional. A small wooden plate projects outward from the cup-shaped frame that encloses the eyes, forcing each eye to see only one half of the stereo card. When viewed at the same time, the separate images appear as a single three-dimensional image.

Cabinet Card

By the mid 1860s proprietors of photographic galleries were searching for another card format that would attract new sales of their photographs. They eventually came up with the cabinet card, a 6½×4¼-inch cardboard mount that carried a photographic print almost three times the size of the image on a *carte de visite*. The name "cabinet card" came from the Victorian-era glass-faced cabinet in which people displayed their family heirlooms (Gilbert 1890:95). The photograph, usually a studio portrait of an individual or group, was large enough to be seen from anywhere in the small parlours of the day.

The larger photograph on a cabinet card showed more imperfections, often caused by flecks of dust lodged in the emulsion, so photographers sometimes retouched the glass-plate negatives to make their prints more appealing to their clients. This helped fuel the ongoing debate about truth in photography. Like *cartes de visite*, cabinet cards were collected and assembled in albums.

Most of the cabinet cards in the Royal BC Museum's Anthropology Department have photographs made or taken in the field, not in a studio, and most are in landscape (horizontal) format instead of the customary portrait (vertical) format of cabinet cards.

Paper envelope for processed prints.
PN 23877.

This envelope may date from as early as 1912. The hand-written code at the top is from the numbering system that Charles Newcombe created for cataloguing his "ethnological" field photographs. It refers

to a dry-plate negative that he took at the Kwakwa̲ka'wakw village of 'Mi'mkw̲amlis. It's ironic that Shaw Brothers, a west-coast company, chose an eastern woodlands paddler as its brand image.

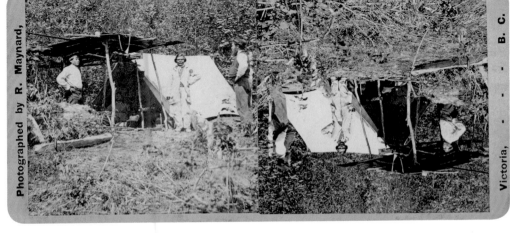

Temporary camp at New Westminster.
Richard Maynard, about 1868.
Stereograph. PN 5965.

Photographers glued prints to their cardboard mounts by hand, usually with the correct orientation. But not this one: the print on the right has been inverted.

The only person identified in this picture is the Caucasian man wearing the vest. Maynard calls him "McLoy ... a shoemaker in Victoria". Richard Maynard was a boot maker as well as a photographer, so it stands to reason that he has recorded McLoy's name.

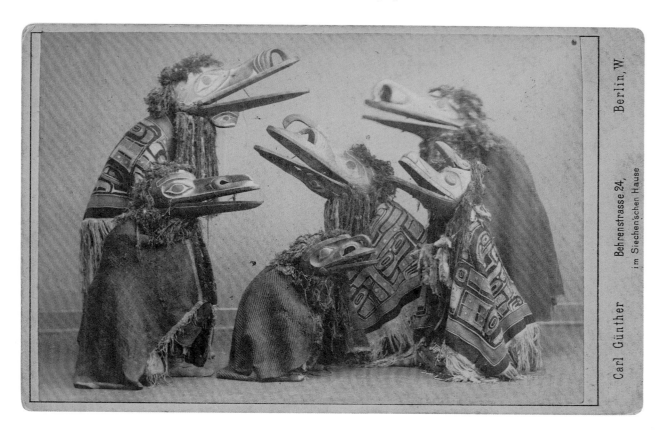

Carl Günther Behrenstrasse 24, Berlin, W.
im Siechen'schen Hause

First Nations dancers in Berlin, Germany.
Carl Günther, 1886.
Cabinet card (actual size). PN 4606.

Carl Günther produced this cabinet card in his Berlin studio. The photograph shows six of the nine Nuxalk (Bella Coola) dancers contracted by Adrian and Fillip Jacobsen in 1885 to give public performances of their culture in Germany. Three dancers wear Chilkat robes (mountain-goat wool and yellow-cedar bark woven into a complex design) and three wear yellow-cedar-bark blankets. They all wear cannibal bird masks. The costumes appear to be cobbled together from material that the Jacobsens had assembled during their visits to British Columbia. Nuxalk people did not make Chilkat robes, and Chilkat robes were never used with cannibal bird masks.

The dancers had agreed to go to Germany while they were passing through Victoria on their way to work in the hop fields of Washington, so they would not have had ceremonial regalia with them. This photograph stands as an example in the debate about truth in photography.

The troupe toured for 11 months visiting 27 cities (Hinsley 1991:345) in Germany, and some of the people who saw them perform did not believe that they were authentic, because they did not resemble the stereotype of "North American Indian", which was based on Plains First Peoples (Cole 1985:71).

Forest of poles at the Haida village of Caynaa 'Llnagaay (Haina).
Richard Maynard, 1884.
Boudoir card (actual size). PN 5572-A.

The Maynards cropped the original field photograph to fit the cardboard mount.

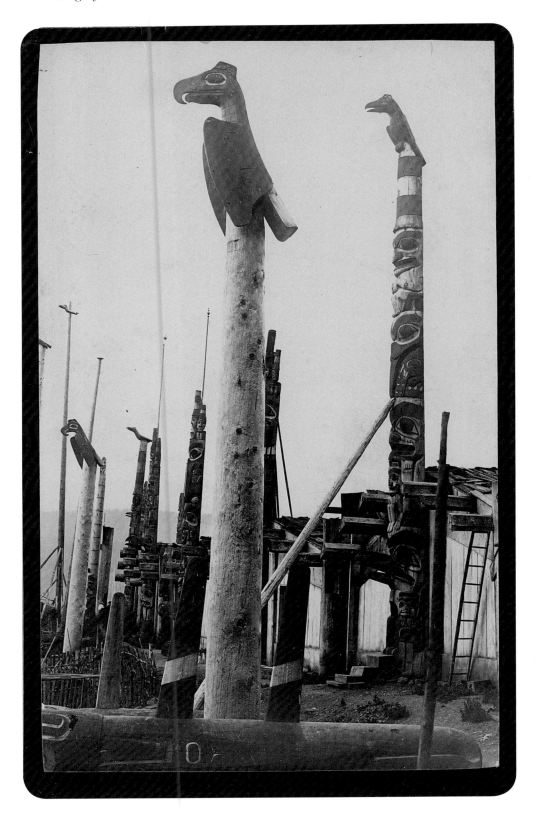

Boudoir Card

The largest form of card photography appearing in this book is the boudoir card, measuring approximately 8½×5½ inches (as shown on the facing page). The boudoir card, named after a woman's private dressing room or sitting room, was usually framed and meant to be displayed on a dressing table. Like other card formats, it was an innovative way of marketing photographs to the public (Gilbert 1980:152).

Postcard

The postcard has been part of Canada's heritage for more than a hundred years. Some can be found in albums specially made to hold them. The postcard's popularity was due partly to its low postal rate, about half the cost of mailing a letter. The first postcards (issued on October 1, 1869, in Austria, one year to the day later in England, and on June 1, 1871, in Canada) were plain note cards with a postal stamp. They were a fast, inexpensive form of communication in the Victorian era – many places in Britain had at least four mail collections a day and guaranteed same-day local delivery (Cronshaw 1989:14) – that performed the same function as present-day e-mails, faxes and text messages.

To facilitate efficient delivery, the front of a postcard was reserved for the address and the back for the message. The Royal BC Museum collection has many examples of postcards bearing this printed instruction: "The Address to Be Written on This Side". Eventually postcards evolved into photographic cards with address and message on the same side. But they went through a stage when one side of the card was reserved solely for the address and the other for the image, with no space left for a message. Some postcard publishers reduced the size of the photograph to create a small space for a statement about the image; sometimes they left this space blank and the sender could use it to write a short note. In the early 1900s, the address space on the back of the card shifted over, leaving half open for correspondence. Postal regulations were relaxed to allow these "divided back" postcards to "pass through internal mails in the United Kingdom in January 1902" and Canada in December 1903 (Steinhart 1979:40), and in the United States in March 1907 (Bogdan and Weseloh 2006:14). This development signalled the dominance of image over address.

Two notable industry developments also took place about this time, both significantly boosting the popularity of postcards. In 1902, the Eastman Kodak Company began

Songhees village, Victoria.
Unidentified photographer, before 1903.
Black-and-white real-photo picture postcard.
PN 6104.

The back of this early picture postcard carries the inscription, "The Address to Be Written on This Side". The caption was probably written by the person who purchased the card.

Many First Peoples from coastal villages in the region visited the Songhees village on the west side of Victoria's Inner Harbour, often drawn by the commercial character of the city.

Totem Poles, Alert Bay, British Columbia

Kwakwa̱ka̱'wakw village of village of 'Ya̱lis (Alert Bay).
Unidentified photographer, about 1910.
Colour printed picture postcard. PN 1850-D.

This postcard was printed in Great Britain and marketed as part of the Valentine (Valentine & Sons) Series from Winnipeg, Manitoba. A photograph (negative no. NA2767) in the University of Washington Libraries' digital collections identifies a similar photograph as "Kwakiutl totem poles and house belonging to Nimpkish Chief Tlah-Co-Glass". The 'Na̱mgis villagers had traditionally lived at the mouth of the Gwani (Nimpkish) River and moved to 'Ya̱lis on Cormorant Island to work in the cannery established in the early 1870s.

These poles are inside house posts carved in the form of Thunderbird and Grizzly Bear. In an earlier time each would have supported a beam (see page 185) that rested between the horns of the Thunderbirds and extended the length of a house to a second set of house posts. Both sets of house posts once faced the centre of a big house. Peter Macnair, former Royal BC Museum curator of ethnology, suggests that the posts shown in this picture stood at the front of the house, because they stand too close to the beach to be rear house posts; after the big house was torn down, the owner turned the poles around to welcome visitors.

Some time after 1929, the horizontal wings seen here were replaced by large, droopy ones, before the poles were removed and placed on either side of the entrance driveway to St Michael's Residential School at Alert Bay.

selling sensitized photographic paper in the size of a postcard. A person simply applied a negative to the card paper, exposed it to light and removed the negative; after washing, fixing and drying the paper, one had a personalized postcard that could be mailed to family or friends. Amateur enthusiasts could also buy a do-it-yourself watercolour tinting kit and hand-colour their personal postcards. The second development came the following year, with the new No 3A Folding Pocket Kodak camera: its negatives measured 3¼×5½ inches and produced postcard-sized prints. With the availability of easily operated cameras, amateur photographers often chose to produce and send prints made from their own negatives as postcards.

Two types of picture postcards appear in this book: printed and real-photo. Although both are derived from black-and-white negatives, they are defined by the processes used to produce them. Printed cards were mass-produced on printing presses, and real-photo postcards were printed from negatives on sensitized photographic paper. Both types were often coloured – printed cards by a process known as photo-chrome (a combination of photography and colour lithography), and real-photo cards by hand using stencils, rollers and brushes.

Photogravure

A photogravure is a printed image made from a photograph. The photographic image is printed on carbon tissue and then transferred to a copper plate. The plate is chemically etched in a series of baths, resulting in an image consisting of depressions of various depths. The plate is inked and placed in direct contact with paper to create a printed image. Only one example of a photogravure appears in this publication, an Edward Curtis photograph on page 112.

Formats of lantern slides.
PN 23879-A, PN 23879-B.

These examples of lantern slides were made in the United States of America (left, 3¼×4 inches) and in Great Britain (3¼×3¼). The American lantern slide was made from a dry glass-plate negative by William Halliday (see page 62) and the British slide originated from a Richard Maynard negative (page 61).

Photographic Lantern Slide

The photographic lantern slide evolved after 1850 from hand-drawn and painted slides used for public entertainment (Hannavy 2008:826). A positive photographic image was printed on a sensitized piece of glass. A second piece of glass of the same size was fixed to this by a black strip of paper tape or cloth to protect the image and prevent it from distorting when it was projected.

The slide was inserted into a "magic lantern", the projector used to display images on a wall or screen during illustrated lectures from the 1850s to the 1930s. Lantern slides were the precursors of 35-mm colour slides and images from a digital projector.

Many lantern slides have survived the negative and photographic prints of the same image. This may be because they were more expensive to produce than prints and, therefore, more valuable, or because they were usually stored in sturdy cases to protect them. Often incorrectly identified as glass-plate negatives, lantern slides are positive images that have been printed on a single piece of glass.

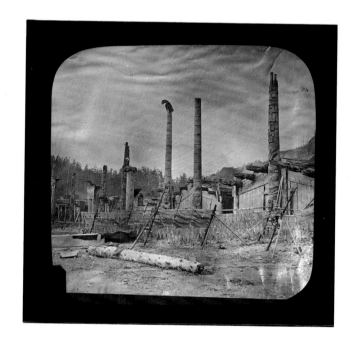

Kekuli **at Nicola Lake.**
Harlan I. Smith, 1899.
Black-and-white recent print.
AMNH 43102.

This uncropped field photograph of an
abandoned Secwepemc *kekuli* (semi-
subterranean winter house) is the same
image as in the lantern slide below. This
recent print was probably made from
Harlan Smith's original dry glass-plate
negative.

Kekuli **at Nicola Lake.**
Harlan I. Smith, 1899.
Lantern slide (made in the United States).
PN 23858.

Negatives could be used to make lantern
slides for public lectures. Hand painting a
lantern slide added colour and a feeling of
realism to the image. This fine example was
painted by John D. Scott of New York.
 Hand colouring lantern slides was a
delicate art. The small size of the image
made them difficult to paint and mistakes
were magnified when projected onto a
screen or wall (Cole 1983:122). Some
artists painted slides with "single-haired
ermine brushes ... and in many cases
the results ... look like the product of a
modern colour film" (Martin and Colbeck
1989:14).

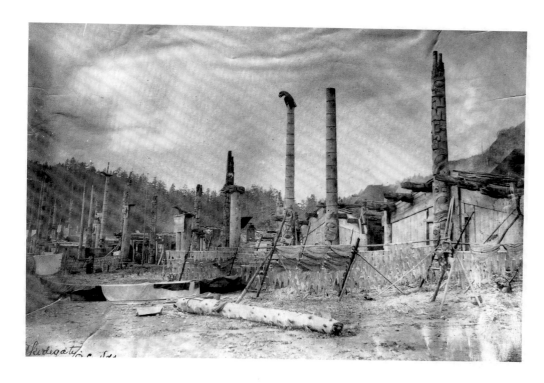

The Haida village of Hlragilda 'Llnagaay (Skidegate).
Richard Maynard, 1884.
Black-and-white recent print. PN 331.

This image was made into the lantern slide on page 59 (right).

 Salmon and other fish hang from drying racks in front of houses along the beach. The canoe on the beach has been draped with sheets and blankets to prevent it from drying out and cracking.

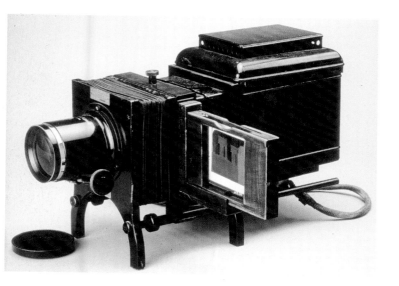

Electric lantern–slide projector.
PN 23880.

This lantern-slide projector could accommodate only one glass slide at a time. A slide has been placed in its holder, ready to be inserted manually. The image could be enlarged and focused using an accordion bellows and lens.

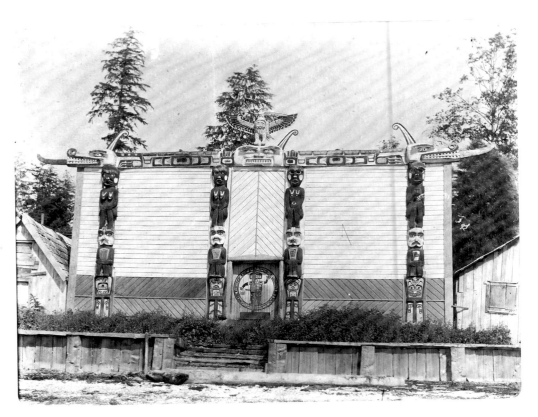

Big house at the Kwakwa̱ka̱'wakw village of T'sadzis'nukwaame' (New Vancouver), Harbledown Island. William Halliday, about 1910. Black-and-white recent contact print from a dry glass-plate negative. PN 12198.

This image was made into the lantern slide on page 59 (left).

The striking facade of this house is made of clapboard siding arranged in decorative herringbone patterns fastened to a framework of milled lumber. The owner may have replaced the original house front of split-cedar planks to create a more imposing presence as visitors approached the village by canoe. If you removed the milled lumber and carvings you would find a classic late-19th-century two-beam house supported by four inside house posts. The roof planks, back and side walls were still made of split cedar.

The four identical columns on the outside of this house are not typical of Kwakwa̱ka̱'wakw houses. Each consists of a large carved wooden copper (representing the house-owner's wealth) at its base, a human figure in the middle holding a smaller copper, and *Dzunukwa* (Wild Woman of the Woods) at the top. The columns support a carving of a *Sisiyutl*, a supernatural double-headed serpent, with human face in the centre, extending across the top of the house. Perched between the two central horns of the *Sisiyutl* is a carved and painted bird known as *Huxwhukw*. This house also appears on pages 43 and 45.

There are only two other documented Kwakwa̱ka̱'wakw houses with a similarly carved and painted *Sisiyutl*: one at the Mamalilika̱la village of 'Mi'mkwa̱mlis on Village Island and the other at the Kwikwa̱sutinexw village of Gwa'yasda̱ms on Gilford Island. I know of only one other house with a similar four-column motif, at the Ławitsis village of K̲alugwis on Turnour Island.

Beginnings

Cultural "truths"…. are created by those telling the story.
– Richard West, Director of the National
Museum of the American Indian, 1998.

The adventurers and explorers who visited the northwest coast of North America during the late 18th and early 19th centuries employed a variety of media to depict and describe the First Peoples they encountered. Journals, ship's logs and personal diaries supplemented the oral accounts of their journeys and official records. Before the invention of practical photography in the mid-19th century, accomplished artists recorded the flora, fauna, landscapes and people in pencil drawings, sketches (as shown below) and watercolours. Many of these prints and paintings, having been executed with great care and attention, are invaluable as art and historical records, especially because they predate the photographic record. Colour paintings certainly displayed a technical capability beyond that of photography until the introduction of glass-plate autochromes in 1907 and Kodachrome roll film in 1935. Few, however, contain the detail afforded in a photograph. The introduction of the Daguerreotype in 1839 and the invention of glass-plate negatives in 1851 eventually resulted in the first photographs of First Peoples in this region during the late 1850s.

Lieutenant Richard Roche of the Royal Navy is believed to have produced the earliest photographs of indigenous people in what is now British Columbia while visiting the naval port at Esquimalt and nearby Victoria in 1857 or 1859. Using a white sheet as a backdrop, he photographed "a group of Victoria Indians taken on board [the gun deck] of HMS *Satellite*" (see page 65).

"View of an Indian village built on a Rock in Norfolk-Sound."
Drawn by Sigismund Bacstrom,
March 29, 1793.
BC Archives PDP01331.

While on board the *Three Brothers*, Sigismund Bacstrom sketched this Tlingit village near Mount Edgecumbe, Alaska.

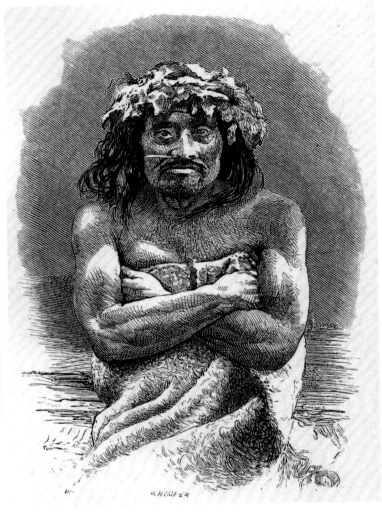

**Nuu-chah-nulth man
at the village of Whyac.**
Carlo Gentile photograph, about 1864.
Carte de visite. PN 5035-B.
Frederick Whymper engraving, 1868.
BCA I-68493.

At the end of the 1890s, refinements
made to the process of half-tone printing
allowed newspapers and book publishers
to faithfully replicate photographic images.
Earlier publications relied on the less
satisfactory technique of wood engraving.

Hand-engraved renderings of photographs
were transferred to the end-grain of wood
blocks from which they were printed.

In 1868 Frederick Whymper printed
many of his own wood engravings in his
book, *Travel and Adventure in the Territory
of Alaska, Formerly Russian America — Now
Ceded to the United States — And In Various
Other Parts of the North Pacific.* For the
engraving shown here, Whymper copied
a field photograph of a Nuu-chah-nulth
man made by Carlo Gentile, whom he
acknowledged in his book.

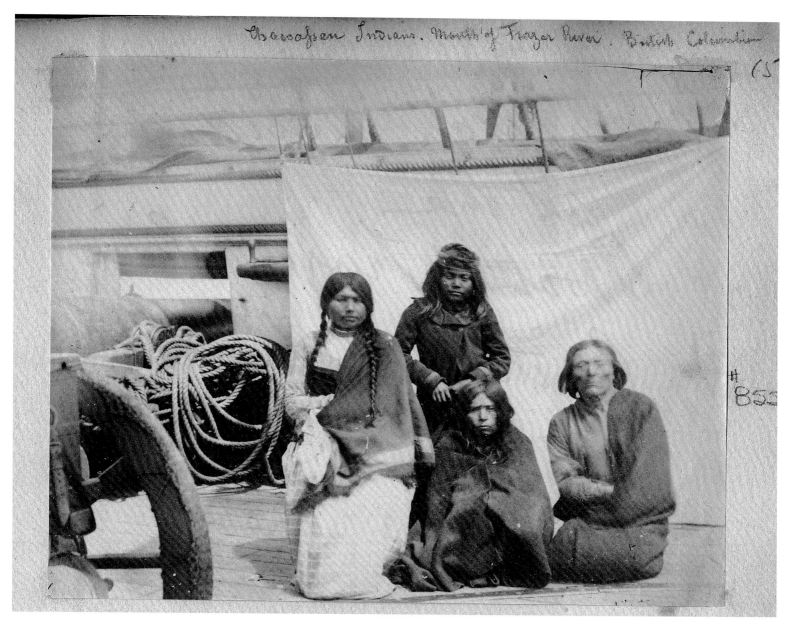

Family portrait.
Lieutenant Richard Roche,
Royal Navy, 1857–59.
Original photograph. E–06422.

This photograph, made on board the gun deck of HMS *Satellite*, is one of the earliest photographs of First Peoples in this region. It may have been made at the mouth of the Fraser River, at the British naval base at Esquimalt or when the *Satellite* lay at anchor in Victoria's Inner Harbour. A sheet, tacked to the ship's rigging, served as a backdrop to outline this family portrait.

Another group portrait, possibly made at the same time, can be found in the Beinecke Rare Book and Manuscript Library at Yale University.

From the Likeness Houses

The majority of studio and field photographs of First Peoples produced in British Columbia before 1900 were made by commercial photographers based in Victoria. Those of Alaskan First Peoples were produced by photographers from Sitka, Juneau and Haines, Alaska, from Seattle and Tacoma, Washington, and from Portland and Eugene City, Oregon.

By the late 1860s, about ten photographers operated studios in Victoria and most produced images of First Peoples. As well as being photographers, the owners of these galleries were entrepreneurs, business people who produced marketable images that would ensure the continued economic viability of their studios. They sold their photographs on various types of cardboard mounts that were mainly purchased by Victoria's non-indigenous community either as souvenirs or collectibles. Why were these photographs made? Gail Buckland offered the simplest explanation in her 1980 book, *First Photographs*: "To show Indians to Europeans."

Initially founded as a Hudson's Bay Company fortified trading post in 1843, Fort Victoria had, by 1866, grown into the centre of commerce for the colony of British Columbia. The local First Peoples, the Songhees, also shared in this commerce as did the many First Nations visitors from as far away as Haida Gwaii (Queen Charlotte Islands) and Alaska who visited to trade at the fort. Among those who established businesses in the city were professional photographers Stephen Allen Spencer (in 1859) and George Robinson Fardon (in 1861), both of whom made photographs of First Peoples. A contemporary, Carlo (Charles) Gentile, working in and away from his Victoria galleries, produced some of the earliest *cartes de visite* to have survived. These date from 1863 to 1866 and the Anthropology Department of the Royal BC Museum has at least 13 original *cartes* with Gentile's name printed on the back. Photographing in both landscape (horizontal) and portrait (vertical) formats, Gentile produced *cartes*

Carlo Gentile's first studio in Victoria.
Carlo Gentile, around 1864.
Carte de visite. BCA A-08350.

On May 18, 1866, the *Daily British Colonist* reported Carlo Gentile's move from this studio on Fort Street: "New Photographic Gallery. Mr C. Gentile has opened a new and neatly fitted up Gallery on Government street, adjoining the Theatre Building. The gallery contains a waiting room and dressing rooms and the light is admirably managed, producing excellent pictures."

The hand-mounted print on this *carte de visite* has been attached slightly askew between the printed borders on the card stock.

Longish Indian Village. Victoria Harbour. Vancouver Island. Brit.ᵏ Columbia. 1864.

Songhees village, Victoria.
Unidentified photographer, 1864.
Original card-mounted photograph.
BCA D-00693.

This photograph was made using a wet-plate negative 20 years after the Songhees village was established on the west side of Victoria's Inner Harbour. Canoes and traditional shed longhouses line the bank above Pallastis (Songhees Point).

In his 2003 book, *Songhees Pictorial*, Grant Keddie provides a visual history of the village almost from its beginning in 1844 to the formal transfer of reserve lands in 1911 to the government of British Columbia.

The back of a *carte de visite*.
PN 7530.

Gallery locations and advertisements often appeared on the backs of *cartes de visite* and stereographs. Photographers considered their studio portraits as artistic as painted portraits, so it is not surprising that Hannah Maynard promoted herself as a "photographic artist". Many wet-plate photographers continued this association with the fine-arts community through the 1870s.

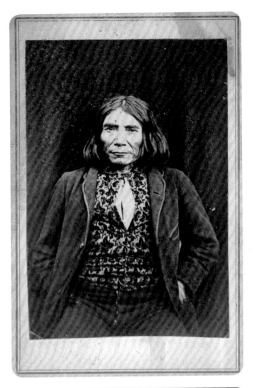

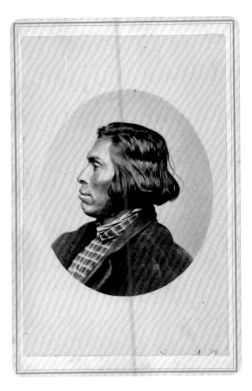

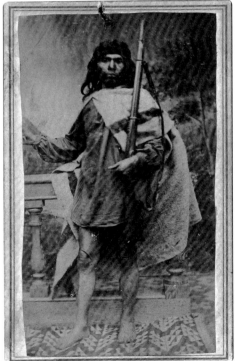

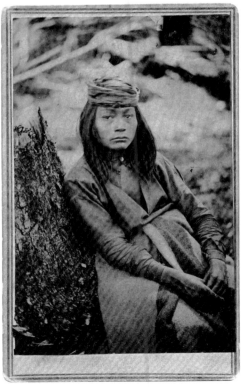

Portrait *cartes de visite.*

These photographs were marketed as *cartes de visite* in portrait format, which was much more popular than landscape (see page 72). Clockwise from top left:

Chief James Sqwameyuqs.
Frederick Dally (probably), 1866–70.
Carte de visite. PN 4816.

This portrait of Chief Sqwameyuqs shows his confidence as chief of the Songhees First Nation (1864–92).

"Chin-e-mit-ze, the Chief of the Nin-cum-shins [Nicomen], Thompson River".
Frederick Dally, 1866–68.
Carte de visite. PN 8734.

Frederick Dally travelled to the Cariboo in 1867 and 1868. Writing about his 1868 trip (Dally n.d.), he stated that he was assisted by "Chin-e-mit-ze [... who] told all the Indians he met, that I was a great chief and could work wonders with a small piece of glass, face work especially, and that I wanted pictures."

This portrait of "Chin-e-mit-ze" may have been made inside a temporary studio during one of Dally's trips.

Ucluelet chief at Barkley Sound.
Carlo Gentile photograph, about 1864.
Carte de visite. PN 4812-A.

The back of the card identifies this person as "MAA–E–Kin, Uke-u-let, Tyee [chief], Barklay Sound".

Unidentified man.
Carlo Gentile photograph, 1863–66.
Carte de visite. PN 11628.

The man has a Hudson's Bay Company blanket draped over his shoulders.

that he hoped to sell to Victoria's resident Euro-Canadian and American community. His business was partially dependent upon producing saleable images of "exotic Indians" as collectibles for his clients' *carte* albums (see page 51). In this respect Gentile's work is similar to that of Frederick Dally, who is thought to have opened a portrait studio in 1866, the same year that Gentile left Victoria. In 1868 Dally advertised his photographic services in the *First Victoria Directory and British Columbia Guide*, proclaiming: "Photographs Of Indians May Be Had At The Gallery, Fort Street, Victoria, V.I." (Mallandaine 1868).

Dally may have been more prolific than Gentile in his production of images of First Peoples; certainly more examples of his studio and field photography have survived. An indication of the extent of his work is revealed in an ad printed in *The Daily British Colonist* on September 7, 1870: "Selling off at half-price, the entire stock of British Columbia Photographs ... also 1000 doz of Indian *Cartes de Visite*.... Mr Dally having disposed of his business to the Messrs Green Bros."

Gentile and Dally, along with Hannah Maynard, account for nearly all the extant photographs of First Peoples made in British Columbia in the 1860s. Maynard also operated a gallery in Victoria, perhaps as early as 1862; she was the only female professional photographer in Victoria in the 19th century. Two amateur photographers, Arthur Vipond and Charles Vieusseux, also produced photographs of First Peoples in Victoria during the 1860s.

First Peoples regularly came to the photographic galleries – the likeness houses – to pose as models (see page 71), but sometimes they came as customers who commissioned studio portraits. It is difficult to determine how much ownership they had in how they presented themselves to the camera. Did they decide how they would dress or were they selected because of their dress in order to create a marketable image? I am unaware of any oral history or written accounts that would provide a First People's perspective on this subject. I do know that, in some instances, First Peoples who permitted their photographs to be made received remuneration. At least once, King Freezy and his wife, from the Songhees village on the western shore of Victoria's Inner Harbour, visited Gentile's gallery and received fifty cents for their session in the studio. It is likely that others who posed (as peddlers, for example) were also paid in cash or in kind in the form of card photographs. Charles Newcombe, in his expense accounts, noted paying three dollars to a Haida woman in 1897 for "1 Skeena hat & privelege to photo her in it" and 50 cents to "Chief Mountain for sitting for photograph" in 1912.

> MR DALLY
> Desires to inform the Inhabitants of Victoria and its vicinity, that he has returned from the Upper Country with a Choice Collection of New Photographic Views of Mountain Scenery and other highly Interesting Subjects. Cartes de visite, groups and views taken with the greatest care and in the best style of Photographic Art, and warranted to give satisfaction.
> The Gallery is situated on Fort Street, Victoria, BC.
> – *The Daily British Colonist and Victoria Chronicle*, February 6, 1869.

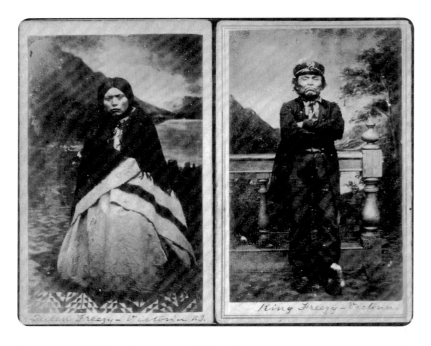

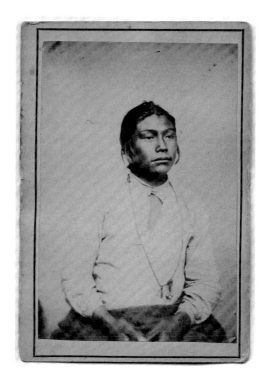

Portraits of King Freezy and his wife, Victoria.
Carlo Gentile, February 1, 1864.
Black-and-white recent print
of *cartes de visite*. PN 6198.

Were First Peoples who frequented Victoria's studios compensated for having their portraits taken or did they initiate the process and commission their likenesses? The question of remuneration is difficult to answer because of the scarcity of documents that record the relationship between subject and photographer. But one somewhat mocking account appeared in the *Daily British Colonist* on February 2, 1864:

ROYAL CARTES DE VISITE – His Majesty King Freezy I, and his Royal spouse the Queen of the Songhishes, visited the city yesterday, and honoured Mr Gentile, Photographic Artist of Fort Street, by sitting for their portraits. Their Majesties appeared to be highly delighted with their counterparts, although in neither case could the words of the poet be applied with justice.

'Love and beauty still that visage grace.' Before taking his departure the wily but uxorious old King requested the artist to *potlatch* his better half *four bits* [fifty cents], which was immediately done, and the *chickamen* having been safely ensconced in the folds of the Royal robes (three point blankets), their majesties stalked off with a dignity becoming their exalted station."

Grant Keddie, in his book *Songhees Pictorial*, notes that King Freezy's Lekwungen name was Chee-ah-thluc and that he posed for this photograph in his favourite outfit, a Royal Navy uniform.

Unnamed person.
Frederick Dally (probably), 1866–70.
Carte de visite. PN 7559.

Many studio portraits made during the 1860s and 1870s do not name the person in the photograph. Many photographers called their subject a "peddler" or another type of labourer, simply to convey the image of an "exotic Indian".

"Salish of Vancouver."
Hannah Maynard, about 1872.
Black-and-white recent print. PN 5899–A.

Other than the title (above), no
documentation came with this photograph.
Dr Margaret Blackman compared the
"studio flooring, backdrops, woodwork,
and props" of Victoria's photographers and
determined that Hannah Maynard made
this photograph in her first studio. In the
title, "Vancouver" refers to Vancouver Island
– the mainland city of Vancouver was not
incorporated until 1886.

Blackman (1986:69) also pointed out
"that the photographic conventions for the
depiction of native subjects differed from
conventions that applied to non-natives".
This image shows the informality of posing
First Peoples sitting and kneeling on the
floor in front of a plain backdrop. A study
of early field photographs made at coastal
villages indicates that these positions were
the accepted conventions.

Both people are wearing Hudson's
Bay Company blankets, one of which is
fastened with a metal blanket pin. The
woman is also wearing a domed, woven
hat. The open-weave basket, perhaps used
for carrying clams or fish, suggests that
they may be peddlers.

This image would have been cropped
before it was sold as a *carte de visite* (see
pages 88–89).

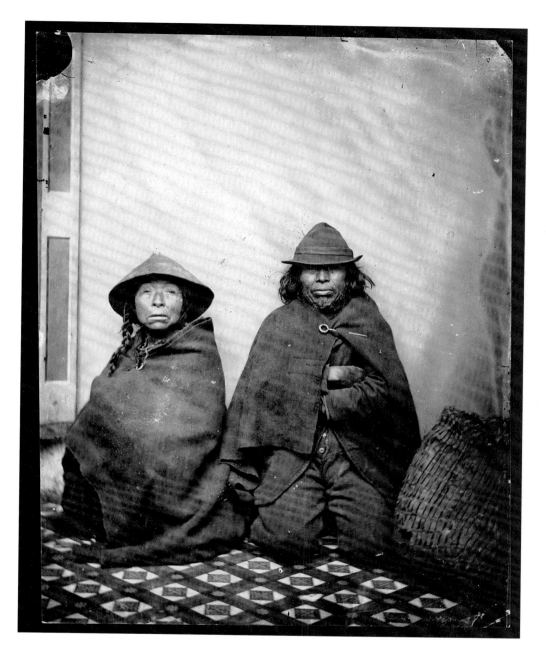

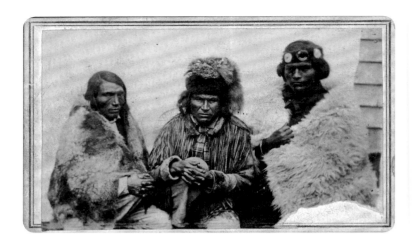

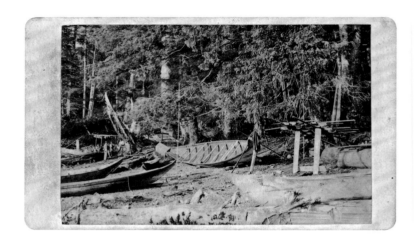

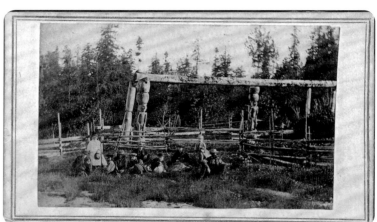

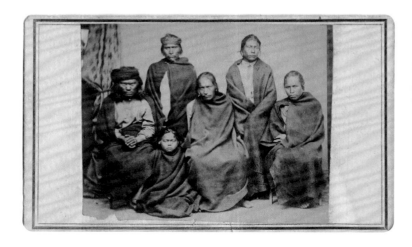

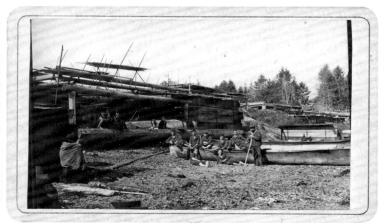

Landscape *cartes de visite*.

Clockwise from top left:

**Chief Tsil.hul.shalst (Joseph)
with two Interior Salish men.**
Carlo Gentile, May 1865 (probably).
Carte de visite. PN 6756.

Chief Tsil.hul.shalst (centre) of the
Xaxli'p (Fountain First Nation) posed for
this photograph with two unidentified
men probably at a large gathering in
New Westminster. *The British Columbian*
newspaper reported on the event on June
1, 1865: "Five thousand Indians, more
or less, with eighty chiefs, representing
as many villages, gathered to join as one
family in commemorating the birth of
Queen Victoria."
 Carlo Gentile used a white sheet
draped from the side of a building as a
backdrop.

**Bonaparte First People
near Cache Creek.**
Frederick Dally (prpbably), 1867 or 1868.
Carte de visite. PN 6701.

Coast Salish house remains.
Carlo Gentile photograph, about 1866.
Carte de visite. PN 15168.

This photograph shows three carved inside
house posts and a solitary beam, integral
components of post and beam house
construction.

**Yuquot villagers
and crew from HMS *Boxer*.**
Richard Maynard, September 10, 1874.
Carte de visite. PN 4653-B.

Everyone in this picture appears
comfortable with the presence of a camera.

**Tseshaht men and a boy, all wearing
Hudson's Bay Company blankets.**
Frederick Dally (probably), 1866–70.
Carte de visite. PN 4818.

**Tlingit or Kaigani Haida fishing camp,
Prince of Wales Island, Alaska.**
Richard Maynard, date unknown.
Carte de visite. PN 10532.

The canoe turned on its side reveals the
thwarts across its width used as seats by the
paddlers. Although this photograph was
marketed as a *carte de visite*, it was produced
with a stereoscopic camera.

PHOTOGRAPHIC – Mr Dally,
Photographer, is on a business
tour through the interior. This is
an excellent opportunity for the
people at all points above Yale to
get their likenesses taken. Mr D's
ability is so well known that we do
not think it necessary to offer any
recommendation.
 – *British Columbia Examiner*, Yale,
 July 20, 1868.

PHOTOGRAPHY – Mr F. Dally
arrived from below last Friday and
has taken a number of excellent
photographic views of the places of
interest along the road; and as he will
be here some time a good opportunity
presents itself of persons getting
likenesses taken in the best style of art.
Mr D is so well known in the colony
as being one of the best accomplished
in the art of photography, that it needs
no recommendation from us to insure
the patronage which he so well merits.
He proposes at an early day to visit
Mosquito and the other principal
creeks, affording ample opportunity to
all of having their likenesses taken in
good style.
 – *The Cariboo Sentinel*, Barkerville,
 Williams Creek, July 26, 1868.

Presentation Staffs

On September 23, 1864, Frederick Seymour, governor of the colony of British Columbia, sent a dispatch to Colonial Secretary Edward Cardwell in London, England, stating his desire "to introduce into this Colony the practice which had worked very successfully in Honduras, of presenting a Staff of Office to the Chief of each friendly tribe". He requested "one hundred canes with silver gilt tops of an inexpensive kind".

The following year, *The British Columbian* reported Governor Seymour's address to a gathering of First Peoples in New Westminster to celebrate Queen Victoria's birthday on May 24: "The Queen has sent out handsome staffs for the best chiefs. I will distribute them during the course of the year to those who may render good service to the Government." Within two years he had the staffs delivered to prominent chiefs as "emblems of authority … whom it may be deemed wise to invest with a sort of civil power".

The Royal BC Museum has two of these staffs in its collection.

Governor Frederick Seymour, Victoria.
Carlo Gentile, 1863–66.
Carte de visite. PN 15928.

"The First Chief of Fort Rupert."
Hannah Maynard, 1865–72.
Carte de visite. PN 6140.

In this studio portrait, a Tsaxis (Fort Rupert) chief wears a naval officer's frock coat and fur cap and holds an official presentation staff.

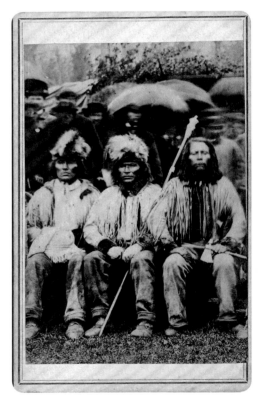

Chief with a staff.
Frederick Dally (probably), May 1867.
Carte de visite. PN 6163.

These men posed for this portrait while attending a celebration of Queen Victoria's birthday in New Westminster.

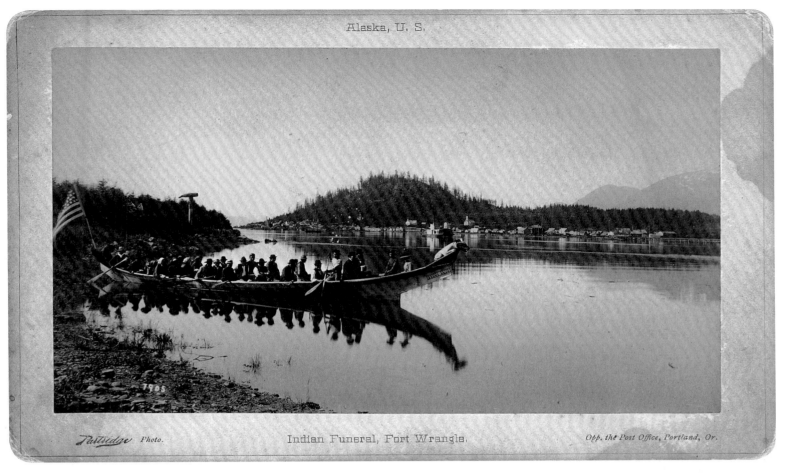

Alaska, U. S.

Partridge Photo. Indian Funeral, Fort Wrangle. Opp. the Post Office, Portland, Or.

**"Indian Funeral, Fort Wrangle",
Alaska.**
William Partridge, about 1886.
Boudoir card. ASL-P88-054.

Twenty-four or more people pose in Chief
Shakes' Brown Bear canoe before paddling
off to attend the funeral on Shakes Island,
in Wrangell's harbour. The prow and stern
figures are bears carved from wood. The
Smithsonian Institution acquired this
Haida canoe in 1894.

Ktunaxa tepees and sturgeon-nose canoes, Arrow Lakes.
Unidentified photographer, unknown date.
Copy negative. BCA C-05654.

Although the surviving print is of poor quality, this is the best field photograph I have seen showing the distinctive profile of a sturgeon-nose canoe. Closer examination of the photograph suggests that these canoes are made of canvas. An upright paddle serves to anchor one canoe (left) to the bank. A man fishes from the other canoe, which is held steady by poles set into the lake bottom.

Canoes in Victoria's Inner Harbour.
Unidentified photographer, 1896–99.
Black-and-white recent contact print from a
glass-plate or nitrate negative. G-05075.

A large Nuu-chah-nulth-style canoe has
been draped with cedar-bark mats and
cloth sheets to prevent it from splitting
in the heat of the sun. The other canoes
contain cedar baskets, bundles of clothing,
wash basins, a pottery jug and a set of
sails. The Songhees village lies in the
background. The two-storey rectangular
building in the distant centre is the Marine
Hospital built in 1874 for non-military
sailors (Keddie 1991:5).

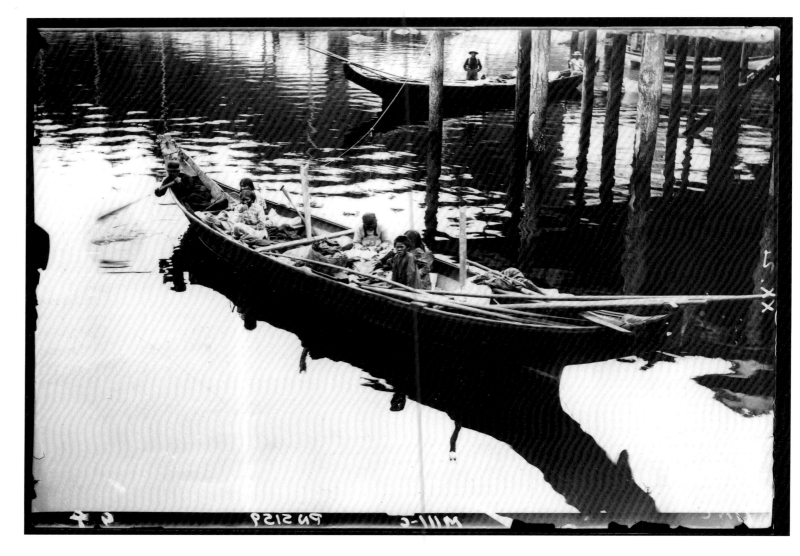

Canoe at the Kwakw<u>a</u>ka'wakw village of 'Y<u>a</u>lis (Alert Bay).
Edgar Fleming, July 1896.
Black-and-white recent contact print
from a nitrate negative. PN 5159.

The long wooden poles resting at the prow
of this northern-style canoe may be masts
used when the canoe was under sail.

Survey Photography

A number of disparate forces generated the diverse collections of photographs that are available for researchers to interpret, view again and reinterpret. One of these was survey photography. The first images of this genre were created by Royal Engineers during their work for the North American Boundary Commission, 1860–61. The Commission was a joint undertaking by Great Britain and the United States to delimit the 49th parallel, which divided British and American territory in North America. The collection of original photographic prints produced during the course of their work resides in the Victoria and Albert Museum, London, United Kingdom.

In the following decade, the government of Canada's political commitment to connect British Columbia to the rest of Canada by rail resulted in an increase in the volume of survey photography. Charles Horetzky, while employed as a photographer with the Canadian Pacific Railway Survey, produced a small collection of ethnographic views during his time in British Columbia. Working with wet-plate negatives, he produced one photograph of Hazelton blanketed with snow in December 1872 and at least three photographs, again in the snow, of Fort Simpson (Lax Kw'alaams) in January the following year. Two of the latter photographs were an attempt to make a panorama of the Coast Tsimshian village and adjacent Hudson's Bay Company fort (he did not use a special panoramic camera, but took a series of overlapping photographs).

Horetzky's photographs illustrate the problem caused by poor-quality images often encountered by researchers in visual anthropology. In this instance I only had access to poorly produced 5×7-inch black-and-white reference prints. The views appeared to be too distant to distinguish either the architecture of the houses and poles that line the bank of the Skeena River at Hazelton or the beach at Lax Kw'alaams. I concluded these would not be of any great value as ethnographic documents. But later, after speaking with Dr George MacDonald, who had the original plate negatives enlarged, I understood that the photographs are indeed valuable in identifying the carved poles and houses.

Two other photographers associated with surveys – George Mercer Dawson, a field geologist with the Geological Survey of Canada, and Richard Maynard, a commercial photographer from Victoria working for the government of British Columbia – produced photographs of villages on Haida Gwaii (Queen Charlotte Islands) in 1878 and 1884 respectively. Dawson also photographed Kwakwaka'wakw villages in 1885. As evidenced by the many images of villages, totem poles and houses, both men were captivated by the architecture and monumental carvings they encountered. Their field photographs are documentary in nature, clear and sharply focused. Dawson's are primarily of geological features and villages and those taken on Haida Gwaii are almost devoid of people.

One would expect the beaches in front of the houses at the principal villages of Hlragilda 'Llnagaay (Skidegate) and Rad Raci7waas (Massett) to have been centres of daily activity. Dawson estimated the population of Hlragilda 'Llnagaay alone to be about 250 people, yet only 4 appear in his photographs of the village. The reason for the absence of people in his photographs may be that the villagers were away at summer fishing camps (most photographers travelled in the summer months) or it may be related to the type of dry-plate negatives that Dawson used. Dry-plates produced before 1878 would have been even less sensitive to light than the earlier collodion wet-plate negatives and so would have required a longer exposure (up to five minutes) to record the image on the negative. Unless people remained stationary, their images would not have been captured on the dry-plate negative. People sitting on a horizontal memorial pole or at the entrance to a house, leaning against a canoe, sitting in front of a house watching a carver working on a pole, sitting on a log on the beach or posing for their portrait would have appeared in these photographs; but anyone walking through the exposure would not be visible.

Richard Maynard's photographs are similar in content to Dawson's. Most are views of villages, totem poles and canoes, with two noteworthy exceptions: a stereo view of Chief Wi:ha's "Monster" House and a view of Chief Anetlas's "Star" House. Both were taken at Rad Raci7waas (Massett) in 1884 and are the only extant photographs depicting the interior of Haida houses before 1897. The view inside Chief Anetlas's house is less well known but it is one of only two 19th century photographs showing people inside a house on Haida Gwaii and is all the more remarkable when you consider the exposure time. The photograph of Chief Wi:ha's house (facing page) took three to five minutes of exposure, and no one appears in this image (Blackman 1972:223).

The two photographs from 1897 were an interior view of Chief Wi:ha's house taken by Edward Allen, a freelance photographer working for the Columbian Museum of Chicago (Field Museum neg. 846), and an interior view of a smoke house by Reverend Barnabas Freeman (page 140, right), a Methodist missionary at Hlragilda 'Llnagaay (Skidegate).

Washing clothes in the Haida village of Caynaa 'Llnagaay (Haina).
Richard Maynard, 1884.
Stereograph. PN 1053-A.

As with most ethno-historic photographs taken in the latter half of the 19th century, this one does not identify the people shown. The woman's labret (lip plug, probably made of wood) signifies that she is of high social standing. Both villagers wear Hudson's Bay Company blankets, his drawn tightly about his chest, hers made into a jacket.

The picture also shows a bent-corner wooden bowl, its rim inlaid with opercula, a finely adzed cedar column, perhaps the base of a memorial post, and the stern of a canoe.

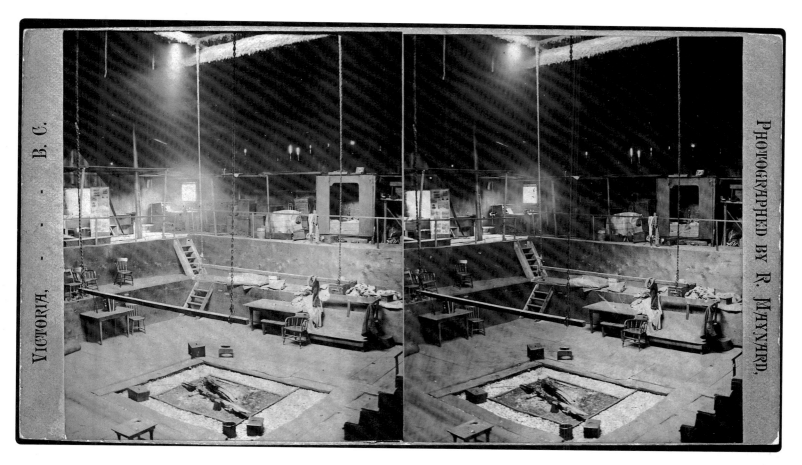

Interior of Chief Wi:ah's house at the Haida village of Rad Raci7waas (Massett).
Richard Maynard, 1884.
Stereograph. PN 5324.

Chief Wi:ah's house contains an intriguing mix of features and items: the excavated floor with its central fire pit, drying racks suspended by chains from the rafters, a smoke hole in the roof, two sleeping chambers on the upper level, bentwood boxes, cedar-bark mats, and a myriad of Euro-Canadian goods, such as tables, chairs, a coffee pot, an accordion and newspapers. In 1972 Dr Margaret Blackman published a paper on the history, size and contents of this house, thus illustrating the type of information that can be discovered from an in-depth analysis of photographs.

The Haida village of Hlragilda 'Llnagaay (Skidegate).
George Dawson, July 26, 1878.
Original card-mounted photograph.
PN 1020.

George Dawson estimated the population of Hlragilda 'Llnagaay to be 250, yet this photograph records only 4 people. All of them are standing or sitting still on a structure made of cedar planks just behind the farthest canoe drawn up on the beach.

The reason for the absence of people in this photograph may be the lengthy exposure time (13 seconds). Many people could have walked through the camera's field of view and not been recorded on the negative.

Colonial and Federal Governance

Governance, like surveys, also encouraged the creation of many of the earliest field photographs, a product of inspection tours of coastal villages undertaken by colonial and federal officials. In 1866, Frederick Dally accompanied Arthur Edward Kennedy, governor of Vancouver Island. In 1873 and 1874, Richard Maynard travelled with British Columbia's first federal superintendent of Indian Affairs, Dr Israel Wood Powell; Oregon Hastings did the same in 1879 (see below), as did Edward Dossetter in 1881 (see page 33).

Whether these photographers were invited or insinuated themselves onto the tours is difficult to determine. In a letter dated June 25, 1873 to the Secretary of State for the Provinces, Indian Branch, Dr Powell notes: "Imbarked [sic] on the evening of the 25th [May] in company with … and a Photographer [Maynard] who accompanied the Expedition for the purpose of taking views of Indian Camps, and photographs of different Tribes." The relationship between government official and commercial photographer was mutually advantageous, as some of the images supplemented the official reports while the majority added substantially to the stock of views available for purchase at the photographer's Victoria gallery.

On each of his tours, Richard Maynard produced images of First Peoples on board the gunboats posing

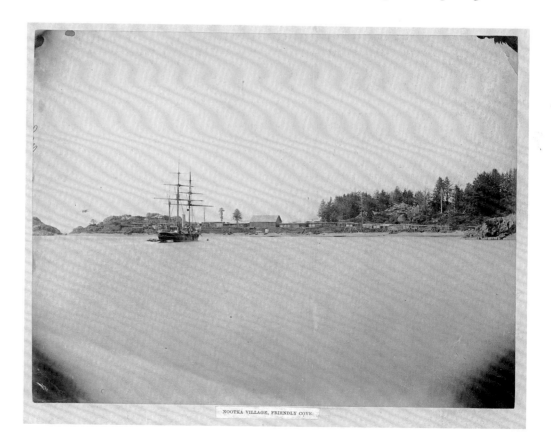

NOOTKA VILLAGE, FRIENDLY COVE.

HMS *Rocket* **anchored at the Nuu-chah-nulth village of Yuquot.**
Oregon C. Hastings, July 31, 1879.
Original card-mounted photograph.
PN 11609.

The inspection tours of Vancouver Island Governor Arthur Edward Kennedy and British Columbia's federal Superintendent of Indian Affairs Dr Israel Wood Powell facilitated the making of many of the earliest field photographs of coastal villages. On shore, Chief Maquinna's newly constructed Euro-Canadian gable-roof house dwarfs the traditional houses constructed of cedar planks.

Powell noted in his report to the superintendent-general of Indian Affairs in Ottawa that Maquinna "has the largest and best built Indian house that I have yet seen in the Province, and gives ample accommodation to 12 families".

before the camera's lens. He took at least three views of villagers on the deck of HMS *Boxer* in June 1873 near the Kwakwa̱ka'wakw village of Dzawadi at the head of Knight Inlet. On September 7, 1874, he photographed a group of Nuu-chah-nulth men on the deck of the *Boxer* (facing page). Others may have also done this, but Maynard's are the only surviving images from Victoria-based photographers.

The overwhelming majority of photographs from these official trips were made on land (see page 4). There are similarities in composition and content in all four photographers' work. Included in Maynard's, Hastings' and Dossetter's portfolios are examples of the obligatory group portrait of assembled villagers and government officials. In Maynard's photographs, the groups are set against a background of traditional 19th-century houses made of split-cedar planking or, in later photographs, the village church, constructed of milled lumber and paned-glass windows.

All four photographers produced oblique views of villages stretching along the beach into the photographic horizon (see page 50). A frontal view of an entire village was almost impossible to obtain, because the houses stood close to the high-water mark and a frontal image had to be taken from the deck of a ship. Although securely mounted on a heavy tripod, a camera usually required a more steady platform than a ship's deck, even when the ship was at anchor. I am aware of only two photographs of villages made from the deck of a ship up to 1890: Eadweard Muybridge's 1868 distant view of the Heiltsuk village of Bella Bella from the deck of the steamer *Pacific* (Bancroft Library, unnumbered) and Robert Reford's spectacular 1890 frontal view of the Haida village of Rad Raci7waas (Massett) from the deck of the *Islander* (Library and Archives Canada, C-060822).

The conventional nature of the photographs made during these tours does not diminish their value as research

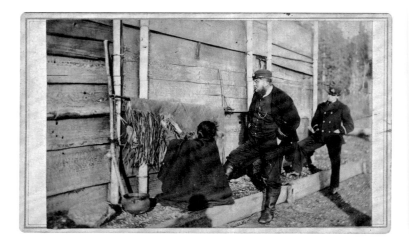 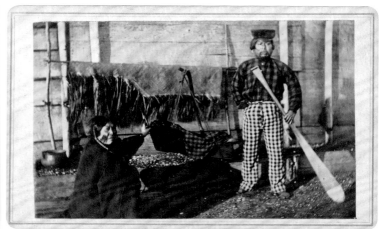

Activities in the Coast Salish village of Cowichan.
Unidentified photographer, about 1866.
Cartes de visite. PN 1382 (left) and PN 6273.

These *cartes de visite* are two of the earliest photographs in the collection of the Royal BC Museum. They were made within minutes of each other.

The one on the left was printed from the original stereographic wet-plate negative. It shows Dr Comrie and a Royal Navy officer from HMS *Scout* watching

a woman finger-weave a cedar-bark mat on a loom fastened to the outer wall of a house. The shadow in the foreground may be the photographer's.

In the photograph on the right, the same woman demonstrates how a cradle is rocked as it hangs suspended from a wooden peg driven through the same mat.

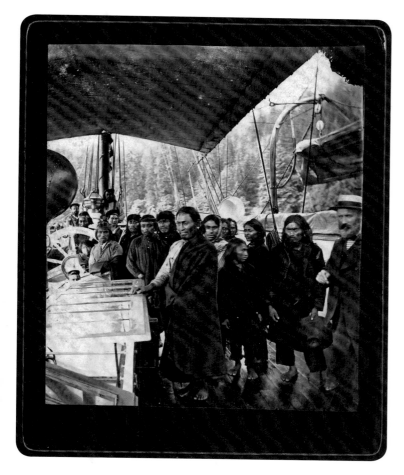 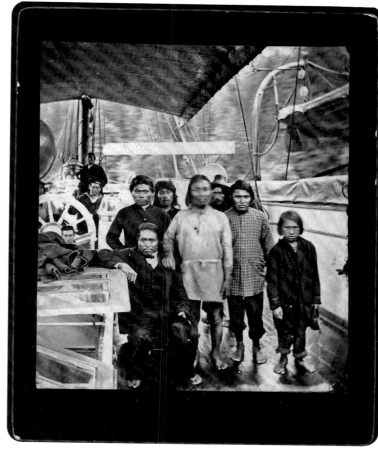

documents. Dally's two photographs made at the Cowichan River in about 1866 provide the first photographic documentation of fish weirs (pages 86-87), while Hastings' 1879 photograph at Ma-ate in Quatsino Sound (BC Archives E-01482, not shown in this book) is the earliest surviving photograph of infant head binding. Such photographs are what they purport to be, accurate ethnographic visual records of an identified location at a known time. Each of these photographers produced unaltered prints from their plate negatives and all but Dossetter sold them from their galleries to an eager public. It is our good fortune that Superintendent Powell arranged the purchase of Dossetter's wet-plate negatives by the American Museum of Natural History in New York (Cole 1985:83), where they are accessible to contemporary researchers. Unfortunately, the existence of the Dally and Hastings negatives remains unknown.

Nuu-chah-nulth men aboard HMS *Boxer*, Barkley Sound.
Richard Maynard, September 7, 1874.
Original card-mounted photographs.
PN 4708 (left) and PN 10503.

Richard Maynard made these photographs within minutes of each other. The man in front in the picture on the left also appears in the centre of the other picture without his Hudson's Bay Company blanket.

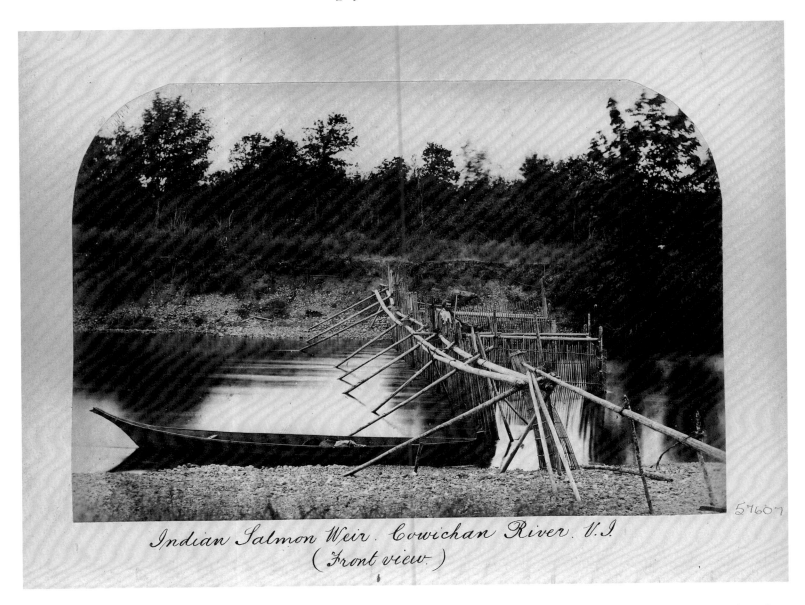

Indian Salmon Weir. Cowichan River. V.I.
(Front view.)

Salmon weir on the Cowichan River.
Frederick Dally, August, 1866.
Original card-mounted photographs.
BCA C-09260 (above) and C-09278.

These are the earliest surviving
photographs of a salmon weir. No
other photographs, even those taken by
anthropologists during this time period,
document a weir so well. Because they
show both the front and back, they have
been extremely valuable to researchers
trying to understand how First Peoples
constructed and used weirs.

These photographs are all the more
remarkable when you consider that Dally
made them with wet glass plates: for each
view he had to move his heavy field
camera and tripod, and also prepare and
process a second plate.

In his diary, Dally commented on the
workings of the weir:

During the salmon season an Indian
will remain seated as depicted in the
view with the trap door of the weir up
both by day and also by night, as soon
as a salmon enters he lets down the trap
door and spears the fish which cannot
possibly escape when once inside.

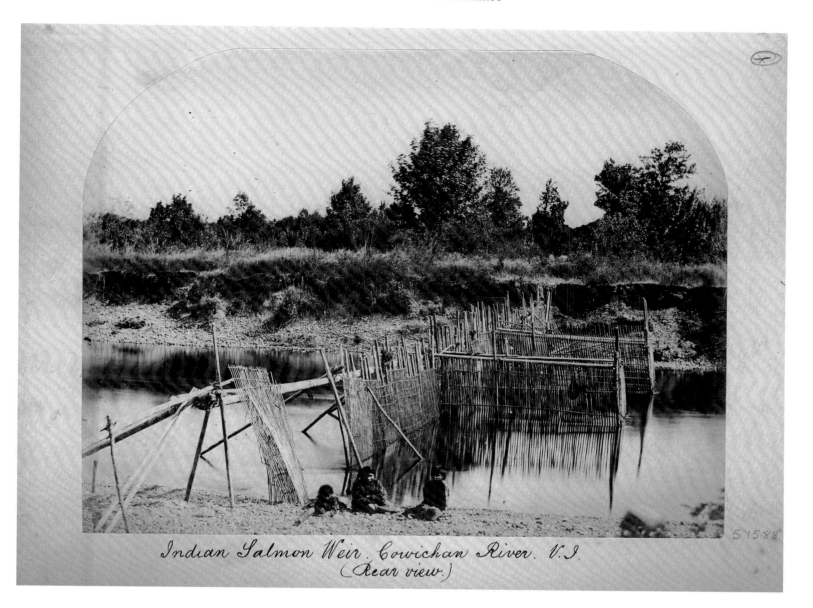

Indian Salmon Weir. Cowichan River. V.I.
(Rear view.)

During the 1873 tour, Richard Maynard made at least seven views of men and women from the Kwakw<u>a</u>ka'wakw village of T<u>a</u>k'us. He posed them on a wooden chest used to transport his chemicals or glass plates. These images are among the earliest surviving photographs of a land-based field studio on the northwest coast. In six of the photographs, Maynard draped a Hudson's Bay Company blanket against the outside wall of a plank house. The blanket and the long grass in front of the chest replaced the painted backdrop and patterned floor in Maynard's Victoria studio. One photograph is of particular interest because it was later cropped and sold as a *carte de visite* under Hannah Maynard's imprint. Powell may have included the unaltered field photograph in his report to the superintendent-general, but the Maynards did not consider it marketable to the public without removing it from the original setting (facing page).

A later government initiative that contributed significantly to the volume of photographs during this era was the McKenna-McBride Commission (formally the Royal Commission on Indian Affairs, 1913–16) established jointly by the governments of Canada and British Columbia. Its popular name derives from James McKenna, one of the federal-government commissioners, and BC Premier Richard McBride. The five commissioners were charged with resolving "all differences between the governments ... respecting Indian lands and Indian Affairs generally in the Province of British Columbia ..." and granted the power to "... adjust the acreage of Indian Reserves in British Columbia." The

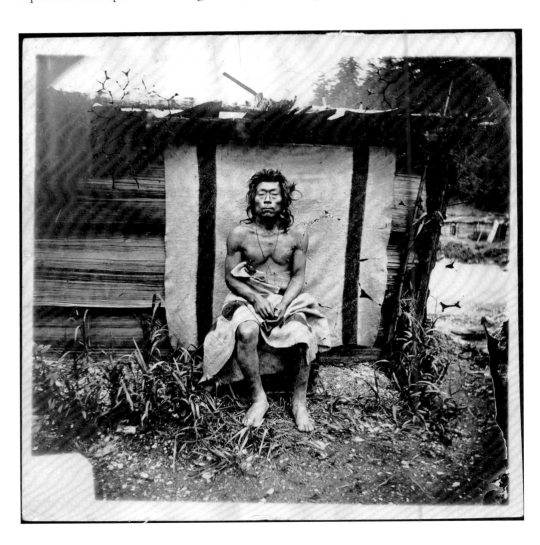

Man in the Kwakw<u>a</u>ka'wakw village of T<u>a</u>k'us.
Richard Maynard, June 9, 1873.
Black-and-white recent print. PN 2094-A.

Richard Maynard's photographs made at T<u>a</u>k'us, Cape Caution, in June 1873 are among the earliest extant photographs of a land-based field studio on the northwest coast of North America. This unidentified man sits on the photographer's wooden box. As a backdrop, Maynard draped a Hudson's Bay Company blanket against the outside wall of a cedar-plank house.

Back in their Victoria gallery, the Maynards cropped this field photograph and sold it as a *carte de visite* (facing page, left). Later, Hannah Maynard superimposed this image against the background of Richard's 1884 photograph of the Haida village of Caynaa 'Llnagaay (see page 56) to produce a large-format, card-mounted composite photograph (far right).

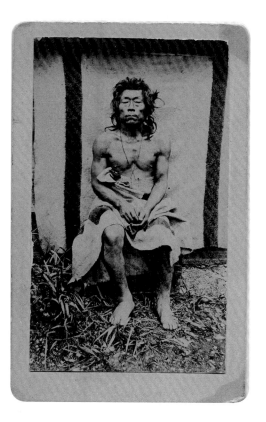

Man in the Kwakwaka'wakw village of Tak'us.
Richard Maynard, June 9, 1873.
Carte de visite. PN 2094-B.

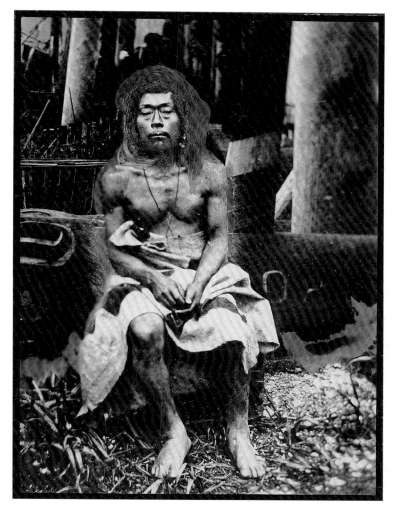

Kwakwaka'wakw man in the Haida village of Caynaa 'Llnagaay (Haina).
Hannah Maynard, about 1895.
Original card-mounted photograph.
PN 2789.

Sometime during the 1890s Hannah Maynard produced this composite of two photographs made by her husband, Richard (pages 56 and 88). She did this by cutting out the image of the Kwakwaka'wakw man and affixing it to a cropped version of the photograph from Caynaa 'Llnagaay, then she re-photographed the blended image. She glued the new print to a cardboard mount measuring 8¾×6⅞ inches.

I do not know what motivated Hannah Maynard to make these composite photographs of First Nations people (or why she altered this man's hair); she clearly produced much more sophisticated composites of herself using multiple exposures in combination with cutting and pasting prints. Margaret Blackman suggests that Maynard was attempting to satisfy customer demand for images of First Peoples in village settings rather than in the sterilized environment of a studio (Blackman 1986:84). The converse may also be true, that she used field and studio photographs of people to enliven the many photographs of villages that lacked images of their inhabitants.

This composite may have been marketable at the time it was made, but it is not valid as an ethnographic record. A Kwakwaka'wakw man in 1873 sits in a Haida village of 1884 – two distinct cultures separated by time and geography.

commission was a misshapen piece in the puzzle that defined the issue of Aboriginal title in British Columbia. It never realized its potential to resolve the First Nations land question, but it did create a photographic record of the people and communities in many of the coastal and interior reserves at that time.

The McKenna-McBride Commission travelled throughout the province from 1913 to 1916. It was charged with the responsibility of determining the amount of land that was "reasonably required for the use of Indians of that tribe or locality". The size of the reserves could be either reduced "with the consent of the Indians, as required by the Indian Act" or increased, or land could be "set aside … for

any Band of Indians for whom land has not already been reserved". The commission submitted a four-volume report on June 30, 1916, to the secretary of state in Ottawa and the provincial secretary in Victoria.

The Royal BC Museum has one souvenir album made for J.A.J. McKenna containing 372 photographs. The album is composed entirely of snapshots except for one commercial postcard taken at Cowichan. I have not been able to discover the name or names of the photographers who accompanied the commission, nor whether the original negatives exist. Neither government appears to have assumed the responsibility of archiving the photographic record.

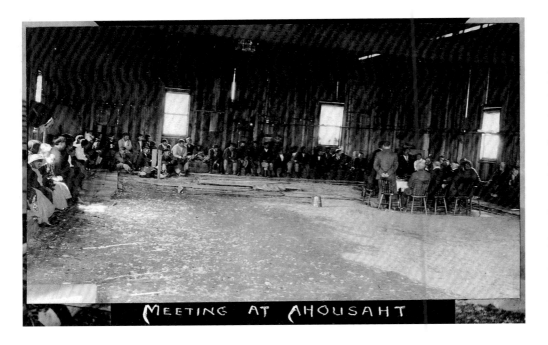

MEETING AT AHOUSAHT

Meeting at the Nuu-chah-nulth village of Maaqtisiis.
Unidentified photographer, May 1914.
Original photograph. PN 12513.

The photographs on these two pages appear in J.A.J. McKenna's souvenir album, which contains more than 300 snapshots.

This one has an incorrect caption: *Ahousaht* is the name of the people, not the community. The meeting probably took place at Maaqtisiis (Marktosis), a reserve on Flores Island. Band members line the inside walls of a house – identified by Luke Swan as Chief Ki.tl's – in support of a speaker who addresses members of the Royal Commission on Indian Affairs at the table. Similar meetings took place in other First Nations communities.

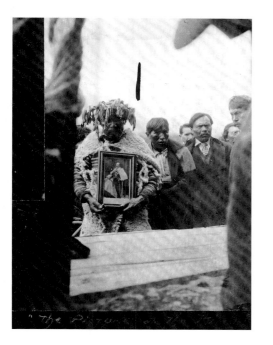

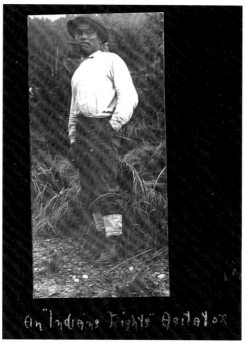

"An 'Indian Rights' Agitator."
Unidentified photographer, August or
September 1913.
Original photograph. PN 12420.

First Peoples grew frustrated by the
provincial and federal governments' refusal
to acknowledge aboriginal title to lands in
their traditional territories.

 This photograph appears on the
same page in McKenna's album as two
photographs that are identified as Hartley
Bay, but it is possible that it was taken at
the Haisla village of Kitlope.

"The Picture of the King."
Unidentified photographer, May or June
1913.
Original photograph. PN 12349.

When the McKenna-McBride
Commission visited the Coast Salish
village of Cowichan, one of the elders
produced a framed photograph of King
Edward VII. This signed portrait was given
to Cowichan Chief Isipaymilt in 1906
following a Royal audience at Buckingham
Palace (Carlson 2005:2), when he and
others petitioned the King on aboriginal
title.

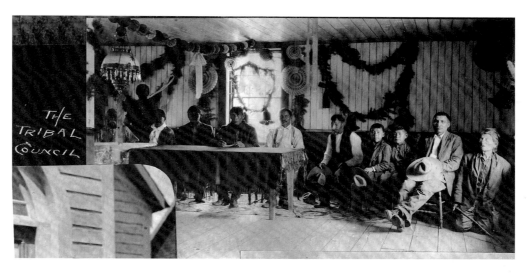

"The Tribal Council."
Unidentified photographer, July 1914.
Original photograph. PN 12556.

This photograph, also in J.A.J. McKenna's
souvenir album, shows the Tribal Council
Hall at the Secwepemc village of Esk'et
(Alkali Lake). The photographer or photo-
graphers who worked for the commission
remain unidentified, and I do not know if
the original negatives still exist.

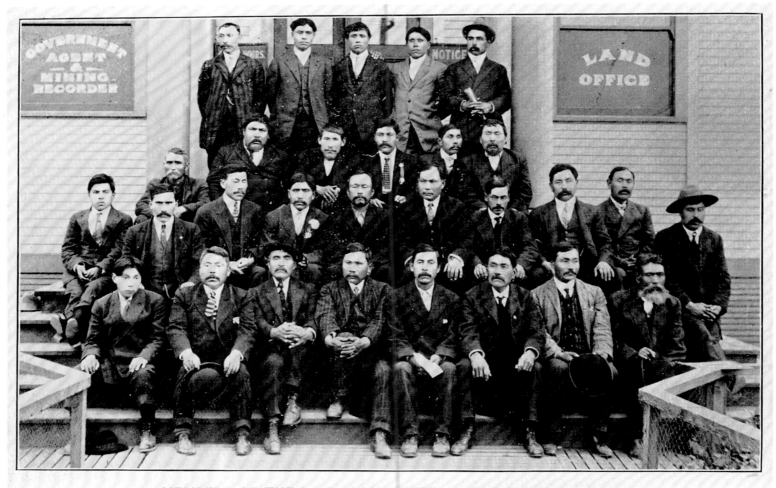

MEMBERS OF THE LAND COMMITTEE OF THE NISHGA TRIBE.
Photograph taken at Aiyansh, Naas River, upon occasion of a meeting of the Tribe held there in October, 1913.

**Nisga'a Land Committee
at the village of Aiyansh.**
Unidentified photographer, October 1913.
Copy negative. PN 13178.

The Land Committee was struck in 1890 to address Nisga'a dissatisfaction with both the provincial and federal governments' refusal to acknowledge their title to lands in their traditional territories. The Nisga'a petition to the British Privy Council in 1913 precipitated the establishment of the Royal Commission on Indian Affairs, 1913–16, known as the McKenna-McBride Commission.

In the early 1980s a Nisga'a researcher identified the men in this photograph while working with the photographic collection at the Royal BC Museum.

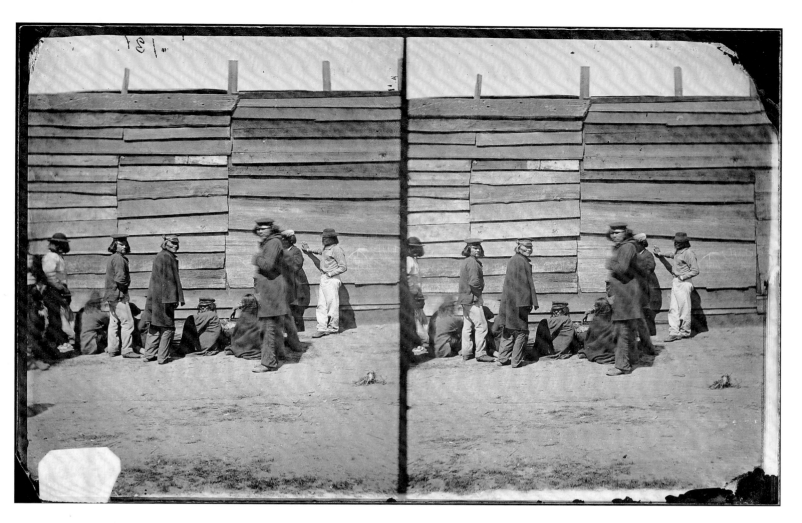

Men gambling in Nanaimo.
Richard Maynard, 1874.
From a wet-plate negative. BCA I-50663.

These men appear concerned about the photographer's presence as they gamble beside a house. First Peoples tolerated outsiders in their villages if they remained unobtrusive. But villagers occasionally challenged a photographer arriving with equipment. Frederick Dally wrote about the experience after he visited the Nuu-chah-nulth village of Ahousat on August 11, 1866:

> When I put my head under the focusing cloth of the camera to my surprise on withdrawing it I found myself surrounded by about 20 of the natives squatting on the ground watching my movements…. I packed up the camera as quickly as possible, and found in my pocket a plug of tobacco which I cut into small pieces [and] gave them to the natives as far as they would hold out and then raised my hat to them and dattawaed [dawdled] to the dingy.

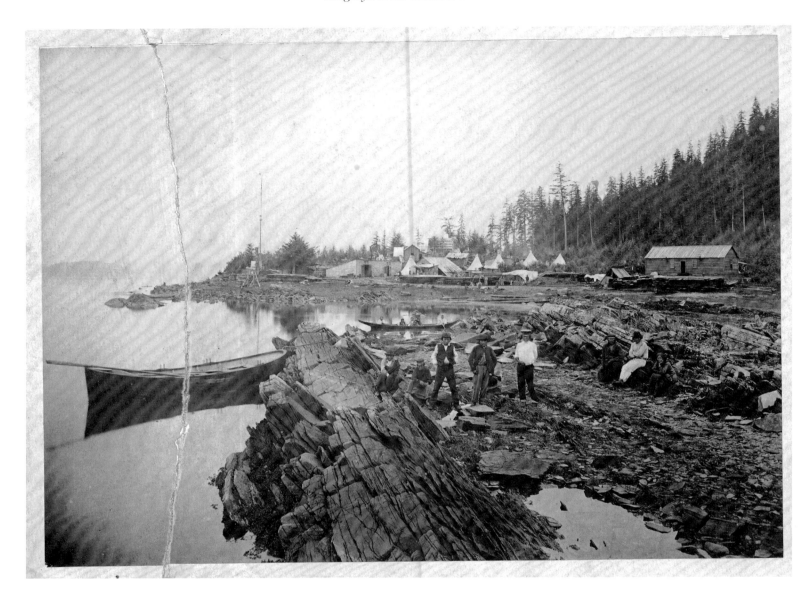

"Alaska Territory, Fort Wrangle."
Eadweard Muybridge, August 1868.
Original card-mounted photograph.
PN 9202.

Known more for his landscape
photography and photographic studies of
human and animal movement, Eadweard
Muybridge made this photograph using a
wet-plate negative when he accompanied

the US Army under the command of
General H.W. Halleck to Alaska in 1868.
Muybridge's are the earliest photographic
images produced after the United States
purchased Alaska from Russia in 1867. But
Muybridge was not the first American
photographer to work in Russian America
– that distinction belongs to Lieutenant
Charles H. Ryder, a member of the
Western Union Telegraph Expedition in
1866 (Sexton 1982: 32).

Tlingit villagers of Wrangell stand in
the foreground and others sit in the canoe
behind them. Muybridge made a second,
slightly different photograph of the same
vista in stereograph format and sold it as
part of a set of Alaskan views published by
Bradley & Rulofson of San Francisco. He
also produced another three stereo views of
the "Indian village". All four stereographs
reside in the Bancroft Library, University of
California, Berkeley.

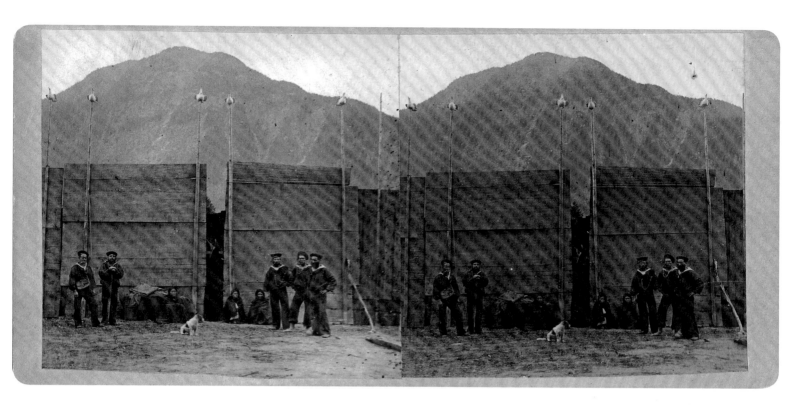

House at the Kwakw<u>aka</u>'wakw village of Dzawadi.
Richard Maynard, June 2, 1873.
Stereograph. PN 2096.

Women from Dzawadi and crewmen from HMS *Boxer* somewhat obscure this remarkable stereograph showing the size of the cedar planks used to construct a mid-19th-century Kwakw<u>aka</u>'wakw house. Vertical binding poles are topped with carved birds. The horizontal wall planks are secured with cedar withes to these poles as well as to the framework of the house. This photograph shows how the wall planks overlapped to shed rain.

Historical photographs, when used with oral descriptions or written ethnographies, can offer a clearer understanding of First Nations technology. Edward Curtis described the traditional use of house boards in *The Kwakiutl*, volume 10 of *The North American Indian*:

Boards for the front wall of a chief's house were made with extreme care, being adzed to a thickness of three-eighths of an inch, and so nicely finished at the edges and sewn together with cedar withes as to seem a single piece. A section about eight feet square formed

half of the front wall. As in everything else, there was considerable rivalry among the chiefs of various tribes in possessing the widest possible board. An ingenious but incredibly laborious method was to trim off the sap wood of half a log, hew it out carefully to the required thinness, invert the curving board over a pit filled with hot stones, and allow it to steam until its own weight flattened it. Battens were then sewn across the ends to prevent warping and splitting.

Inside a Nuu-chah-nulth communal house at the village of Yuquot.
Richard Maynard, September 10, 1874.
Stereograph. PN 10508.

Richard Maynard made this photograph when he accompanied BC's first federal superintendent of Indian Affairs, Dr Israel Wood Powell, on an inspection tour of Vancouver Island in 1874. It shows the massive post-and-beam framework of a Nuu-chah-nulth house. The roof and wall planks have been removed, perhaps to be used in the construction of a temporary fishing camp. The central house beam or ridge pole, carved in the form of a sea lion, is supported by three house posts one of which is carved in the form of a human supporting an unidentified figure (possibly a bear).

This is one of several houses built with the longer walls parallel to the beach front, as evident by the other posts, beams and rafters extending into the background. These massive houses were 9 to 12 metres wide and 12 to 30 metres long. The posts supporting the central beam stood about 3 to 4 metres high. The chief who owned a house inherited the rights to carve the inside house posts and the protruding central house beam.

**Interior pole in the Haida village
of Hlragilda 'Llnagaay (Skidegate).**
Richard Maynard, 1884.
Original card-mounted photograph.
PN 5839.

This carving has been attributed to Haida
master carver Charles Edenshaw. It stood
at the back of a house and may have
supported the roof's ridge beam.

 The unidentified man in this picture
provides a sense of scale, so that viewers
can estimate the size of the pole. He was
probably Richard Maynard's assistant.
The leather carrying case draped over
his shoulder held glass plate holders and
possibly the folded field camera.

 The Provincial Museum of Natural
History (Royal BC Museum) acquired this
pole in 1893.

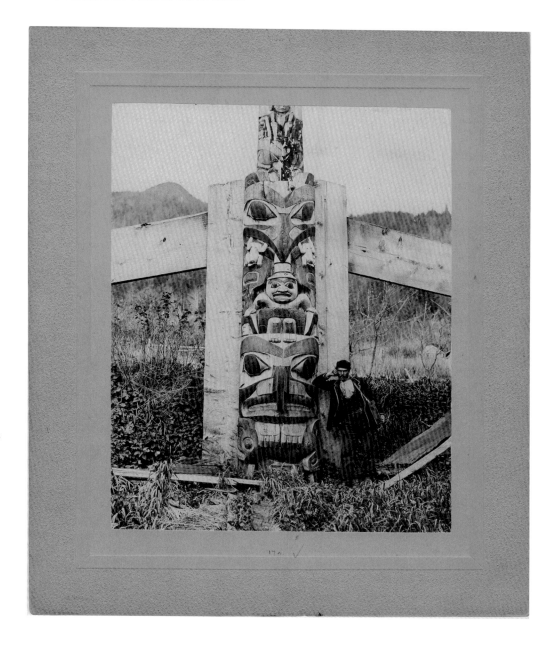

Scientific Research

Expeditions and fieldwork sponsored by institutions generated more collections of research photography. The Royal Museums of Berlin, the British Association for the Advancement of Science, the University Museum (University of Pennsylvania), the American Museum of Natural History, the US National Museum, the Columbian Museum of Chicago (Field Museum), the Milwaukee Public Museum, the Geological Survey of Canada for the Victoria Memorial Museum, and other lesser known local and perhaps less scientific undertakings, such as the Laing Expedition in 1896, increased the number of expedition photographs.

Although the multi-city tour of nine Nuxalk men who accompanied Adrian and Fillip Jacobsen to Germany in 1885 (see page 55) was not part of a museum-sponsored expedition, it had its roots in an earlier collecting expedition undertaken by the Jacobsens on behalf of the Royal Museums of Berlin. The 1886 Berlin performances inspired Franz Boas to direct his research to the peoples of this region (Cole 1982:118). Franz Boas, Harlan Smith, Marius Barbeau, Samuel Barrett, George Emmons and Albert Niblack produced their own photographs while visiting BC's

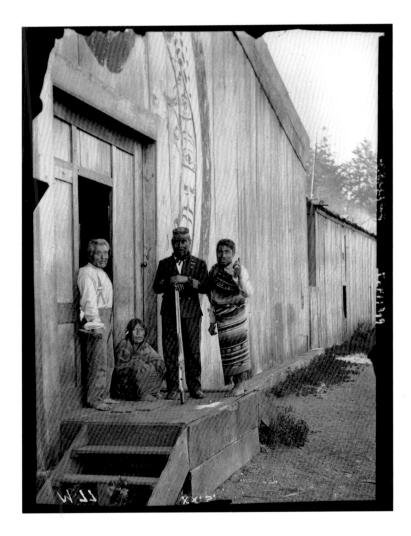

Chief Maquinna and others at the Nuu-chah-nulth village of Yuquot.
Edgar Fleming, summer 1896.
Black-and-white recent contact print from a nitrate negative. PN 11447.

Chief Maquinna poses at the entrance to his house in a navy captain's tunic and pants, resting his arms on a shotgun. The man dressed in the white shirt holds what appears to be the iron tip and attached line for a sealing harpoon. Edgar Fleming, a commercial photographer from Victoria, took this photograph when he accompanied the John Laing Expedition to explore central Vancouver Island from 'Ya̱lis (Alert Bay) to Yuquot in the summer of 1896.

Roof planks on a wall, Lummi Reservation, Washington.
Harlan I. Smith, 1899.
Black-and-white recent print.
AMNH 12132.

Most photographs of First Nations houses in this region were taken at ground level, so they do not show the roof planks. The few photographs taken from higher elevations are usually too distant from the houses to distinguish the details of how the planks were made.

 This is a classic example of a photograph taken by an anthropologist who recognized the significance of details. By the time Harlan Smith visited this community, traditional post-and-beam houses (below) were no longer built. But he found and photographed three traditional Coast Salish channelled roof planks nailed to the end wall of a recently constructed building. In an earlier time these would have been placed on the roof alternately facing upward and downward, like roof tiles.

Longhouse frame, Lummi Reservation, Washington.
Harlan I. Smith, 1899.
Black-and-white recent print.
AMNH 12131.

The roof and wall planks, having been removed from this traditional shed longhouse, reveal the basic elements of its post-and-beam construction. The dry glass-plate negative was cracked and chipped before this print was made. Even though, at that time, photographers could use film negatives, many accepted the risks in using glass plates in the field because high quality prints could be made from them. Harlan Smith took this photograph in 1899, during the Jesup North Pacific Expedition (1897–1902).

coast. Boas also hired two Victoria photographers to work with him: Edward Brooks in 1888 and Oregon Hastings, probably in the same year and again in 1894. Harlan Smith used Hastings in 1898 at the Kwakwaka'wakw village of Tsaxis (Fort Rupert), and George Dorsey, the curator at the Columbian Museum of Chicago, brought freelance photographer Edward Allen with him when he visited the coast in 1897.

Extensive collections of photographs were produced as a result of fieldwork in this region, by: Franz Boas among the Kwakwaka'wakw in 1886, 1888 and 1894; Harlan Smith with the Jesup North Pacific Expedition (1897–99), the American Museum of Natural History (1909) and the Geological Survey of Canada (1915 and 1918–20); Albert Niblack for the US National Museum in 1885–87; George Emmons among the Tlingit in 1882–89 and the Tsimshian in 1909–10; Samuel Barrett among the Kwakwaka'wakw in the winter and spring of 1915 for the Milwaukee Public Museum (more than 350 photographs); Louis Shotridge's Tlingit and Tsimshian views taken during the Wanamaker Expedition, 1915–20; and Edgar Fleming for the 1896 Laing Expedition (see page 21, bottom, and page 98).

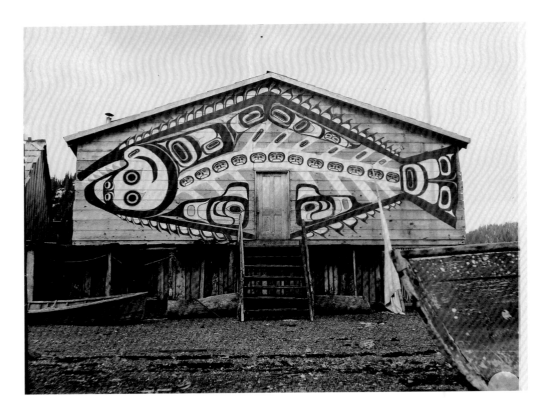

House at the Tlingit village of Saxman, Alaska.
George T. Emmons, about 1889.
Direct duplicate negative. PN 11816.

The size and the pitch of the roof indicate that this house, built in the 1880s, was based on a traditional Tlingit dwelling. But the form has been modified: the chimney pipe jutting from the roof (left) suggests the absence of a smoke hole in the roof and the pilings preclude the existence of a traditional excavated floor; a framed doorway has replaced the traditional oval entrance; and milled lumber has replaced split wall planks. The painted Halibut crest is a traditional feature.

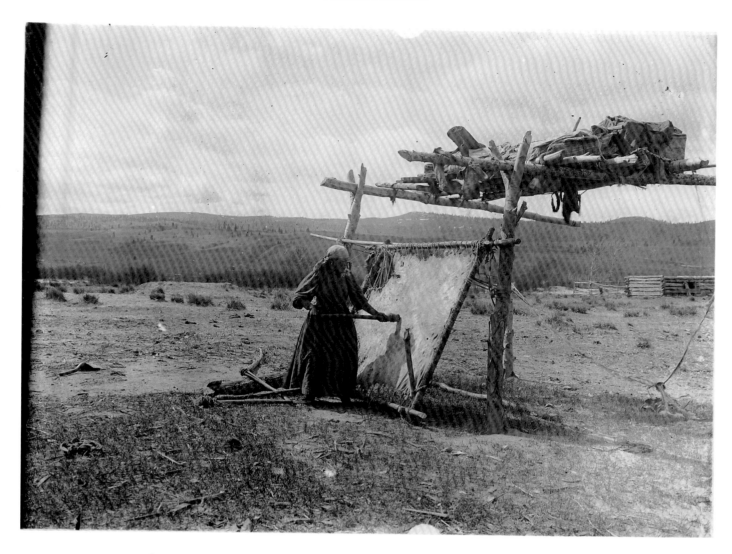

Secwepemc woman preparing a skin, Kamloops.
Harlan I. Smith, 1898.
Black-and-white recent print.
AMNH 411796.

A Secwepemc woman uses a hafted stone tool to soften an animal skin, perhaps elk, stretched on a frame. She has more tools at her feet. A rush mat lies on the elevated storage platform. Harlan Smith used a dry glass-plate negative to take this photograph while working for the Jesup North Pacific Expedition (1897–1902).

In his book, *The Thompson Indians of British Columbia* (1900), James Teit describes the Secwepemc method of preparing skins:

The skin is first dried, and the flesh side scraped free from fatty substance with a sharp stone scraper. Then it is rubbed all over the inside with the decomposed brains of deer, with marrow extracted from the larger bones, or with the oil extracted from salmon-heads by boiling. It is then rolled up and put in a cool place. This latter process is repeated each morning for two or three days, until the under side of the skin is soft and oily. If the weather is not hot or breezy, the skin is dried near a fire. After it has been made soft and pliable, it is stretched on a framework of four poles and beaten or pounded until quite soft by means of a stick sharpened at one end, or a stone scraper inserted into a wooden handle three or four feet in length. This completes the dressing of skins intended for robes or blankets.

Tourism

Tourism among British Columbia's growing Euro-Canadian population contributed further to the expanding compendium of First Nations photographs. As early as 1866 tourist excursions provided opportunities for picture making. However, as noted earlier, using wet-plate negatives in the field was a complicated and somewhat frustrating enterprise. Hannah Maynard noted her photographic failures and successes in her diary kept during a trip in August 1879 with her husband Richard around Vancouver Island on the paddle steamer *Princess Louise*. "Friday 15. Up [at] 5 o'clock to try to take some photos before we leave [Opitsat] but found it very foggy … no photographs yet. Sat. 16 [at Friendly Cove] …

we took two negatives … met with an accident, broke our bath bottle and spilled part of the bath [which was used to process the negatives]."

Steamers stopped at Alert Bay, Winter Harbour, Prince Rupert, Massett, Wrangell and Ketchikan with increasing frequency over the next quarter century. The Alaska Steamship Company advertised round trips between Seattle and Skagway to "travellers who are not particularly in a hurry and want to see … Indians in their homes and get Indian baskets and curios at first hand" (Maring and Blake 1904).

With the growth of tourism came the evolution of the postcard, which became a popular means of document-

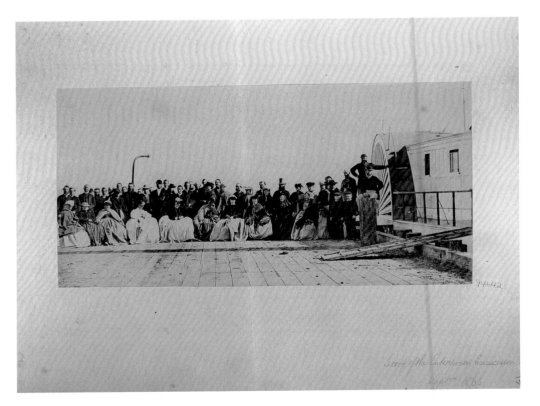

Port Townsend.
Frederick Dally, October 6, 1866.
Original card-mounted photograph.
BCA F-08528.

This is one of the earliest surviving photographs of tourism on the coast. Commander Edmund Porcher of HMS *Sparrowhawk* wrote of this excursion to American ports in Puget Sound in his journal, noting the date, location and maker of this photograph.

ing one's travels in the 1890s. Postcards depicted basket makers, graveyards, villages, solitary or grouped totem poles, delegations of chiefs, Halkomelem *sxwayxwey* dancers, infants in cradle boards, potlatches and Ktunaxa horsemen (below). Postcard images came from a variety of sources. For example, Benjamin W. Leeson, a resident of Quatsino Sound on Vancouver Island, took at least 90 photographs of Kwakwaka'wakw people in the area (see next page). In an article for *Camera Craft* (Leeson 1914: 494), he stated, "I also supply most of my pictures in post card form and these last have quite a satisfactory sale where tourists call [at Winter Harbour] and on such of the Coast steamers as I can get them."

The 1902 introduction of Kodak postcard-sized paper and the availability in 1903 of the No. 3A Folding Pocket Kodak camera, whose negatives produced postcard-sized prints, made it possible for amateur photographers to send personalized postcards that they had printed themselves from their own negatives. Unlike many of the commercial views, these were not re-touched, coloured, tinted or composite photographs of scenes pasted together, so they present a more reliable record of life for study.

Ktunaxa men.
Unidentified photographer and location, about 1910.
Black-and-white real-photo picture postcard.
PN 3713.

Handwriting on the back of this postcard indicates that most of these Ktunaxa men came from Windermere. The riders are dressed in a variety of traditional and contemporary clothing, including beaded moccasins, cloth leggings, beaded cuffs and vests, feather headdresses, a fringed buckskin jacket, cotton shirts, wool pants, and wide-brimmed hats. The man fourth from the left holds a coup stick, indicating that he had fought many times at close quarters.

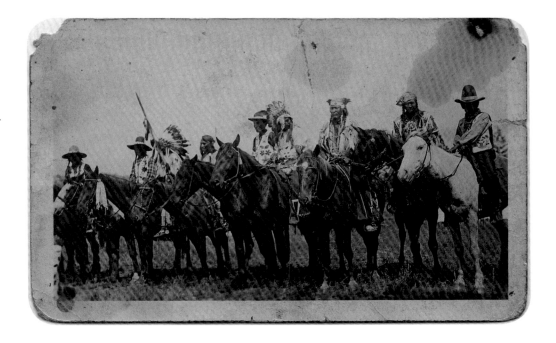

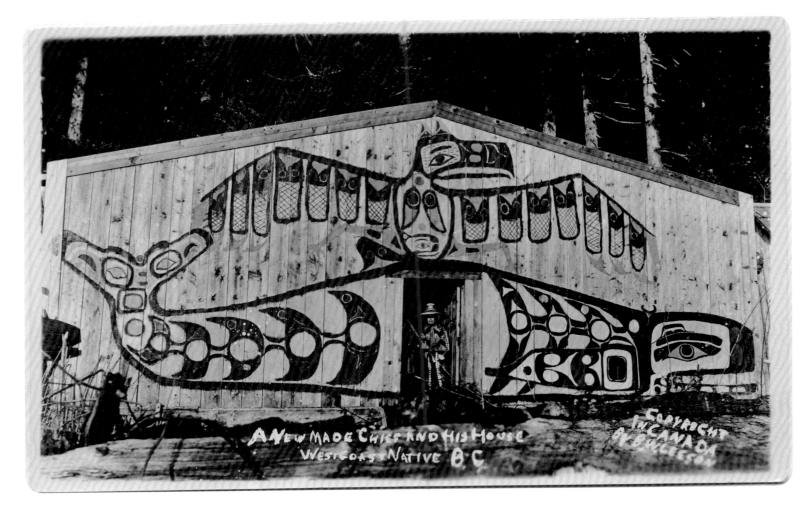

"A New Made Chief And His House" at the Kwakwaka'wakw village of Xwatis (Quatsino).
Benjamin W. Leeson, 1900–1910.
Real-photo picture postcard. PN 23914.

Although he shared Edward Curtis's mistaken theory of a "vanishing race", Benjamin Leeson did not depict the First Peoples of Quatsino Sound dressed in archaic cedar-bark clothing in his photographs (with one exception). A Thunderbird lifting up a whale has been painted on the split-cedar vertical planking that forms the house front.

Catalogue notes at the Vancouver Public Library state that this photograph was taken using a 5×7-inch dry-plate negative.

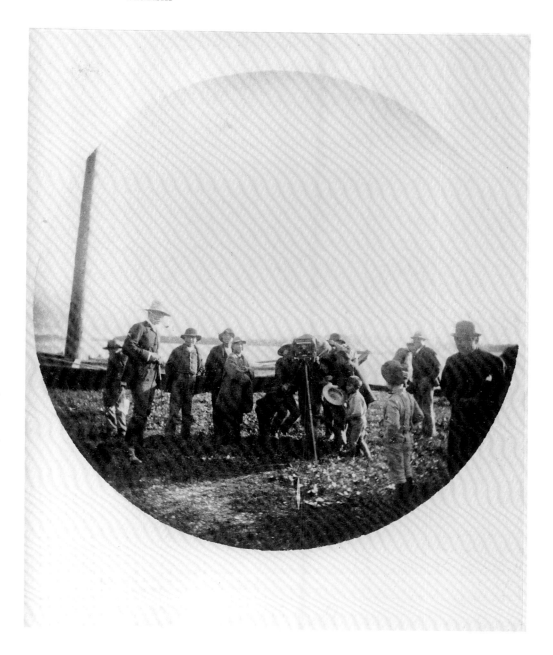

"Town Council taking it in" at the Haida village of Rad Raci7waas (Massett).
Robert Reford, October 1890.
Black-and-white recent print.
LAC C-060834.

Amateur photographer Robert Reford took this photograph while on a coastal excursion aboard the SS *Islander*. The people here show no reluctance to being photographed and no shyness with a camera. They even pretend to use the large view camera to capture Reford's image. One adult has his head under the camera's light-proof focusing cloth. Reford took three cameras with him on the trip (Sherwood: 2007) and used his hand-held Kodak box camera to take this photograph.

This image was printed from the circular negative stripping film used in the first Kodak box camera, introduced in 1888 (see pages 33–35).

Indian Tepee
Creston B.C.

Ktunaxa family at Creston.
Unidentified photographer, about 1910.
Black–and–white real–photo picture postcard.
PN 3719.

Although this photograph was taken in
about 1910, a traditional tepee dominates
the image. Father and mother wear their
hair braided. One of the small children
wears a hat decorated in a geometric
design using small beads, possibly made
of seeds; the infant is laced onto a cradle
board. The father's confident and relaxed
pose may indicate that he was familiar with
photographers and their cameras.

 Initially I thought that this photograph
may have been taken by a relative or friend
of the family, but the impersonal caption
on the face of the card is more indicative
of a commercial photographer.

Hop harvesters.
Unidentified photographer and location, about 1910.
Black-and-white real-photo picture postcard. PN 6339.

This informal group portrait of workers was taken in a hop field, possibly in Washington. The baskets are full of hops picked from the vines in the background. Every August, large families of First Peoples went to work in the hop fields. Men, women and children worked alongside each other, but most of the workers were women (Raibmon 2005:77). Regrettably this postcard does not indicate who these people are or where they came from.

The estimated date of this photograph is based on the people's clothing and the fact that the first real-photo picture postcards appeared around 1907 (Cronshaw 1989:13).

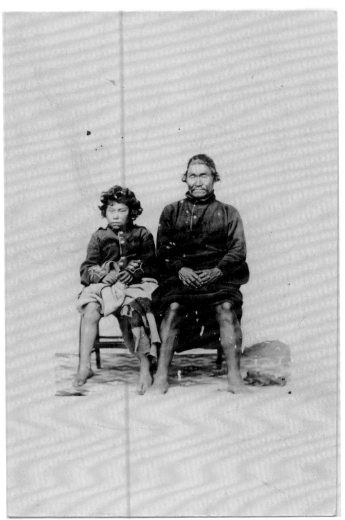

Chief Setta Canim and son.
Unidentified photographer, 1860–75.
Carte de visite (left)
and real–photo picture postcard. PN 1441.

Many photographs marketed as commercial postcards in the early 1900s were produced decades before. The photographer who made this studio portrait of Tla-o-qui-aht Chief Setta (Cedar) Canim and possibly his son, "Curly Ish Kab" (named on the back of the *carte de visite*) used the wet-plate process. The photograph appeared originally as a *carte de visite*, then about 40 years later as a postcard.

Tourists' perceptions of First Nations culture in the early 1900s were skewed by the dated images that appeared on postcards like this one. Even current researchers, unaware of a photograph's history, might use a postmark, postage stamp or card format to incorrectly date an image.

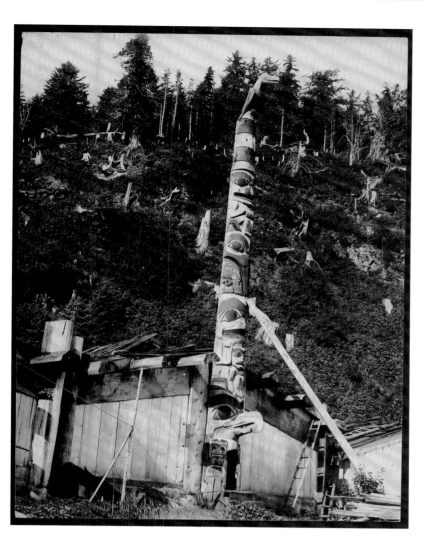

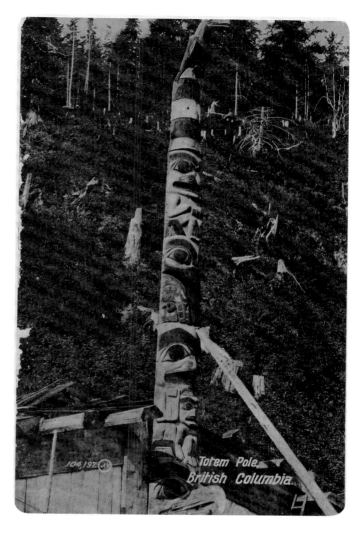

Lightning House in the Haida village of Caynaa 'Llnagaay (Haina).
Richard Maynard, 1888.
Original photograph (left) and coloured printed picture postcard. PN 5651.

Richard Maynard's photograph of a Haida traditional six-beam house, named Ts'amti (Lightning House), was reissued as a postcard in the early 1900s by Valentine & Sons' Publishing of Montreal and Toronto. Although the card is not postmarked, we know that it was issued sometime after December 1903, when postcards began being printed with a divided back (for message and address).

A postcard's format can help establish the date of its release, but it does not necessarily indicate when the image was photographed. By the time this postcard was marketed, Caynaa 'Llnagaay was no longer a permanent village and its inhabitants had moved to the nearby village of Hlragilda 'Llnagaay (Skidegate).

Edward Curtis

In the second decade of the 20th century, Edward Sheriff Curtis visited Haida Coast Salish, Nuu-chah-nulth, Kwakwaka'wakw, Ktunaxa and Interior Salish peoples. This single-purposed American photographer produced texts, still photographs and cine film that set him apart from all others. Mick Gidley (1984:165) described him as "… an extremely ambitious visionary with a tremendous sense of his own capacity to achieve". Volumes 9, 10 and 11 of Curtis's *The North American Indian* and their accompanying photogravure portfolios are devoted to the peoples of the northwest coast of North America, and volume 7 and its portfolio to the Salish and Ktunaxa peoples of BC's interior. Curtis's singular quest was to photograph all First Nations west of the Mississippi River (including the Eskimo of Alaska) to create "the visual epitome of vanishing Indian ideology" (Raibmon 2005:5).

Curtis's fieldwork was partially underwritten by a grant of $75,000.00 from financier John Pierpont Morgan and by pre-selling subscriptions to his opus, *The North American Indian*. Initially forecast to take five years, this epic undertaking took more than thirty years to complete. Curtis wrongly believed that the demise of First Peoples throughout North America was imminent and inevitable – that they were the "vanishing race" – and he intended to produce a photographic record of time and place that would depict their cultures before Euro-American influences. The challenge he faced was almost insurmountable: how could his photographs, taken more than 135 years or more after contact with Europeans, present First Peoples and their life-ways as they were before contact? To accomplish this he had to reconstruct a lifestyle that no longer existed in its traditional form. He often posed people in clothing made of cedar bark or raffia and other traditional garments (facing page), even though they customarily dressed in the fashions of the day. As documented by Christopher Lyman in 1982, careful examination of Curtis's images sometimes reveals evidence of non-aboriginal material culture.

Curtis's work continues to receive both praise and condemnation. More and more often the public is questioning the authenticity of many of his photographs. Some perceive his work among the Kwakwaka'wakw to be contrived and inaccurate. The extent of this popular opinion is reflected in a comment card written by a visitor to the Royal BC Museum after viewing a short film clip from Curtis's retitled motion picture, *In the Land of the War Canoes*, that is shown in the *First Peoples* gallery. The footage was shot at the same time as the still photograph on page 149 and shows dancers performing as Wasp, Thunderbird and Grizzly Bear atop wooden platforms set across or inside the gunwales of three canoes. The comment card reads: "The documentary film … is widely known to be fabricated, he [Curtis] himself dancing in the boat. This should have a disclaimer, something to say that the film is simply his imagination of what it was like."

But Curtis is not one of the accomplished dancers in the film. Bill Holm and George Quimby, in their 1980 study of the film, state: "Grizzly Bear is especially expertly portrayed. A number of [Kwakwaka'wakw] people guessed that the dancer was Herbert Martin, a renowned dancer, but he told Bill Holm that he and his older brother Mungo were away at Rivers Inlet during the filming". At least one of Edmund Schwinke's still photographs taken during the making of the film shows the Kwakwaka'wakw man who danced as Wasp with his mask removed. Edward Curtis would have

> The Northwestern University Library has digitized the illustrations from all 20 volumes of *The North American Indian*. This includes the plates in each volume and the accompanying portfolio. The URL for this site is: http://memory.loc.gov/ammem/award98/ienhtml/curthome.html. It is the most complete and highest quality online site containing Curtis's work.

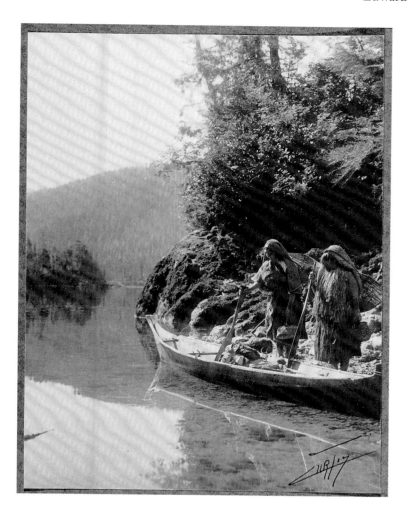

been either setting up the shot for Schwinke, who also operated the motion picture camera, perhaps directing the scene or possibly operating the motion picture camera himself. But he was not one of the dancers who appeared in the film.

A recurring criticism is that Curtis costumed First Peoples in archaic clothing. In the introduction to volume 10 of *The North American Indian*, the volume dedicated to the Kwakwaka'wakw, Curtis freely acknowledged this to be the case and explained: "The primitive garments shown in the illustrations were prepared by Kwakiutl [Kwakwaka'wakw] men and women for the author, and are correct in all respects. Such costumes, of course, are not now used". Curtis's good fortune was not only that enough material culture remained to evoke the past in his photographs but, even more importantly, that he had access to and the cooperation of knowledgeable consultants and artisans in the First Nations communities he visited.

Nuu–chah–nulth women at Clayoquot Sound.
Edward S. Curtis, 1915.
Original photograph. PN 16839.

These Nuu-chah-nulth women wear old-style cedar-bark or raffia capes and skirts to evoke an earlier way of life. In many of Curtis's field photographs the people remain unidentified, but the woman on the right in this image was widely known – she is Virginia Tom (Frank 2000:172).

Curtis has been criticized for keeping evidence of industrialization out of his photographs. But in the description of this canoe for another photograph taken at the same time, he wrote: "It will be noted that the canoe has been fitted with rowlocks."

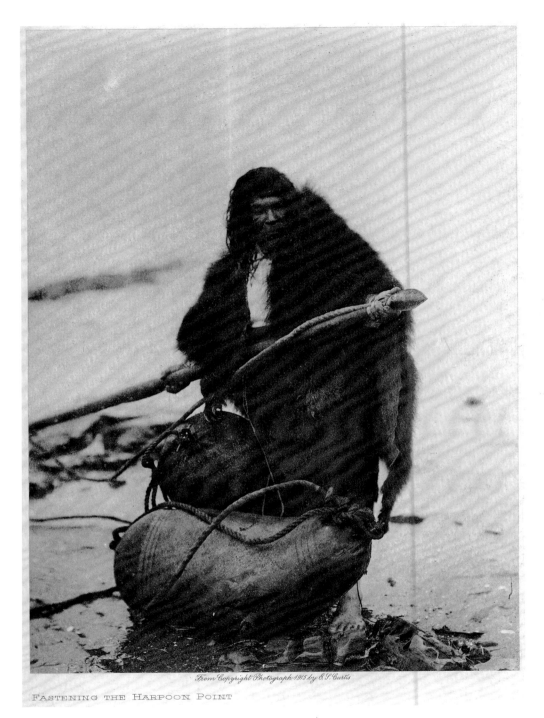

From Copyright Photograph 1915 by E.S.Curtis

FASTENING THE HARPOON POINT

**"Fastening the Harpoon Point"
at the Makah village of Neah Bay,
Washington.**
Edward S. Curtis, 1915.
Photogravure. PN 4980.

This staged photograph shows Nukmiss
(Wilson Parker), a Makah whaler. The
photograph differs significantly from
brother Asahel's documentary photographs
taken a few years earlier at the same village
(example on facing page). Edward's intent
was to place the Makah of the early 20th
century in a setting that would evoke the
past, a past in part constructed by Curtis
himself.

Although the traditional harpoon
shaft of yew wood, lanyard of whale sinew
wrapped in wild-cherry bark or nettle-
fibre string and the two inflated hair seal
floats were still used in whale hunts at
the time that this photograph was taken,
Makah men did not dress in bear-skin
cloaks; they wore shirts and trousers.
Nukmiss appears to be wearing a wig.
The use of soft focus makes it difficult to
determine whether the harpoon head is a
traditional composite made of large mussel
shell blades or a non-traditional type made
of copper or steel.

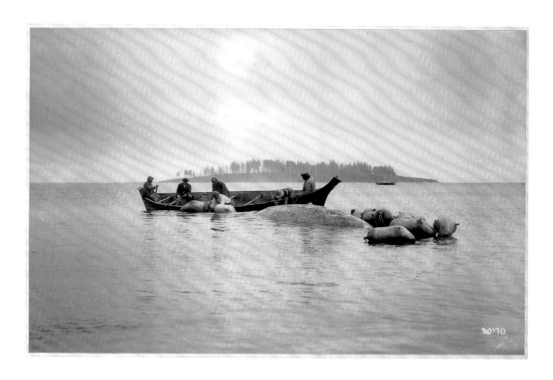

Makah whalers of Neah Bay.
Asahel Curtis, about 1910.
Black-and-white recent print. WSHS 20178.

Asahel Curtis, Edward's younger brother, took a series of at least 17 photographs at Neah Bay, Washington. The high quality of this image is partly due to Curtis's use of a dry glass-plate negative that measured 8×10 inches. The Makah hunted whales in the open ocean (page 147) in canoes like the one in this photograph; the inflated sealskin floats are attached by harpoon lines to the whale's half-submerged carcass. Unlike the people in Edward Curtis's staged photographs, these men wear 20th-century clothing.

Benjamin Leeson's photograph album, 1895–1920.
PN 23908.

In the early 20th century, many North Americans accepted the theory that the cultures of First Nations throughout the continent were vanishing. The title of this Photo Gems souvenir album produced by Benjamin Leeson of Winter Harbour, a remote community at Quatsino Sound on Vancouver Island's west coast, reflects how widespread this faulty premise had spread. The album features fourteen 3½×5½-inch postcard-sized photographic prints made from Leeson's large-format dry-plate negatives (now housed at the Vancouver Public Library). Many of these are captioned and coloured by hand. Leeson sold albums and individual prints to tourists who came to Quatsino Sound aboard coastal steamers.

Charles Newcombe

Charles Frederic Newcombe (1851–1924) emigrated from England and settled in Victoria in 1889. A medical doctor by training and a Renaissance man by nature, Newcombe began in the 1890s to document the cultures of the First Peoples of British Columbia and Alaska, primarily along the coast.

Newcombe's written ethnographic contributions are valuable, but minor in terms of published works when compared to the work of James Teit (see page 125). But his collection of photographs, lantern slides, dry glass-plate and nitrate negatives make up the most complete photographic survey of this region's First Peoples produced by one man during the time frame covered by this book.

Newcombe's interests varied and consequently his photographic collection is reasonably comprehensive as well as extensive. He documented First Peoples' technologies, means of transportation, monumental carvings, structures, art and ceremonies. Among the subjects he photographed are: women weaving hats, mats, tump-lines, baskets and blankets; general and detailed village views; exterior and interior views of houses (pages 43 and 46); inside house posts; potlatch visitors; remains of eulachon fisheries; river and ocean-going canoes; semi-subterranean houses; a Secwepemc sweathouse; canoe making at the Kaigani Haida village of Kasaan; spinning mountain goat hair at Musqueam; two fully loaded northern canoes in open water being towed by a gas boat; and a potato field at the Haida village of Ya.aats' (Ya-tza).

In addition to his field photographs, Newcombe also photographed many of the pieces he collected, either in situ or after he brought them back to his residence in Victoria. These photographs document the physical condition of museum pieces at the time they were collected and are invaluable to curators, researchers and conservators in providing them with appropriate treatment (see page 11). He also collected and conducted research for the American Museum of Natural History, the Brooklyn Museum, the Museum Branch of the Geological Survey of Canada, the Columbian Museum of Chicago, the BC Provincial Museum of Natural History (now the Royal BC Museum – see page 195) and other clients.

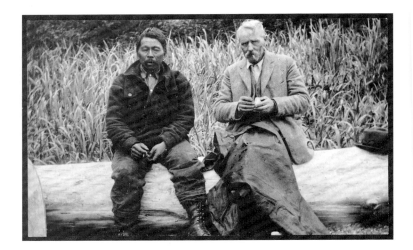

Henry Moody and Charles Newcombe.
Arthur H. Newcombe, May or June 1923.
Original photograph. PN 5429.

Dr Charles Newcombe (right) sits on a log with Haida consultant Henry Moody at the Haida village of T'anuu 'Llnagaay (Tanu). Newcombe died in the following year.

**Secwepemc sweathouse frame,
Nicola River valley.**
Charles F. Newcombe, 1903.
Black-and-white recent contact print
from a dry glass-plate negative. PN 998.

This sweathouse frame is made of thin,
flexible saplings (possibly willow). The
stones on the ground inside the framework
would have heated the finished sweathouse
(below).

**Secwepemc sweathouse,
Nicola River valley.**
Charles F. Newcombe, 1903.
Black-and-white recent contact print
from a dry glass-plate negative. PN 999.

In *The Thompson Indians of British Columbia*,
James Teit recorded that the Secwepemc
finished a sweathouse by covering it
"thickly with dry pine needles, and that
again with a thick covering of earth"; and
they covered the floor "thickly with the
ends of fresh fir-boughs, often mixed with
juniper, sagebrush, or some other aromatic
plants". The sweathouse "accommodated
from one to four persons in a squatting
posture". Stones heated in a fire outside
were carried inside with tongs to heat up
the sweathouse and water poured on them
to create steam. When in use, the entrance
was covered with a blanket or skin.

The three men may have built the
sweathouse or Charles Newcombe may
have included them simply to provide scale.

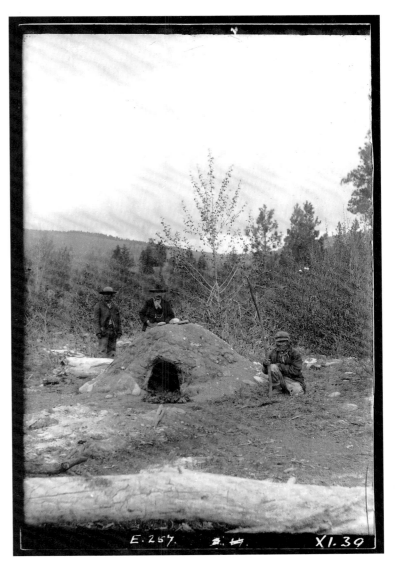

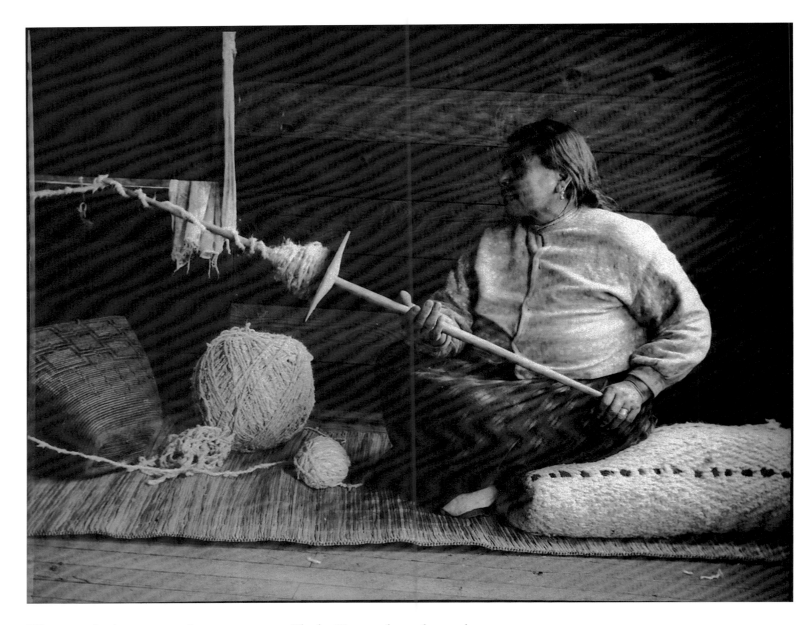

Woman spinning yarn at the Coast Salish village of Musqueam.
Charles F. Newcombe, December 5, 1915.
Direct duplicate negative. PN 83.

Charles Newcombe took two, three or four photographs of C'elicia spinning mountain goat hair at Musqueam; only two have survived. C'elicia uses a spindle stick (a tapered rod) and a whorl (the disc) to spin the hair into thick yarn. This yarn could then be used to weave a Salish blanket similar to the one she sits on.

Potato field in the Haida village of Ya.aats' (Ya-tza).
Charles F. Newcombe, May 1913.
Black-and-white recent contact print from a dry glass-plate negative. PN 5633.

Potatoes were an "important cash crop for the Haida, who raised them in large numbers for sale at Fort Simpson" (Wright 2001:43). I have seen only three photographs (two by Charles Newcombe and one by Richard Maynard) of potato hills. Seed potatoes have been planted in early spring, but no plants are visible in this photograph taken in May.

Newcombe catalogued this photograph as "Yats – house & Pole", but does not mention the man standing beside the pole. Robin Wright has identified him as Mark Alexander, the son of the person who raised the solitary pole that stood at the village when Newcombe took this photograph.

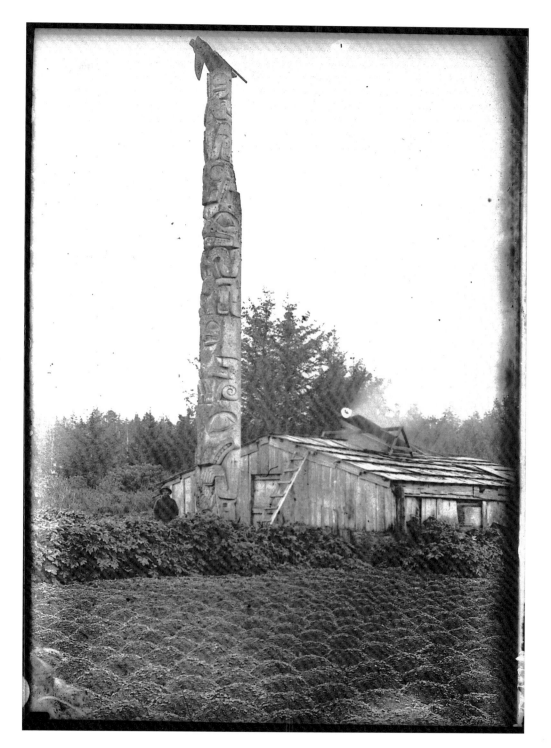

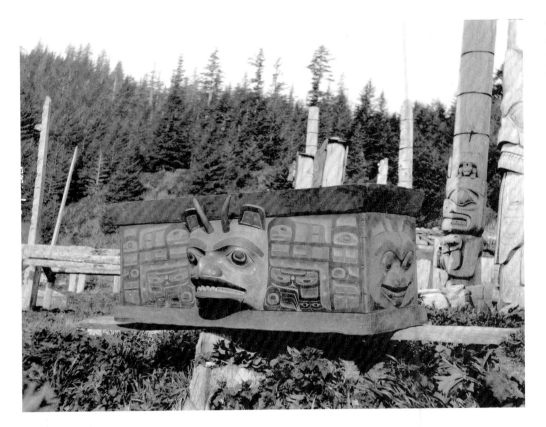

Cedar chest at the Haida village of Q'una 'Llnagaay (Skedans).
Charles F. Newcombe, 1901.
Direct duplicate negative. PN 89.

Charles Newcombe usually photographed the smaller objects that he collected after returning to his residence in Victoria, so this is a rare field photograph of a collected piece that is not a monumental carving.

Newcombe purchased this yellow-cedar, bent-corner storage chest in 1901 for the American Museum of Natural History. John Swanton noted in his 1905 ethnography that this box was originally intended for the remains of the dead, "although the chief who had it made, about 1880, changed his mind afterwards and disposed of the remains of his predecessor in another manner. It was intended for one of the town chiefs of Skedans, and is ornamented with three of his highest crests". Two of these crests – Mountain Goat and Grizzly Bear – can be seen in this photograph.

River canoe at Yale.
Charles F. Newcombe, December 1912.
Direct duplicate negative. PN 610.

This Coast Salish dugout river canoe is secured by rope to a pole set into the sand. Its broad beam and slight draught provides stability and allows access to the shallow parts of rivers.

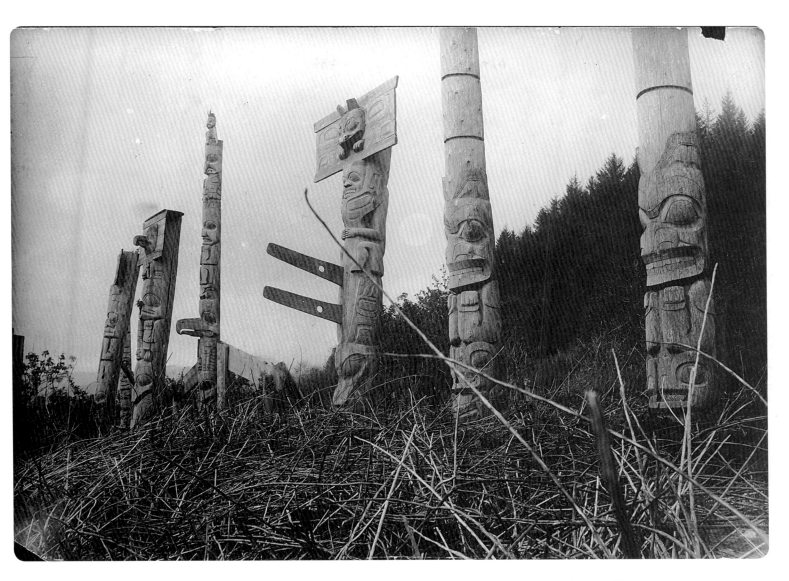

Poles at the Haida village of Hlqin7ul (Cumshewa).
Charles F. Newcombe, May 1901.
Original photograph. PN 956.

From about 1890 to 1920, Canadian, American and some European museums competed fiercely to acquire carvings and other cultural objects from First Nations sites in this region. Charles Newcombe took this photograph just before the house frontal pole (fourth from right) was cut down. It stands against the two wide front gable plates of Frog House. These plates were removed first and then the pole was cut at its base. One of these plates can be seen lying on the ground in the photographs on the next page. Newcombe collected the pole for the American Museum of Natural History in New York.

Newcombe used a dry glass-plate negative, measuring 4¾×6½ inches, to take this photograph and three 4×5-inch nitrate film negatives to take the photographs of the pole as it fell to the ground. The larger negative provided a better quality print of the static scene, but it would have taken longer to change plates if he had chosen to record the pole's descent on glass. That said, two of the roll-film negatives are blurred (see next page) because of the pole's movement, even though, as Newcombe's diary entry notes, this pole "fell slowly and gently, not breaking anything".

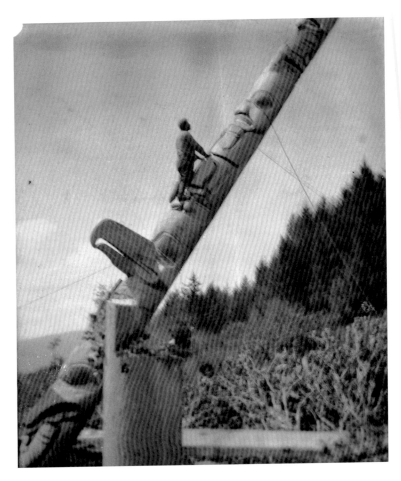

Falling a pole at the Haida village of Hlqin7ul (Cumshewa).
Charles F. Newcombe, May 1901.
Direct duplicate negatives.
PN 82 (left) and PN 695.

These photographs and one other that Charles Newcombe took at the same time are the only surviving field photographs from this era documenting the act of collecting a monumental carving. Newcombe's attempts to produce a clearly-defined image as the pole fell to the ground were unsuccessful even though he used 4×5-inch nitrate roll film and a hand-held camera. The film's emulsion was not sensitive enough nor the camera's shutter speed fast enough to freeze the action without blurring the pole's features.

Newcombe's diary entry for May 18, 1901, reads: "Took ... 2 or 3 of Abr. Moss's pole on slope, one showing Klew [Chief Klue] climbing up to weigh end down."

Frederick Landsberg's curio shop, Victoria.

Unidentified photographer, after 1901. Original card-mounted photograph (digitally modified to remove graffiti from the original). PN 9748.

Frederick Landsberg numbered and moved part of his collection onto the boardwalk in front of his store so that they could be photographed. The sign in the window identifies this collection as "Indian baskets, curios and relics". It includes bentwood boxes, box-lid flanges (in front on the boardwalk), masks, whale-shaped feast dishes, carved figures and a Chilkat robe.

An address written in ink on the back of the original photograph suggests that Landsberg intended to sell these pieces to "Frost & Son, Bead Importers, N.Y. Howard St." But Charles Newcombe may have made a better offer for some of them. He bought the two large figures from Landsberg in 1905 and sent them to the Field Museum of Natural History in Chicago.

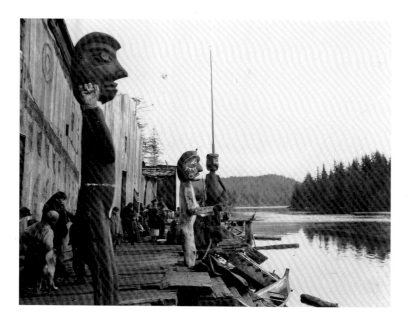

The Kwakwa̲ka'wakw village of Ba'a's (Blunden Harbour).

Charles F. Newcombe, March, 1901. Direct duplicate negative. PN 258.

Four years before Newcombe bought the two large figures from Frederick Landsberg, he had photographed them in situ at Ba'a's.

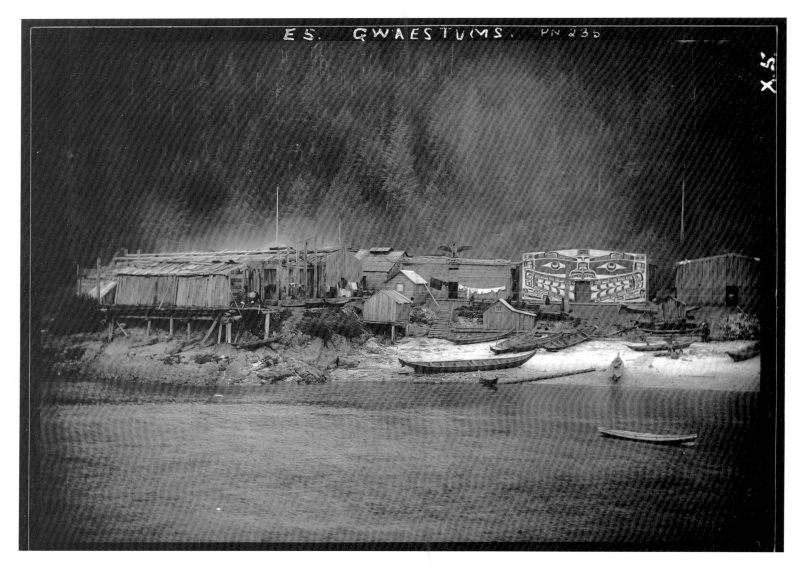

**The Kwakwa̱ka̱'wakw village
of Gwa'yasda̱ms.**
Charles F. Newcombe, April 1900.
Black-and-white recent contact print
from a dry glass-plate negative. PN 235.

This photograph features the painted front
of Chief John Scow's Sea Monster House
at Gwa'yasda̱ms on Gilford Island. Because
it is a contact print, the positive is the same
size as the negative (4¾×6½ inches).

The Nuxalk village of Talyu.
Charles F. Newcombe, April 1913.
Black-and-white recent contact print
from a dry glass-plate negative. PN 10978.

The house frontal pole shown below stands
on the right in this partial view of Talyu
(Talio).

House frontal pole at Talyu.
Charles F. Newcombe, April 1913.
Black-and-white recent contact print
from a dry glass-plate negative. PN 7174.

People entered Raven house through the
opening at the base of the pole. Charles
Newcombe purchased the house frontal
pole in 1913 and recorded that it had been
carved by Skyuswalus of Talyu (Talio).
The figures on the pole refer to the family
histories of its owner, Chief Hemas. The
Provincial Museum of Natural History
(Royal BC Museum) acquired it that same
year and it is now exhibited inside a glass
hall near the east entrance to the museum.

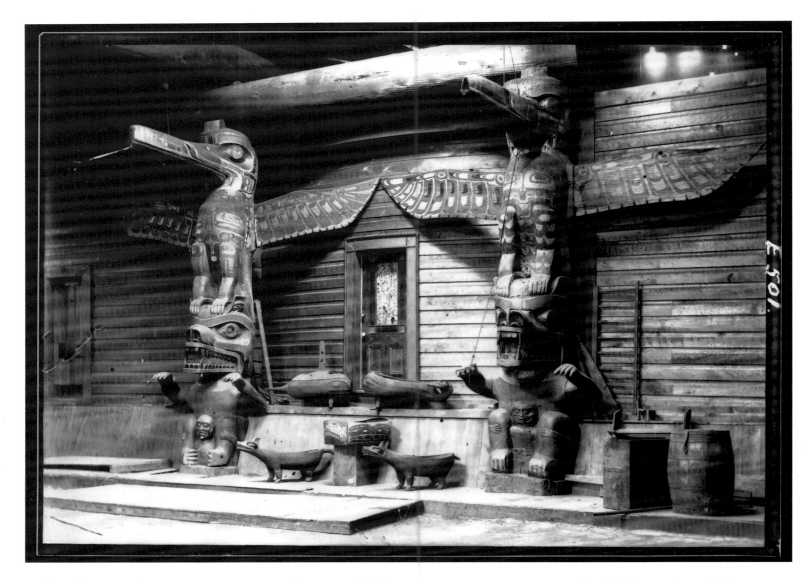

Inside a house at the Kwakwaka'wakw village of 'Mi'mkwamlis.
Charles F. Newcombe, April 1912. Black-and-white recent contact print from a dry glass-plate negative. PN 29.

These rear inside house posts represent *Huxwhukw* (Cannibal Bird) and Grizzly Bear, both presumably crests of the house owner. The lines attached to pulleys hanging from the roof beams served to open and close the long beaks of the *Huxwhukw*s and move the arms of the bears. The door provided access to a chamber built of milled tongue-and-groove lumber.

Charles Newcombe took this photograph before he purchased the four feast dishes between the house posts for the British Columbia Provincial Museum of Natural History (Royal BC Museum). The feast dishes sitting in front of the door represent killer whales, one with fin lid and the other with a curved tail; the dishes on the lower platform represent wolves.

James Teit

James Alexander Teit (1864–1922), like Charles Newcombe, was a self-trained ethnographer who collected examples of First Nations material culture, conducted ethnographic field work and took photographs in First Nations communities. Also like Newcombe, Teit came to Canada from the United Kingdom (Scotland). He settled in Spences Bridge in 1884 and remained in the area for the rest of his life. And his anthropological work just about paralleled Newcombe's. He began documenting First Nations cultures in the 1890s, but where Newcombe did most of his field work on the coast, Teit concentrated on interior communities.

James Teit's various jobs included a clerk in a dry goods store, miner, fur trader, farmer, big game hunter and guide. In 1894 he began a life-long association with Franz Boas, who was conducting field work for the British Association for the Advancement of Science at Spences Bridge. Teit's formal work for Boas and the American Museum of Natural History in New York continued through the Jesup North Pacific Expedition years (1897–99) and on until 1911, when he accepted Edward Sapir's offer to work for the Anthropology Division of the Geological Survey of Canada "as an anthropologist in the outside service" (Thompson 2007:1). He worked for the survey intermittently until 1921, the year before his death.

Like Newcombe, Teit was an amateur photographer and collected artifacts and ethnographic information for museums, among them BC's Provincial Museum of Natural History, the American Museum of Natural History and the Museum Branch of the Geological Survey of Canada. Unlike Newcombe his work focused almost exclusively on Interior Salish and Tahltan First Peoples; he was fluent in his first wife's language, Nlaka'pamux (Thompson) and collected wax cylinder sound recordings of First Nations languages from northwestern and south central British Columbia. He also authored many scholarly articles.

Teit championed Aboriginal title and First Nations rights through his work with the Interior Tribes of British Columbia and the Indian Rights Association in 1909 and with the Allied Tribes of British Columbia in 1916, as the author of the "Declaration of the Tahltan Tribe" in 1910 and as the representative of First Nations interests in the 1920 inquiry into the *Report of the Royal Commission on Indian Affairs for the Province of British Columbia.*

Teit's earliest ethnographic photographs associated with a museum are those he took while working for the Jesup North Pacific Expedition (1897–99). But he thought himself very much an amateur photographer, so in May 1910, during a visit to Vancouver, he hired a commercial photographer, Valient Vinson, to take photographs of Nlaka'pamux men and women at Spences Bridge. Vinson arrived in July and, under Teit's supervision, took many photographs of people wearing traditional costumes supplied by Teit (Tepper 1987:ix).

Two years later Teit tried unsuccessfully to sell these images to Edward Sapir. In a letter dated August 2, 1912, he extolled their importance in terms of visual anthropology: "I consider them most excellent pictures … you have here a splendid chance to commence with them the building up of [a photo] album for the museum which will from the beginning be of great value for studies of facial types of the various stocks and tribes, and of costumes." But by November he had changed his opinion of the costume photographs, stating in a letter to Sapir: "The other pictures are not of much scientific value, and as you say the pose of some is not good. They were taken to show the different costumes."

Sapir returned Vinson's photographs later that month with a letter of explanation: "I have decided that it would not be advisable for us to invest in them. They are undoubtedly very fine but in view of their excessive price and the fact that we have such facilities for adding to our stock of photographs in the course of field work, I have thought it would be better not to make any definite arrangements with Vinson for their purchase."

During Teit's years with the Geological Survey he used primarily 4×5-inch dry glass-plate negatives to take

**Chief John Tedlenitsa of the Pekai.st,
near Spences Bridge.**
Valient V. Vinson, July 1910.
Original photograph. PN 6582.

Chief Tedlenitsa poses in front of a mat
tepee near Spences Bridge. He wears
traditional clothing consisting of a bearskin
headdress set with owl wings and tail, a
bearskin poncho fringed with buckskin,
a buckskin breech cloth, an apron with a
beaded flower design, fringed moose-skin
leggings, painted buckskin garters hung
with fawn hoofs, and buckskin moccasins.
He also wears a beaded throat necklace
and a breast necklace of horse teeth, and
he holds a stone pipe with a wooden stem;
looped over his forearm is a buckskin
tobacco pouch. This is not the style of
everyday clothing worn in 1910.

The Provincial Museum of Natural
History (Royal BC Museum) purchased
several Valient Vinson photographs taken
for James Teit at Spences Bridge in
1910. Teit almost certainly provided the
detailed description that accompanies this
photograph.

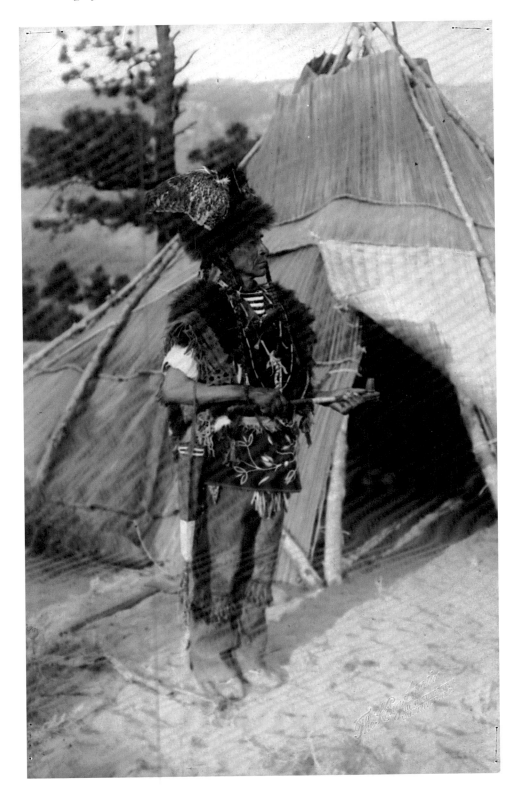

hundreds of full front, three-quarter and full profile views of Nlaka'pamux (Thompson), Stl'atl'imx (Lillooet), Secwepemc (Shuswap) and Okanagan people dressed in contemporary and traditional clothing (see page 128-29) Many of these have been reproduced in a catalogue edited by Leslie Tepper and published by the Canadian Museum of Civilization. Teit also took photographs using nitrate-film negatives during the two seasons of fieldwork he conducted in 1912 among the Tahltan and in 1915 among the Tahltan and Kaska Dena.

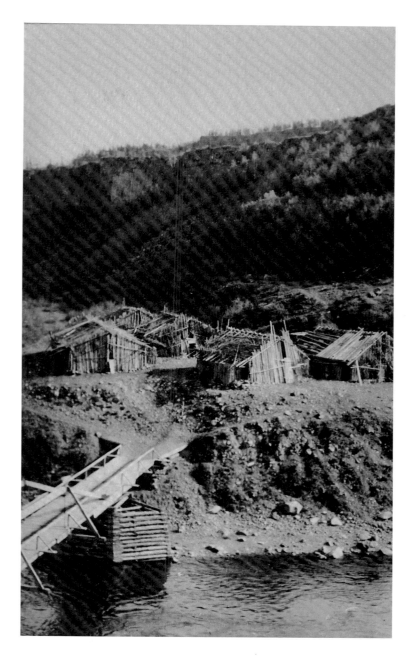

Houses at the mouth of the Tahltan River.
James Teit, September 1912.
Transparency from an inter-negative of the original 4×5-inch nitrate negative.
CMC 19454.

In his 1911 book, *The Tahltan Indians*, George Emmons described this fishing village: "The houses are built of upright saplings stuck in the ground and bound together with rope of twisted bark and roofed with [poles or] slabs of spruce bark."

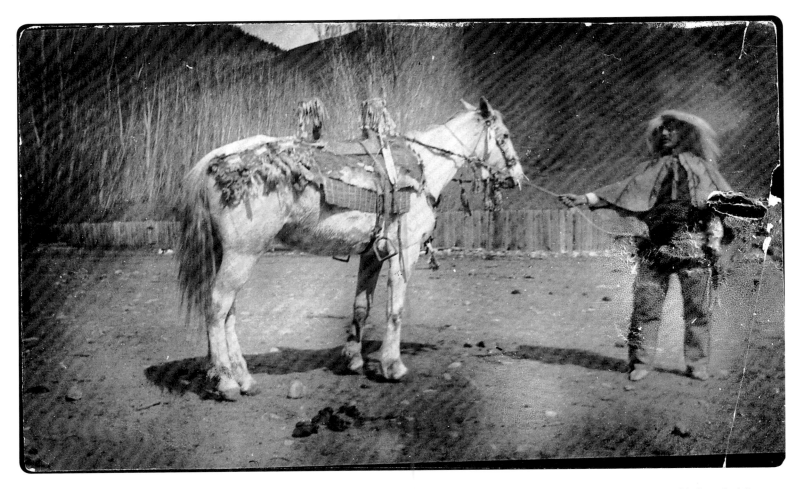

Nlaka'pamux people in traditional clothes at Spences Bridge.

Like Edward Curtis, James Teit understood that the cultures of First Peoples were changing and felt compelled to re-create the traditional past in some of his photographs. Nlaka'pamux (Thompson) people ordinarily dressed in contemporary Euro-Canadian clothing, yet Teit believed that the ethnographic photo album that he was creating for Edward Sapir should include photographs of people dressed in traditional costumes. His solution was to rely on his extensive personal collection and he probably provided the Nlaka'pamux men and women who appear in these photographs with all or part of their costumes. The quoted descriptions beneath each image on the facing page were written on the backs of the photographs, likely by Teit. Few historical photographs have such detailed descriptions.

"Thompson Indian in old dress holding horse with old style Indian bridle, saddle, saddle blankets, crupper & quirt."
James A. Teit, 1912–18.
Original photograph. PN 6708.

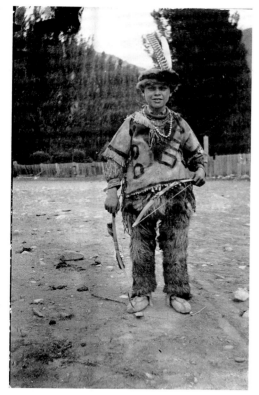
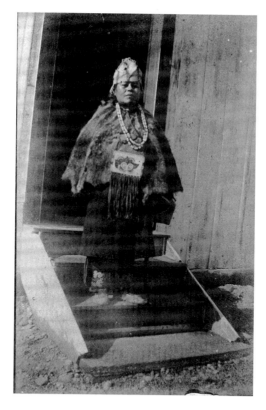
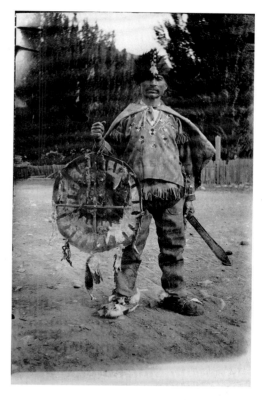

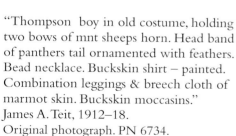

"Thompson boy in old costume, holding
two bows of mnt sheeps horn. Head band
of panthers tail ornamented with feathers.
Bead necklace. Buckskin shirt – painted.
Combination leggings & breech cloth of
marmot skin. Buckskin moccasins."
James A. Teit, 1912–18.
Original photograph. PN 6734.

"Thompson woman in old dress holding
birch bark basket & beaded buckskin bag
suspended from neck (tobacco pouch)
necklace of beads & shells. Poncho of
marmot skin. Cloth skirt & blue cloth
leggings embroidered with beads. Buckskin
moccasins & buckskin cap."
James A. Teit, 1912–18.
Original photograph. PN 6736.

"Thompson man in old dress, holding
skin shield & war knife-club of iron
(machete or sword). Wolf skin head band
ornamented with hawks feathers. Buckskin
shirt ornamented with coloured silk.
Buckskin fringed breech cloth. Buckskin
leggings & sheepskin moccasin & buckskin
cloak."
James A. Teit, 1912–18.
Original photograph. PN 6749.

Expositions

Expositions such as the World's Columbian Exposition (Chicago 1893), the Louisiana Purchase Exposition (St Louis 1904), the Lewis and Clark Centennial Exposition (Portland 1905), and the Alaska Yukon Pacific Exposition (Seattle 1909) provided opportunities for photographing northwest-coast First Nations dance performances and exhibitions of totem poles, house types and crafts.

Among a collection of snapshots held at the Royal BC Museum are four that record X̱ixanus (Bob Harris), a Kwakwa̱ka'wakw artist and dancer, performing as a *hamat'sa* (cannibal dancer) on an elevated wooden stage in St Louis (page 133). Although the images are not well focused (the dancer's movement is captured clearly in only one) and

the dancing is outside the traditional setting of a big house during the Winter Ceremonials, these are significant images because they are the earliest extant photographs showing the movements in sequence of a live northwest-coast dance performance. They are refreshing and spontaneous when compared to posed photographs, such as John Grabill's static photograph of David Hunt performing as a *hamat'sa* at the World's Columbian Exposition in 1893 (page 132).

In his 1982 essay "The Northwest Coast Collections: Legacy of a Living Culture", Peter Macnair gives a concise description and explanation of the *hamat'sa* and refers to a performance by X̱ixanus and his Nuu-chah-nulth associates in St Louis.

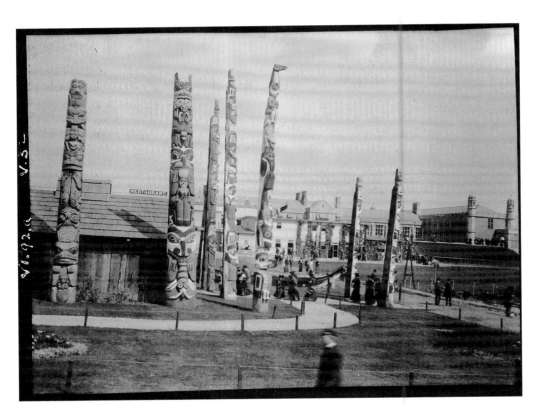

The Louisiana Purchase Exposition, St Louis, Missouri.
Charles F. Newcombe, 1904.
Direct duplicate negative. PN 11820.

This is one of the few candid snapshots showing fairgoers visiting First Peoples exhibitions at major expositions during this era. Tlingit and Kaigani Haida totem poles, as well as a northern-style canoe, stand in front and to one side of a quasi-Tlingit house. This exhibition was part of Alaska's contribution to the Louisiana Purchase Exposition in association with the Alaskan Building, which stood next to it but does not appear in this photograph.

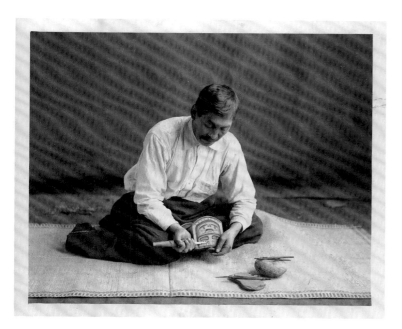

X̱ix̱anus demonstrating a carving technique at the Louisiana Purchase Exposition in St Louis.
Charles Carpenter, 1904.
Black-and-white recent print. FM 13572.

Authenticity is sometimes compromised for the sake of producing an eye-catching photograph. This staged photograph shows X̱ix̱anus (Bob Harris) demonstrating the final surface trimming and smoothing of a bent-corner wooden bowl. But this work would have been completed *before* the bowl was painted.

Charles Carpenter's last field assignment as staff photographer for the Columbian Museum of Chicago (Field Museum) was the Louisiana Purchase Exposition. He took more than 3,000 photographs using dry glass-plate negatives, including portraits of Geronimo, X̱ix̱anus and Charles Nowell.

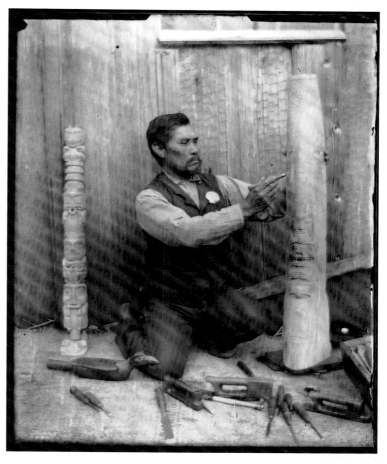

Chief ʔAtɬyo and a carving in progress at the Nuu-chah-nulth village of Opitsat.
Reverend William Stone, 1904.
Black-and-white contact print
from a dry glass-plate negative. PN 17768.

Although staged, this photograph accurately demonstrates a carving technique. Chief ʔAtɬyo uses a straight-bladed knife or awl to score a design on a carving, possibly made of whale bone. Later that year, Charles Carpenter photographed the finished carving at the Louisiana Purchase Exposition in St Louis (not shown in this book).

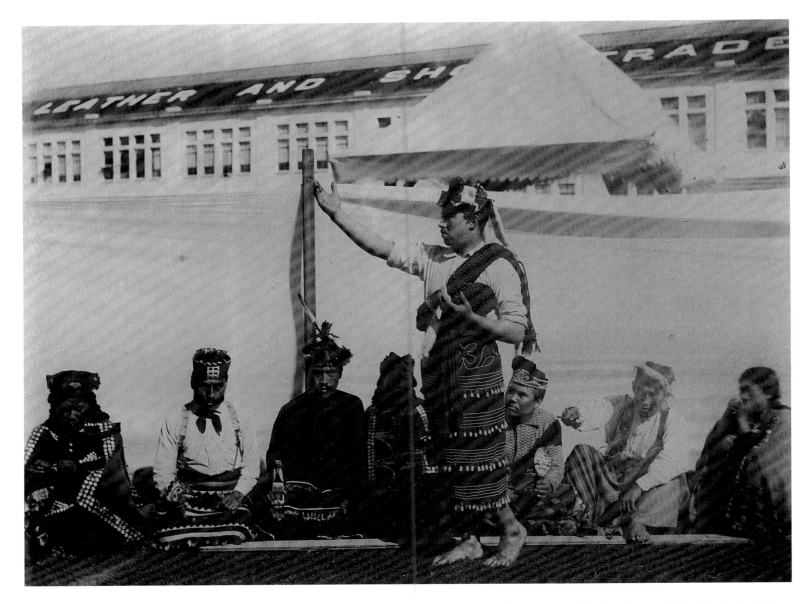

Hamat'sa pose at the World's Columbian Exposition, Chicago.
John Grabill, 1893.
Original photograph. PMAE N 29641.

Compare this photograph showing David Hunt's static pose demonstrating a movement of the *hamat'sa* (cannibal dance) with the series of snapshots on the facing page. The type of camera and negative that John Grabill used to take this photograph required Hunt to pose rigidly. Grabill probably used a dry glass-plate negative in a view camera set on a tripod. He would not have been able to change plates quickly enough to capture the spontaneity of movement that a hand-held Kodak camera could.

The Leather and Shoe Trades building in the background establishes that Grabill took this photograph beside the composite village shown on page 135.

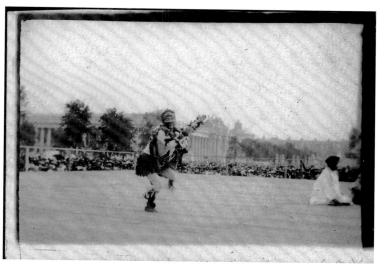
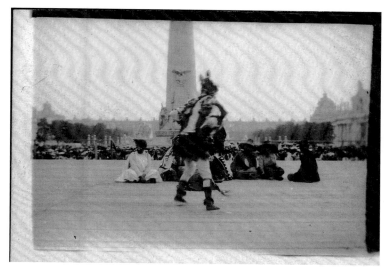
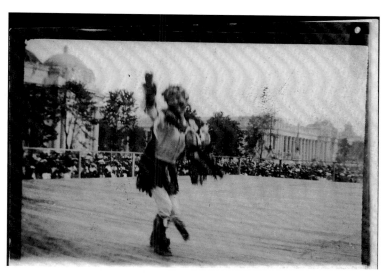

Hamat'sa performed at the Louisiana Purchase Exposition, St Louis, Missouri.
Unidentified photographer, 1904.
Original photographs. PN 2616-19.

X̱ix̱anus (Bob Harris) performs as a _hamat'sa_ (cannibal dancer) on a large, elevated wooden stage. This is one of the potlatch dances associated with the _t'seka_ or Winter Ceremonials. This set of images is the earliest surviving photographic sequence of a live First Nations dance performance from Canada's west coast. At least seven Kwakwa̱ka'wakw and Nuu-chah-nulth artisans and performers accompanied Dr Charles Newcombe to the Louisiana Purchase Exposition in 1904.

Charles Nowell, a member of the group, in his biography, _Smoke From Their Fires, The Life Of A Kwakiutl Chief_ (Ford 1941:188), wrote, "People come with Kodaks taking our pictures; the guards couldn't keep them away."

The Royal BC Museum catalogued these four snapshots with numbers that were out of sequence, but Chief Henry Seaweed put them in the correct order, as shown here (clockwise starting at the upper left corner).

Archer & Sons view camera.
Rick Noakes, January 2009.
Digital image.

This is the type of view camera that Walter Massey refers to in his account of a visit to the World's Columbian Exposition (right). Although smaller than their counterparts used from 1860 to 1890, these cameras were considerably more cumbersome than hand-held cameras. "Commercial photographers ... preferred these heavy, bulky instruments because they required large glass-plate or sheet-film negatives that created crisp, clear, detailed prints" (Bogdan and Weseloh 2006:79).

BC coastal First Nations "village" at the World's Columbian Exposition, Chicago.
A.J. Rota, 1893.
Black-and-white recent print.
AMNH 322897.

During the World's Columbian Exposition held in Chicago in 1893, the monumental carving and architecture of British Columbia's coastal First Peoples were presented to visitors in a composite "village" facing a small inlet on the fairgrounds built on the shore of Lake Michigan. Although the poles and houses were authentic, shipped from BC's coast to Chicago, they were drawn from three distinct cultures. This amalgam of carving and architecture did not exist in any one coastal village.

This photograph shows (left to right): a Haida house and its frontal pole from Hlragilda 'Illnagaay (Skidegate), with two more Haida poles; a Kwakwaka'wakw house from X̱wa̱mdasbe', Hope Island, its front painted with Thunderbird over the door and the sun on each side; and two Nuxalk monumental carvings, a bear and a house frontal pole.

The shadows of fair visitors leaning against a railing can be seen in the right foreground. They are probably waiting for George Hunt, standing in front of the bear carving, to introduce the Kwakwaka'wakw men and women who had been hired to perform at the fair.

Some of these spectators may have been amateur photographers who were required to pay a considerable fee for the right to take photographs at the exposition. Walter Massey (1894:6-10), a Canadian visitor, noted the measures that officials took to protect the rights of the holder of the commercial photography concession:

> Scarcely had I passed the turnstile when two men, noticing the black case in my hand – at once suspecting it to be a camera – demanded to know if it were. On my answering in the affirmative, a fee of $2.00 was ordered to be paid, this fee entitling me to the use of the camera for one day, and that, too, under rigid restrictions. Among other things, no camera is allowed which takes a view over 4×5 inches ... and worst of all no "tripod" or stand can be used.
>
> [The] much used "permit" (which I at last tied to the camera handle ...) had to be produced no less than eight or ten times that day, if not more ... [transgressors] have been given a free ride in a patrol wagon – all for the dreadful crime of taking a few photographs.

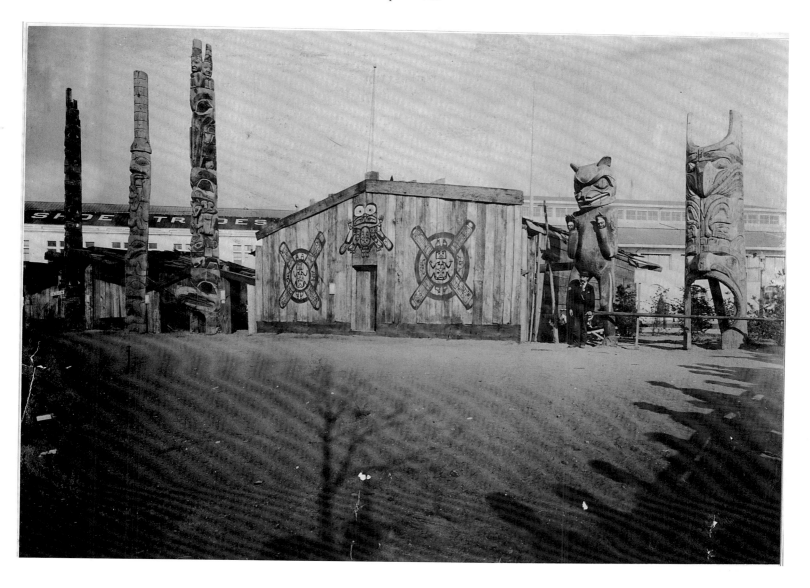

Missionary Photographers

Missionaries in British Columbia and Alaska contributed greatly to the photographic collections in public archives. The Royal BC Museum has 11 collections of photographs taken between 1890 and 1930 by the reverends B.C. Freeman, C.M. Tate, V. Lord, A.W. Corker, W. Stone, J.H. Keen, W.H. Collison, J.B. McCullagh, V.H. Sansum, R.W. Large and C. Proctor.

These collections contain the predictable photographs: a women's sewing circle (below), church interiors, students studying in mission school classrooms, building bees, church brass bands (facing page) and the reverend at his office desk or dispensing medicine or appearing with his parishioners in a group photo (page 138) — all taken to provide visual affirmation of industry and conscientious performance of one's obligations to the church. These images were often produced as lantern slides and used in fundraising lectures presented to distant congregations. Methodist minister Reverend Charles Montgomery Tate (1930:14) reflected on his "furlough" from missionary work among the Coast Salish of Vancouver Island in the late 1890s: "When I reached Toronto a six-months

programme was put into my hands, which meant preaching three times every Sunday, a lantern lecture almost every night of the week, throughout Ontario, Quebec, New Brunswick, Nova Scotia and Prince Edward Island. It took the remaining six months to recuperate."

It is among the unexpected photographs of this genre that the most interesting and informative ethnographic photographs are found. For example, Methodist minister Reverend Barnabas C. Freeman's 1897 photograph of Haida men and women pulling Western Hemlock boughs that are covered with herring spawn into their canoes and skiffs at Skidegate Inlet (page 139). Another example is Reverend William J. Stone's 1904 photograph of Chief ?Atłyo at Opitsat using a straight-bladed knife to scribe the design on a carving (page 131, right). This candid photograph holds much more value than the misleading, staged studio view by Charles Carpenter at St Louis during the Louisiana Purchase Exposition the same year that shows X̱ix̱anus (Bob Harris) trimming and smoothing the surface of a bent-corner wooden bowl (page 131, left). Ironically, it is a Carpenter

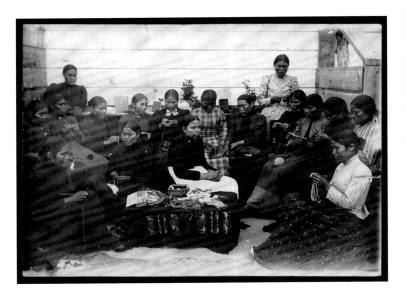

Women's sewing circle, possibly Nisga'a.
Unidentified photographer and location, about 1900.
Original photograph. PN 6637.

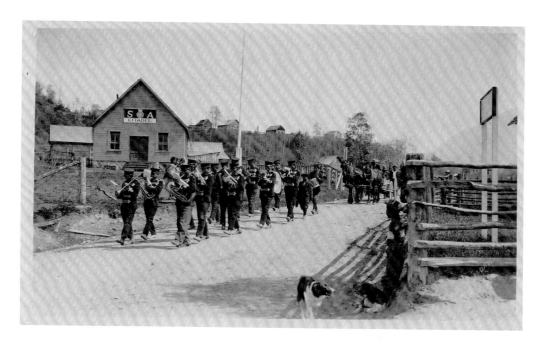

The Salvation Army band at the Gitxsan village of Gitanmaax (Hazelton).
John Morgensen, about 1920.
Copy negative. PN 8013.

Compare the military style uniforms of this band with the First Nations dress worn by Nelson's Cornet Band (below).

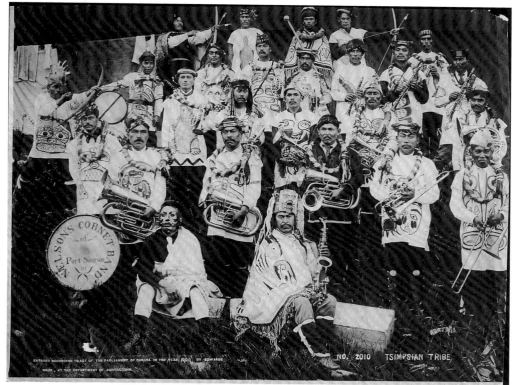

Nelson's Cornet Band in Vancouver.
George and Edgar Edwards,
October 3, 1901.
Original photograph. PN 9331.

Nelson's Cornet Band came to Vancouver, BC, from Lax Kw'alaams (Port Simpson) to perform during the visit of their Royal Highnesses the Duke and Duchess of Cornwall and York. Although someone has printed "1900" at the bottom of the photograph, the correct year is 1901 (Mattison 1982:14).

The band's leader was Job Nelson, probably the man wearing the tie and dark jacket standing in front or the sitting man holding the saxophone (Mattison 1982:15). The musicians wear an assortment of traditional items, including ceremonial neck rings, a painted face mask, a dancing headdress (complete with ermine train), and more recently created canvas interpretations of Chilkat robes and tunics featuring two-dimensional, decorative animal crest figures that were painted by Coast Tsimshian artist Frederick Alexie (MacDonald 1985:209).

photograph, also taken at the St Louis exposition that features Chief ʔAtɬyo standing beside the finished work that Stone had photographed earlier (another Field Museum print, FM 13569, not shown in this book).

Another of Stone's intriguing photographs (also not in this book) was taken inside a big house at Clo-oose. It shows Chief ʔAtɬyo, three other men and a woman behind a painted cloth screen during a council meeting. A framed large-

format, cropped photograph of the celebrated warrior Seta Canim, Chief of the Tla-o-qui-aht, has been placed in front of the screen. In her book *Framing the West, Race, Gender, and the Photographic Frontier in the Pacific Northwest*, Carol Williams (2003:155) comments on the importance of the photograph: "The conspicuous display of Set-Kanim's framed portrait ... secured [his] continued place of honour and respect in the public history of the Clayoquot people."

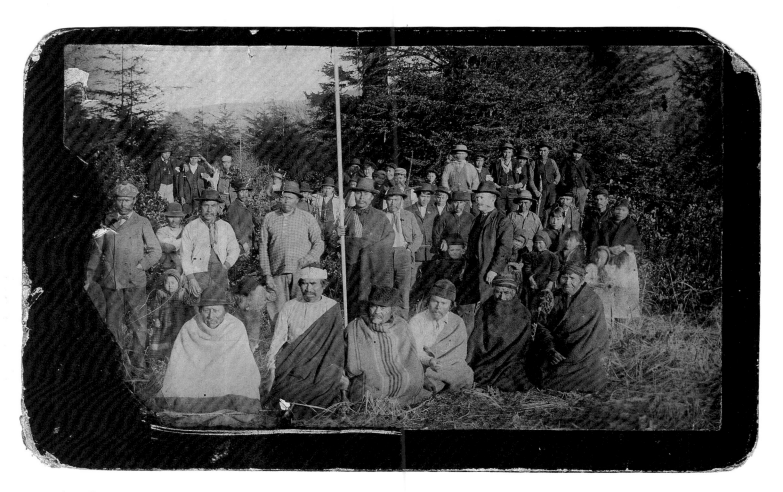

Reverend William Stone and his congregation at the Nuu-chah-nulth village of Clo-oose.
Unidentified photographer, 1896.
Boudoir card. BCA F-08207.

Although taken in an informal setting, this is a rare, formal group portrait of a cleric and his congregation. Most photographs in missionaries' collections show the routine of daily life. Here, the six men in the front row and man in the centre

holding the pole are wearing wool blankets more characteristic of mid-19th-century dress. The two young girls on the right moved their heads during the exposure, so blurring their faces in the photograph.

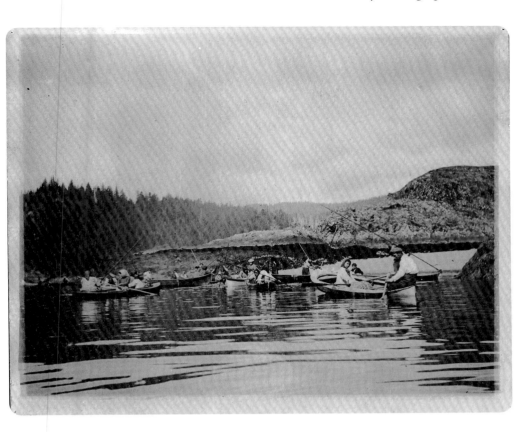

Harvesting herring eggs in Skidegate Inlet.
Reverend Barnabas C. Freeman, 1897.
Original photograph. PN 355.

Haida men and women pull up western hemlock boughs laden with herring eggs. They will cook the eggs or dry them on wooden racks set up on the beach.

Almost all First Nations along the coast of British Columbia used hemlock boughs to collect herring eggs. "During the spawning season, from March to June, people tied the boughs in bundles and lowered them into the ocean near river estuaries. Later, they pulled up the boughs, scraped off the spawn and ate it fresh or dried" (Turner 1998:99).

Drying herring eggs at the Nuu-chah-nulth village of Yuquot.
Harlan I. Smith (possibly), about 1909.
Original photograph. PN 7226.

Hemlock or spruce boughs heavy with herring eggs. Most First Peoples considered hemlock the best material for collecting herring eggs "because it has flexible, easily handled boughs and the needles impart a mild, pleasantly resinous flavour to the spawn" (Kuhnlein & Turner 1991:67). Once the eggs dried they were separated from the boughs, washed and spread over a flat surface to dry again.

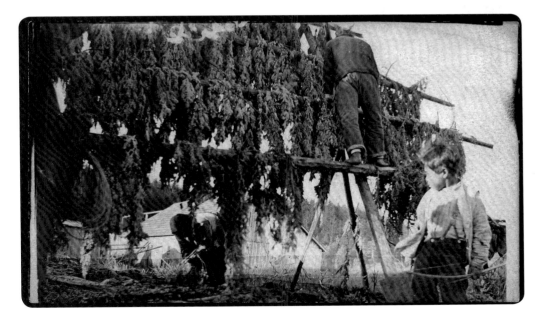

Images from the Likeness House

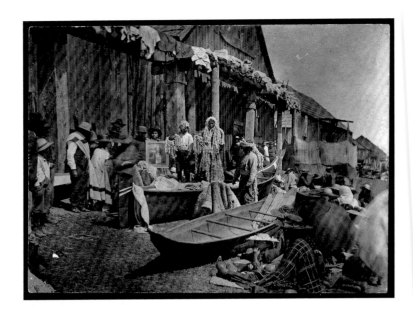

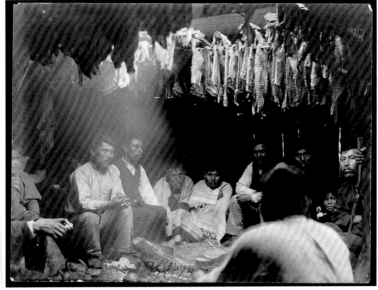

**Potlatch at the Coast Salish village
of Quamichan.**
Reverend Charles Tate, 1913.
Original photograph. PN 1499.

Framed photographs became part of
the ceremonial and political life of First
Peoples. At this commemorative potlatch,
a man standing behind a Nuu-chah-
nulth-type canoe filled with traditional
Salish blankets steadies a framed portrait
of a deceased woman. This is one of three
photographs taken by Reverend Charles
Tate during the potlatch. Homer Barnett
published it in *The Coast Salish of British
Columbia*, calling it "A Cowichan boy and
girl at a naming ceremony".

 Later, the host and his assistants
will throw the Salish and Hudson's Bay
Company point blankets to the guests from
narrow platforms constructed in front of
the houses for this purpose.

Smokehouse, Haida Gwaii.
Reverend Barnabas C. Freeman, 1897.
Original photograph. PN 366.

This is one of the few extant photographs
taken before 1900 inside a building. The
fish hanging from the racks are halibut.
Reverend Barnabas Freeman may have
been able to take this photograph because
of the sunlight entering from a smoke hole
in the low roof. Smoke from the fire has
obscured some of the image.

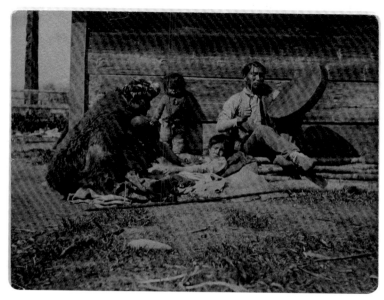

**Reverend William Stone
treating a parishioner.**
Unidentified photographer, 1894–1904.
Black-and-white recent contact print
from a dry glass-plate negative. PN 17774.

Missionaries took photographs to
document their work at their missions. This
posed photograph, probably taken at the
Nuu-chah-nulth village of Clo-oose, shows
Reverend Stone applying medicine with
a swab to the chest of a man identified
as Tsoo-opp. It came to the Royal BC
Museum in 1989 as part of the Reverend
William J. Stone Collection.

**"Shaman practicing on sick boy"
at the Gitxsan village of Gitwangak
(Kitwanga).**
George T. Emmons, 1910.
Original photograph. PN 4192.

George Emmons took at least three
other photographs of either the Gitxsan
shaman or the child leaning against the
wall. Taking these associated photographs
into consideration, I believe that this
photograph was staged. Nevertheless the
shaman is dressed authentically and the
healing practice appears to be realistically
portrayed. The shaman wears a bear-skin
robe and a headdress with a crown of bear
claws, and he holds a carved globular rattle.
His assistant is beating a tambourine drum,
"an essential element in the exorcism of
sickness from a patient's body" (Suttles and
Sturtevant 1990:251).

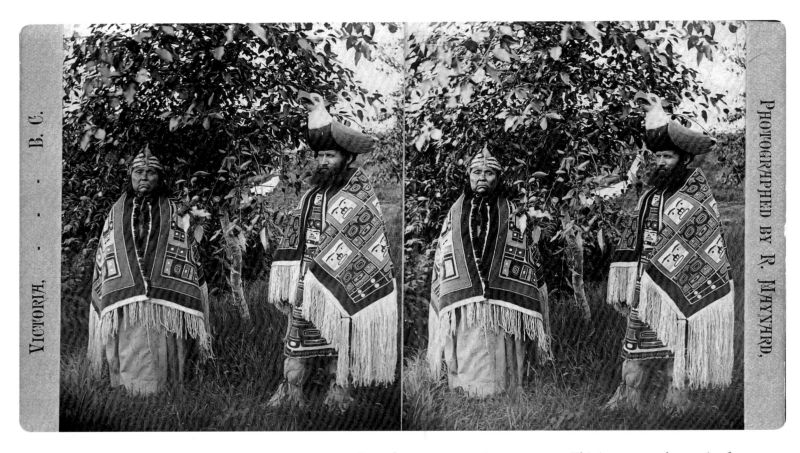

Su-dalth and Reverend Thomas Crosby at the Tsimshian village of Lax Kw'alaams (Port Simpson). Richard Maynard, date unknown. Stereograph. PN 4191.

Su-dalth (Victoria Yonge), wearing a headdress and Chilkat robe, looks directly at the lens of Richard Maynard's stereoscopic camera. *Su-dalth* means "new woman", a reference to accepting Christianity, the "New Way", by the First Peoples of Lax Kw'alaams. Reverend Thomas Crosby, a Wesleyan missionary based in Fort/Port Simpson from 1874 to 1897, wrote that he was fortunate to have the support of this "vigorous and talented Chiefess whose official name was 'Neas-tle-meaque'" (Crosby 1914:383).

This is an unusual portrait of a missionary, because it shows Reverend Crosby dressed in ceremonial regalia. He is wearing a wooden eagle headdress and Chilkat robe, tunic and leggings. Richard Maynard used a dry glass-plate negative to take this photograph.

First Nations Photographers

Most of the photographs related to First Nations in the collections of libraries, museums and archives were created by non-aboriginal photographers. These collections contain so few images created by First Peoples that they remain somewhat removed from the cultures represented in them. Nevertheless, aboriginal photographers made significant contributions to the photographic record.

Toward the end of the 19th century First Nations photographers began to record their communities and cultures on glass and film negatives. Their late arrival in commercial photography may be due, in part, to the considerable expense associated with operating a gallery, but when they took up the medium, First Nations photographers brought a new intimacy to picture taking. Their photographs often reflect a relaxed and candid view of life that was denied to outsiders.

The best known First Nations photographers from this region are George Hunt (the son of a Tlingit woman and English man, and raised Kwakwaka'wakw) and Louis Shotridge (a Chilcat Tlingit), partly because they both took photographs for institutions (Hunt for the American Museum of Natural History and Shotridge for the University of Pennsylvania Museum). Naitesket, a Stl'atl'imx chief from Lillooet (right), outfitted and guided tourist hunting parties, photographed his clients in action. Lesser-known First Nations photographers include Thrift Meldrum, Daniel Quedessa, Shobid Hunter (see photograph on page 147), Benjamin Haldane and Henry Haldane.

Thrift Meldrum, Benjamin Haldane and, possibly, Haldane's cousin Henry were the only professionals among this group. Benjamin Haldane operated a studio in Metlakatla, Alaska; he warrants only half a paragraph in George Davis's *Metlakahtla, A True Narrative of the Red Man* (1904:123): "The village photographer, Benjamin A. Haldane, does not hesitate to work in the cannery when it is running and looks after his picture-making and developing after or before working hours. Mr Haldane is a versatile and talented young man. In addition to being an excellent photographer, he is leader of the village band, and plays the pipe organ in the church."

The back of a card-mounted photograph (page 145) in the Royal BC Museum collection is stamped "Haldane & Bro. Alaskan Photographers. 7 West Street. Metlakahtla, Alaska". It is possible that Benjamin Haldane learned photography from his cousin, Henry. The Haldane photographs in the Royal BC Museum collection were taken at the Nisga'a village of Gitlakdamix and the eulachon processing workings at Fishery Bay on the Nass River (page 172).

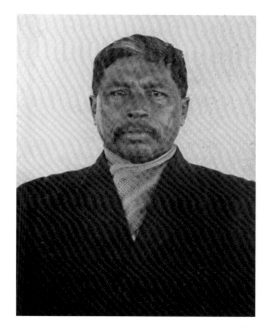

Chief Naitesket of Lillooet.
Unidentified photographer, date unknown.
From (Smith 1914). BCA I-68475.

In 1967 the Royal BC Museum acquired about 60 nitrate negatives from the Cadwallader's store in Tsaxis (Fort Rupert). Most were exposed at 'Yalis (Alert Bay) and Tsaxis, although several are images from the village of Kalugwis on Turnour Island. George Hunt may have taken these images with a Kodak camera that Franz Boas had given to him in about 1900. Most are outdoor group portraits showing people dressed either in contemporary clothing or ceremonial regalia. Almost half of them record some facet of the potlatch. Three were taken at the Kwakwaka'wakw village of 'Yalis during a potlatch given by Tom and Clalas Nowell on the same day in 1900 that Charles Newcombe took a series of eight photographs.

Hunt's photographs are significant not only for their ethnographic content but also because they are his earliest known photographs. The 'Yalis collection contains the earliest published images by a BC First Nations photographer: five, including the bottom picture on the facing page, appeared in an article titled "The Man Who Would Be Chief" by J. Gordon Smith in the October 1902 edition of *The Wide World Magazine*. Hunt's photographs of a potlatch were just the type of exotic images sought by this magazine. The introduction in the first edition proclaimed (Ray 2008:1): "*The Wide World Magazine* may safely be trusted to carry into every home, by means of the infallible camera and the responsible traveller, the almost incredible wonders of the Wide World."

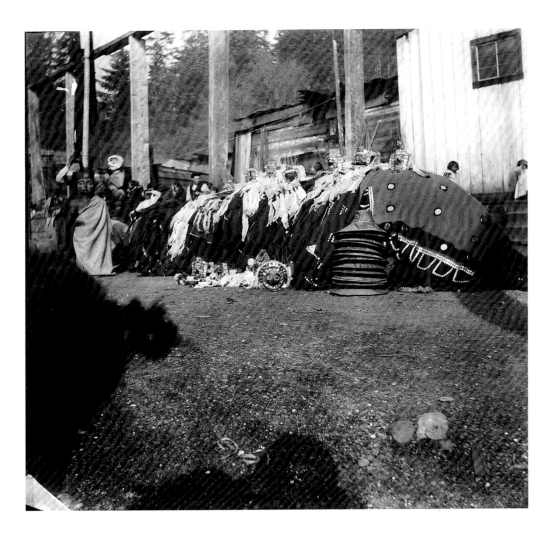

Potlatch goods at the Kwakwaka'wakw village of 'Yalis (Alert Bay).
George Hunt, 1900.
Direct duplicate negative. PN 1078.

Dancing headdresses complete with ermine trains lie on top of piles of button blankets ready for distribution at a potlatch. A stack of 13 spruce-root hats painted with crest figures will also be given away to distinguished guests.

**Nisga'a chiefs at the village
of Gitlakdamix.**
Benjamin A. Haldane, about 1903.
Original card-mounted photograph.
PN 16970.

This rare group portrait of Nisga'a
chiefs from the early 20th century
has considerable ethnographic and
genealogical importance. I am aware of
only one other photograph like this one,
also taken at Gitlakdamix, probably by
the same photographer. I have no doubt
that Tsimshian photographer Benjamin
Haldane was able to take this picture
because of his personal relationship with
the people whose likenesses he captured
– they either permitted or commissioned
him to take this photograph. This
photograph also belongs to that limited
and valued genre of interior views of
traditional late-19th-century houses.

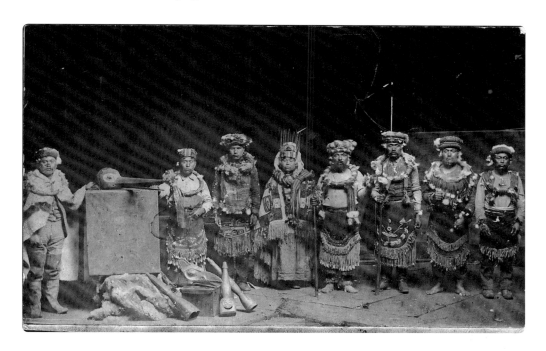

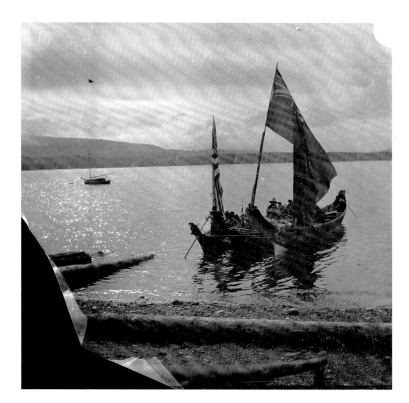

Potlatch guests arrive 'Y̲alis.
George Hunt, 1900.
Direct duplicate negative. PN 1084.

Potlatch visitors approach the shore in two
northern-style canoes and one Nuu-chah-
nulth-style canoe (left). The scene is similar
to Edward Curtis's staged photograph
(taken 14 years later) showing dancers
performing on three canoes (see page 149).
Besides the absence of dancers, this image
differs in one major respect: these potlatch
guests wear the clothing of the day, not
cedar-bark or replica raffia capes, as in
Curtis's photograph.

This is one of the earliest published
photographs by George Hunt; it appeared
in the October 1902 edition of *The Wide
World Magazine*. The original nitrate
negative has been torn and is curling.

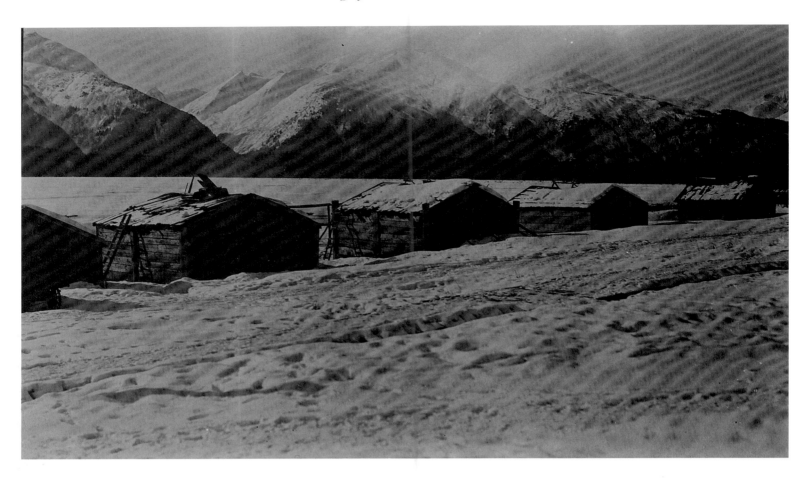

Storage houses in the Tlingit Chilkat village of Klukwan, Alaska.
Louis Shotridge, March 1923.
Copy negative. UPM 15105.

Louis Shotridge returned to Klukwan, the village of his birth, in 1923, when he was employed as an assistant curator at the University of Pennsylvania Museum. Because he used a large-format nitrate negative (5×7 inches), an enlargement of the image shows the details of the houses lining the bank of the Chilkat River, such as how the back walls were constructed. This photograph is among the few ethnographic images from this era taken in the winter.

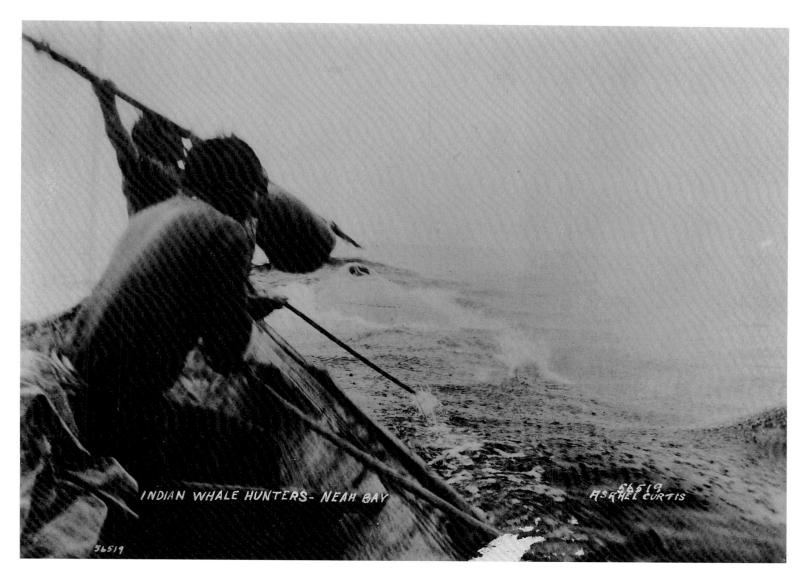

INDIAN WHALE HUNTERS- NEAH BAY

56519
ASAHEL CURTIS

56519

**Makah whalers
near the village of Neah Bay.**
Shobid Hunter (probably), about 1910.
Black-and-white recent print. WSHS 56519.

A Makah whaler is about to thrust a
harpoon into a whale as it surfaces on
the open ocean. The dark object beside
the harpoon shaft is a seal-skin float. It is
attached to a cedar-withe rope, which in
turn is connected to the harpoon head.
The float will slow down the whale and
tire it, then help keep the whale afloat after
it dies. The man in the foreground holds a
lanyard made primarily of whale sinew or
sea lion gut that is secured to the harpoon
head imbedded in the whale from an
earlier strike (Waterman 1920:34).

Although Asahel Curtis's name
appears on the face of the print, he did
not take this photograph. A letter from
the Washington State Historical Society
states: "He [Curtis] copied an existing
photo using 5×7 nitrate film in 1930 …
numbered the negative and added it to his
collection." It's likely that Shobid Hunter,
a Makah, took this photograph, because
the Makah only allowed First Peoples on a
whale hunt (Marr 1989:61).

Cine Film

The photographic imagery produced from 1860 to 1920 was dominated by the still picture, but at least three extant cine films contain footage of First Nations cultures in this region.

The first of these was made more by happenstance than design. In the summer of 1910 a crew from the Edison Manufacturing Company produced a documentary entitled *The Life of a Salmon* for the Canadian Pacific Railway. This film includes footage of a Coast Salish canoe race in Victoria's Inner Harbour. Why the filmmakers chose to show a canoe race in a documentary film on salmon is unclear. Perhaps it was because the race starts in front of the Empress Hotel, a Canadian Pacific Railway hotel opened just two years before the making of the film. Lasting about 90 seconds, this part of the film follows the canoes along the Gorge Waterway and its intertitle (the words that appear on the screen in a silent movie) calls the event "Canoe races between Indians employed in the canneries". The three 11-man crews were probably drawn from Coast Salish communities on southern Vancouver Island. The film shows actors posing as excited racing enthusiasts, the obligatory scene of a starting pistol and the awarding of a cash prize to the head of the winning crew. This is the earliest surviving film footage of First Peoples in British Columbia.

In the same year, Edward Curtis began formulating plans to produce a silent motion picture that would feature the theatrics of the Kwakwa̱ka̱'wakw of northeastern Vancouver Island. John Pierpont Morgan's five-year commitment to fund Curtis's fieldwork was nearing its end (see page 110) and Curtis realized that he had to secure another source of income. With the financial backing of Seattle businessmen, Curtis formed The Continental Film Company in 1912 "… for the making of commercial motion pictures of the Indian and the Indian life" (Holm and Quimby 1980:113). *In The Land of the Head Hunters* became the first full-length documentary motion picture of aboriginal North Americans. A story of love and revenge, it was a "combination of anthropology and Hollywood melodrama" (Russell 1999:99). In

the summer of 1913 Curtis travelled to northern Vancouver Island to begin preparations for the film that was shot in the spring and summer of the following year.

He faced the same challenge in making his motion picture as he had in his stills: how to represent First Nations cultures prior to European contact more than 135 years afterwards. To accomplish this he reconstructed a facsimile of a lifestyle that no longer existed. Among the film props were a "village" made of five house fronts built on Wazulis (Deer Island), across the water from Tsaxis (Fort Rupert), and an interior set of a house at Ba'a's (Blunden Harbour). Curtis produced and directed the film, and wrote the storyline and text with the help of the Kwakwa̱ka̱'wakw (*Strand* 1915:109, Holm & Quimby 1980:57). Curtis did not have a free hand with the film's production. In an interview published in the August 1915 American edition of *Strand Magazine*, he stated: "It was utterly impossible … to get any Indian to wear a mask to which by birth and tribal custom he was not entitled. Other little difficulties, too numerous to mention – in themselves trivial, but requiring marvellous tact to handle – cropped up every day." In the same interview, he acknowledged George Hunt's contributions to the film: "This man gave me a great deal of help and assisted me in overcoming scruples which every 'actor' and 'actress' raised a dozen times a day. Before we settled upon any performer we had to establish the fact that that particular person was entitled to perform the part according to tribal rules and customs."

In The Land of the Head Hunters starring its all-First Nations cast opened in New York and Seattle in December 1914. But the film never attained financial success and the World Film Corporation stopped its distribution in 1916. In January 1924 the American Museum of Natural History bought the master print and negative from Curtis.

In 1973 Bill Holm and George Quimby of the Thomas Burke Museum (University of Washington) produced a reworked version of the film, calling it *In The Land Of The War Canoes*. In their book *Edward S. Curtis in the Land of*

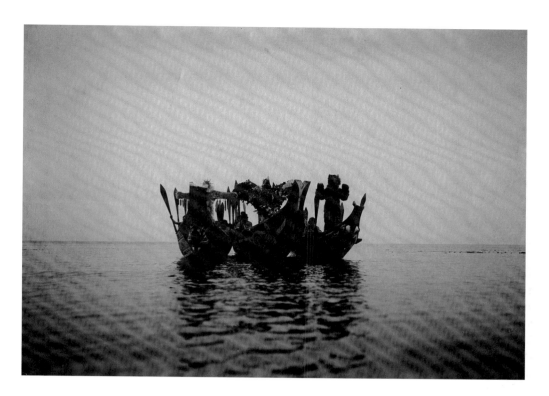

"Masked Dancers In Canoes –
Qagyuhl" near the Kwakwaka'wakw
village of Tsaxis (Fort Rupert).
Edward S. Curtis, 1914.
Original photograph. PN 16920.

Edward Curtis took this still photograph
during the filming of the motion
picture *In The Land Of The Head Hunters*.
Kwakwaka'wakw dancers dressed as (left to
right) Wasp, Thunderbird and Grizzly Bear
perform on wooden platforms set across or
inside the gunwales of three canoes. The
paddlers are wearing old-style cedar-bark
clothing or replica raffia capes that portray
a way of life of an earlier era.

The canoe on the right is the
same one that Charles Newcombe
photographed in Knight Inlet the year
before (shown on next page).

the War Canoes, Holm and Quimby (1980:65) explain their
decision to change the title: "The original title put undue
emphasis on what was actually a minor if visible and spec-
tacular aspect of Kwakiutl life. No doubt Curtis saw a box
office advantage in the reference to headhunting, but the
implication is that the custom was more important than it
actually was. There was neither a headhunting cult nor elabo-
rate reutilization of head-taking among the Kwakiutl. Heads
were war trophies, not central features of ceremonialism. On
the other hand the canoe was not only central to Kwakiutl
traditional life, but is directly or indirectly part of every scene
in the film."

Unlike the original, the 1973 version has a sound-
track. It features Kwakwaka'wakw elders, three of whom
were actors in the original film, singing songs and speaking
dialogue recorded at the Royal BC Museum. The refur-
bished film also had new intertitles (and fewer of them), a
speed of 24 frames per second instead of the original silent-
film speed of 16 frames per second, and a scene that the
Kwakwaka'wakw elders remembered as having been shot but
not included in the original film.

The third cine film showing First Peoples before 1920
was produced by A.D. Kean, "cowboy photographer of
BC", called *The North British-Columbians Warden's Warriors.
102nd Batt. C.E.F. Historic Departure*. Kean shot the film in
1916 near Comox to document the battalion's departure for
Europe during the First World War. Half way through the
film is a short piece of footage documenting an aboriginal
women's horse race held on Dominion Day 1916.

1920s Cine Film

Even though the 1920s are outside the scope of this book
I think it important to acknowledge the increased produc-
tion of films with First Nations content in British Columbia
during this decade and provide a brief description for each.
George Hunt and Tsaxis (Fort Rupert) were two of the con-
stants during this period of filmmaking. Both figured promi-
nently in the Curtis film, in Pliny Goddard's 1922 field work
towards producing a documentary for the American Museum
of Natural History and in Bernard E. Norrish's Associated

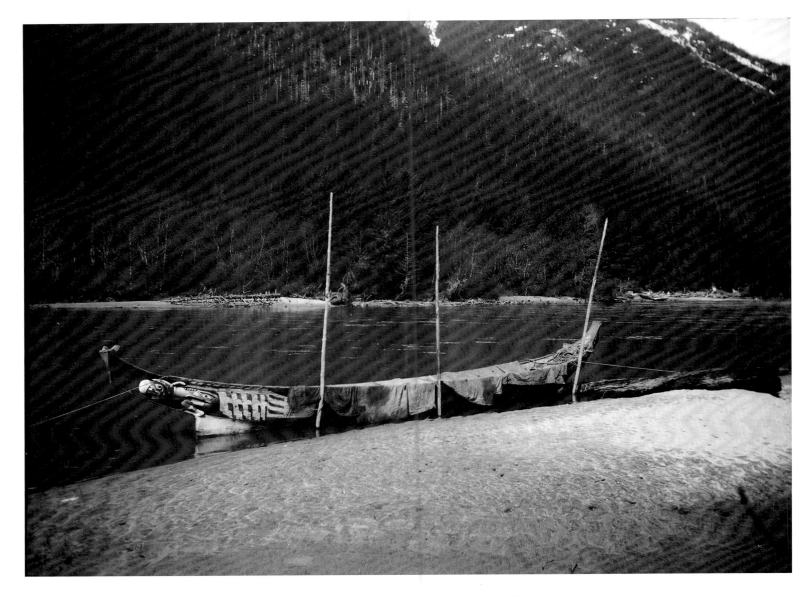

Canoe at Knight Inlet.
Charles F. Newcombe, April 20, 1913.
Direct duplicate negative. PN 50.

The sheets draped over this canoe
prevented it from developing cracks by
drying in the sun. Although the three-
dimensional Thunderbird design on its
bow is Nuxalk, the canoe itself was made
on Haida Gwaii (Queen Charlotte Islands)
and probably acquired by trade or as a gift
(Kopas 1970:144).

The year after Charles Newcombe
took this photograph, Edward Curtis used
the canoe as a prop in his film *In The Land
Of The Head Hunters*. This shows how
photographs from different collections can
help tell an object's story.

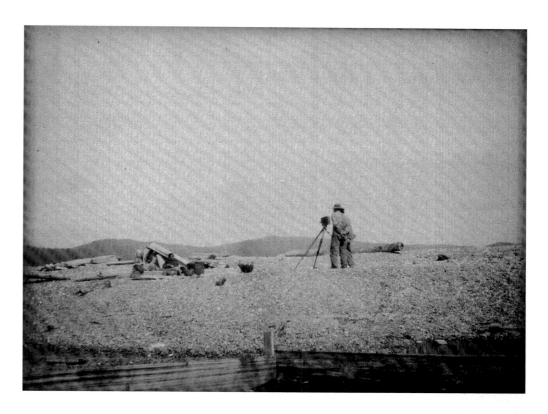

**Filming on the beach
at the Kwakwa̱ka'wakw village
of Tsa̱xis (Fort Rupert).**
Charles F. Newcombe, July 1922.
Direct duplicate negative. PN 6074.

A relaxed George Hunt, hands clasped
behind his back, stands with Pliny
Goddard, curator of ethnology at the
American Museum of Natural History,
on the beach at Tsa̱xis. Goddard used his
movie camera to record Francine Hunt,
George's wife, preparing to cook clams.
 A small amount of cine film was
produced in the second decade of the 20th
century, but it was not until the 1920s
that documentary motion pictures of First
Peoples of this region were produced in
some quantity.

Screen News film *Totem Land*. Goddard filmed both George
Hunt and his wife, Tsukwani (Francine), on the beach at
Tsa̱xis in July 1922 (above). Presumably, some of the foot-
age showed Tsukwani using a bark shredder to separate and
soften the inner bark from a cedar tree, as well as other scenes
of her preparing and cooking clams. Unfortunately, the film
did not survive and stills are the only photographic record of
its content (Jacknis 2000:103).
 Another film genre featuring First Peoples was the
travelogue. Sometime between 1920 and 1923, Pathescope
of Canada produced *Traveltour Of The West Coast of Vancouver
Island*. The silent, black-and-white 35-mm film follows a
steamship as it visits coastal settlements along Vancouver
Island's west coast. Apart from a short scene of the houses at
the village of Yuquot (Friendly Cove), footage at Ahousat,
showing a man using a D-adze to hew out the inside of a
cedar canoe, and women at X̱wa̱tis (Quatsino), making and
selling baskets, this film does not have a great deal to recom-
mend itself. A significant misrepresentation in the film is the
use of plains tepees as graphics on the intertitles that intro-

duce or describe each of the villages visited by the steamship.
 It remained for Harlan I. Smith, Head of the
Archaeology Division of the Geological Survey of Canada,
to create a considerably more accurate ethnographic film
record of coastal and interior First Nations. Smith joined the
Geological Survey in 1911, after working for the American
Museum of Natural History (AMNH) in New York since
1895. While with the AMNH, he worked with James Teit as
a member of the Jesup North Pacific Expedition.
 Smith spent his first years with the Geological Survey
working in central and eastern Canada. In 1919 he returned
to British Columbia and between 1923 and 1929 produced
ten short films on various cultural-linguistic groups, which
David Zimmerly (1974:19) called "...probably the most
complete collection of documentary films on the early life
of ... Northwest Coast Indians". Only seven films survive
today: *The Bella Coola Indians of British Columbia* (1923–24),
The Carrier Indians of British Columbia (1923–27), *Tsimshian
Indians Of Skeena River British Columbia* (1925–27), *The
Shuswap Indians of British Columbia* (1928), *Kootenay Indians*

of *British Columbia* (1928), *Coast Salish Indians of British Columbia* (1928) and *The Nootka Indians of British Columbia* (1928–29). These are housed at Library and Archives Canada in Ottawa, and videocassette reference copies, excluding *The Carrier Indians of British Columbia*, are available to view at the BC Archives in Victoria. The three films that no longer exist are *The Kwakiutl of British Columbia, The Okanagan Indians of British Columbia* and *Lillooet Indians of British Columbia*.

All of Smith's films run 12 to 15 minutes long and follow the same formula. The opening footage shows the Victoria Memorial Museum building in Ottawa, the home of the Geological Survey's Division of Anthropology. Each has a map of British Columbia with a shaded area identifying the land occupied by the featured cultural-linguistic group. The originals are silent black–and–white 35-mm films with intertitles explaining their content. Smith produced the films, but only one (*The Shuswap Indians of British Columbia*) credits Smith as writer of the titles. Like Goddard, Smith took still photographs at the same time as he made some of his films.

Smith made the films to accompany the Victoria Museum's Saturday-morning lecture series (Jessup 1999:22). They show women weaving hats, mats, tump-lines, baskets, blankets and fish traps, gathering roots and berries, stripping cedar bark from trees, scraping hides, and sewing moccasins. They show men carving bent-wood boxes and silver brace-lets, women and men dressed in traditional clothing, men dancing in ceremonial regalia, a painted cloth screen, people salmon fishing and digging for clams, fishing stages, grave-yards, pack dogs, smoke houses and food caches, chalked-in petroglyphs, pictographs, carvers using adzes, people playing gambling games, a canvas tepee, a *kekuli* (semi-subterranean house), a sweat house and a bark lodge.

Smith was an archaeologist, not a professional cinema-tographer. His films contain some clumsy scene transitions and small sections of overexposed footage, but they are informative and the intertitles remain on screen long enough to read them. These ethnographic documentaries do not hide the changes that were taking place in the First Nations communities. In spite of the displacement of traditional lifestyles occurring in the 1920s, Smith's films provide visual evidence that a sizable amount of material culture remained among First Peoples at that time. The tone of the films is largely respectful of the cultures Smith studied, but some of the intertitles contain phrases such as "strange Head-dress" or "grotesque wooden masks". Although Smith is not credited

with scripting these intertitles, he was probably responsible for the final edit.

One of the projects Smith was involved in was the restoration and moving of totem poles at the Gitxsan village of Gitwangak (Kitwanga) on the upper Skeena River. This was a joint undertaking of the National Museum of Canada, the Department of Indian Affairs and the Canadian National Railways, from 1926 to 1928, "to preserve as many as possible of the totem poles of the Gitksans, where they could be seen by the tourists" when they disembarked from the CN trains that stopped at the village (Barbeau 1950:856; page 154). Smith documented part of this project in *Tsimshian Indians of Skeena River British Columbia*. As an experiment in promot-ing tourism it was a success: "the *Montreal Gazette* claimed Kitwanga as the showplace of northern British Columbia and, next to Niagara Falls, the most photographed spot in Canada" (Cole 1985: 272).

Both of Canada's major railway companies had com-mercial interests in conveying tourists by train to their terminals in Vancouver (CPR) and Prince Rupert (CNR). Cooperation between the National Museum of Canada and Canadian Pacific Railway continued via Marius Barbeau, a colleague of Smith's who had also joined the Geological Survey in 1911 as an ethnologist. In 1927 Barbeau was in the field awaiting the arrival of his co-researcher Dr Ernest MacMillan of the Toronto Conservatory of Music when he received a proposal from MacMillan to allow an American filmmaker, Dr James Sibley Watson Jr, to document their research among the Nisga'a. Barbeau wrote the intertitles for the film called *Nass River Indians* produced in 1927. The first intertitle summarized the intent of the film: "A screen recording of the vanishing culture, the rites and songs and dances of the Indians along the Canadian Pacific Coast, north of Vancouver." Another confirmed the influence of Euro-Canadian culture on Nisga'a society: "The ways of the white man – and radio jazz – are sweeping away the old colour of Indian life of British Columbia".

Nass River Indians was produced by Associated Screen News (Canadian Pacific Railway was a major stockholder) for the National Museum at the National Gallery of Canada's 1927 Exhibition of Canadian West Coast Art, Native and Modern. The film has since been lost, though footage and intertitles survived in two shorter films that Associated Screen News recut for commercial release: *Saving the Sagas* and *Fish and Medicine Men* (Jessup 2001:119). Later, Library

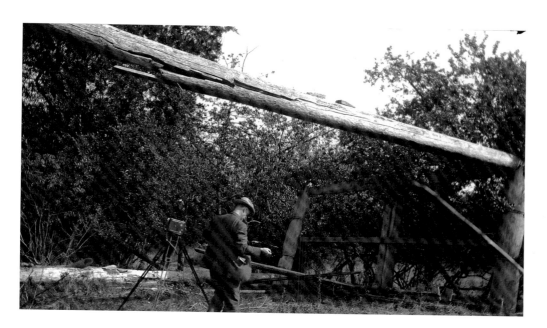

Harlan Smith at the Coast Salish village of Tsawout.
William A. Newcombe, January 9, 1928.
Direct duplicate negative. PN 926.

Harlan Smith stands inside the frame of
an abandoned house at Tsawout on the
Saanich Peninsula, north of Victoria. He
was probably in the process of filming
Coast Salish Indians of British Columbia.

and Archives Canada, with the assistance of Lynda Jessup,
reconstructed *Nass River Indians* from the two shorter films.

Associated Screen News produced a second film
for the CPR, also associated with the 1927 exhibition.
Photographed by J.B. Scott, probably in 1927, and titled by
Terry Ramsaye, *Totem Land* it is part travelogue and part
salvage ethnology. Intended to encourage tourism, it features
the CPR steamship *Princess Maquinna* making its way along
the coast of Vancouver Island and stopping at the Nuu-chah-
nulth village of Yuquot and the Kwakwaka'wakw villages
of X̲watis (Quatsino) and Tsax̲is (Fort Rupert). The film
contains footage of basket making and dancing, predictable
scenes in a film that promoted tourism, but it also includes
scenes of clam digging and harvesting wild carrots, rice and
onions that are of special interest to anthropologists and con-
temporary ethnographic filmmakers. Unfortunately, much of
the film in the copy I viewed is severely underexposed.

The final film from this era that I will comment on was
made by Franz Boas at Tsax̲is in the autumn of 1930. *The
Kwakiutl of British Columbia* almost suffered the same fate as
Pliny Goddard's film shot at the same location eight years
earlier. It was not made into a film until 1973, when the
University of Washington Press published it in 16-mm silent
black-and-white format. Unlike Curtis, who built movie
sets at Wazulis (Deer Island) and Ba'a's (Blunden Harbour)
16 years earlier, Boas did not attempt to reconstruct

Kwakwaka'wakw culture. Many of the scenes were shot on
the beach, in an open field or against the side or front of a
traditional 19th-century cedar-plank house.

This was Boas's last visit to the Kwakwaka'wakw and
he concentrated on traditional technology, showing people
spinning wool, shredding cedar bark, carving wood, weaving
mats and making cedar rope. He also included short scenes
of many types of dances, adult and children's games, as well as
some footage of a female shaman. Parts of the film are under-
exposed and the people are sometimes out of focus, perhaps
because Boas shot the film himself, even though he had
never used a motion picture camera before (Jacknis 1984:9).
His shadow can be seen in the foreground of some of the
frames and there are distractions, such as pet animals walking
into scenes. And, as Stanley Walens explains in his film review
(1978:204), Boas had to contend with more than his own
inexperience: "His wind-up camera limited shot duration to
a maximum of about 25 seconds.... In order to conserve his
limited supply of film, Boas was forced to shoot only a few
seconds of activities ... and to shoot these from only one or
two camera positions when a half-dozen would have best
captured an activity's essential attributes". These frustrating
annoyances aside, *The Kwakiutl of British Columbia* is fairly
well shot and well lit by natural light. It is an extremely valu-
able research tool in visual anthropology.

Tourists admiring carved poles at the Gitxsan village of Gitwangak (Kitwanga).
Unidentified photographer, after 1925.
Real photo picture postcard. PN 8371.

In his 1926 report on his first season of fieldwork restoring the poles at Gitwangak, Harlan Smith wrote:

> The "Out-of-Doors Totem Pole Museum" ... has not only attracted tourists but stimulated the Indians themselves. In 1925, John Laknitz, a Gitksan Indian, opened beside it a museum of ancient Gitksan costumes, musical instruments, and other objects; he played phonograph records taken by himself of Gitksan songs and exhibited photographs of some Gitksan portraits painted by Mr [Langdon] Kihn. (Barbeau 1950:858)

People

Tyee Jim?
John Wallace Jones or
Thomas McNabb Jones, about 1897.
Contact print from a dry glass-plate negative.
PN 1134.

This man has been variously identified
as a Stl'atl'imx chief from Lillooet, a
Nlaka'pamux chief from North Bend,
a Ktunaxa chief, Stó:lo Chief Emmitt
Liquatum and Tyee Jim (the man shown on
the next page).

This image has had a varied and
colourful public life. The original 8×10-
inch dry glass-plate negative resides in the
Anthropology Department at the Royal
BC Museum. Its first known published
use was in R. Gosnell's *The Year Book of
British Columbia and Manual of Provincial
Information* (1897) as the central figure in
a photo montage captioned "Some Indian
Types". A note with the montage reads:
"the Chief of the Kootenais [Ktunaxa],
in modern costume". Later, it was sold
in cabinet-card format as a Christmas
greeting card and again as a coloured
printed picture postcard (see page 157).

Readers who grew up in the
late 1960s may also recognize it as
the centrepiece of the Family Dog
logo that appeared on more than 200
psychedelic posters between 1966 and
1970 advertising Chet Helms's rock
concerts and light shows at the Avalon
Ballroom and Family Dog on the Great
Highway in San Francisco and the Denver
Dog in Denver.

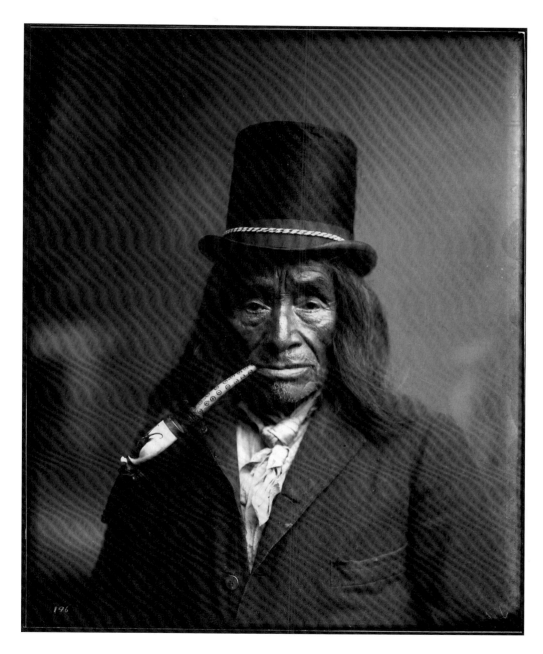

Tyee Jim at Lytton.
Frederick Dally (probably), 1867 or 1868.
Carte de visite. PN 6765.

During one of his two trips to Barkerville
in 1867 and 1868, Frederick Dally
probably made this field photograph using
a wet glass-plate negative. Writing on the
back of this photograph identifies the
man as "Tyhee Jim" (*tyee* means "chief" in
Chinook, a trade language). This may be an
earlier photograph of the man who posed
for the portrait on the facing page.

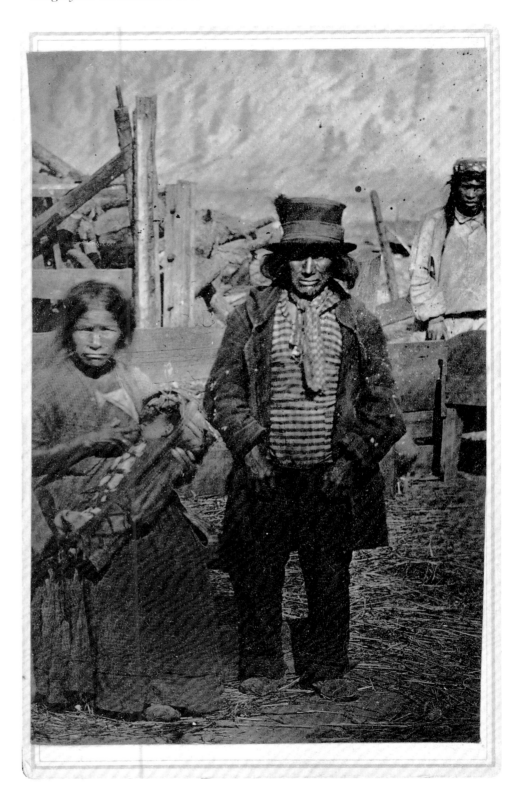

With the Season's Greetings

Indian Chief.

T.N. Hibben & Co. Columbia B.C. No 44

Tyee Jim?
John Wallace Jones or Thomas McNabb Jones, about 1897.
Cabinet card (left) and coloured printed picture postcard. PN 1134.

Many cabinet Christmas cards featured portraits of indigenous people, but it's unusual that this card does not have an imprint advertising the photographer's studio. Perhaps it was published without permission by someone other than Jones & Co. Certainly the photographic print is not the same quality as the contact print made from the original negative (page 155).

The postcard was printed and distributed after 1903 by Victoria bookseller and stationer T.N. Hibben & Co.

The smoking pipe is German, with a locally made stem that replaced the original. The porcelain bowl has a hand-painted image of an ibex-like animal, indicating that it is one of the more expensive pipes called hunters or tankard pipes. The upper stem appears to be a piece of carved antler incised with a First Nations circle-and-dot motif.

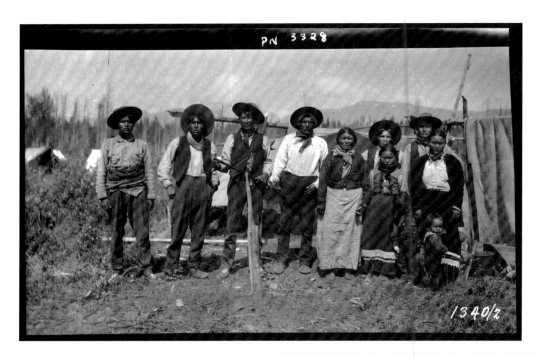

Sekani people at Fort Grahame.
Unidentified photographer, 1914.
Black-and-white recent contact prints
from nitrate negatives. PN 3328, PN 3329.

These photographs came to the Royal BC
Museum from the British Columbia Forest
Service. Fort Grahame was a Hudson's Bay
Company trading post on the Finlay River
in north-central BC. Unfortunately the
people are not identified.

 This community was flooded after the
construction of the W.A.C. Bennett dam
in 1967, so the map on page 8 shows Fort
Grahame in Williston Lake.

**Coast Salish chiefs
at a potlatch in Duncan.**
John Wallace Jones or
Thomas McNabb Jones, 1899.
Black-and-white recent contact print
from a dry glass-plate negative. PN 1142.

The mats hanging against the back wall
blocked wind and rain from entering the
house through the gaps between cedar
planks. The shallow depressions in these
planks indicate that they were roughly
dressed with an elbow adze before the wall
was erected.

Although commercial photographers
had access to flexible nitrate-film negatives
when this photograph was taken, some
chose to take glass-plate negatives into the
field. The photographer used an 8×10-inch
glass plate. Thankfully the chip at the top
of the plate does not extend too far into
the image.

"Indian captain & police, Kamloops."
Unidentified photographer, 1901.
Original photograph. PN 6766.

The title and year (above) are written in
pencil on the back of this photograph. In
his report to the superintendent-general of
Indian Affairs for the year 1901, Kamloops-
Okanagan Indian Agent A. Irwin wrote
about "the appointment of a paid Indian
constable" for the Kamloops Band. This
group portrait shows either more police
than the report acknowledged or that
constables from several bands had gathered
in Kamloops.

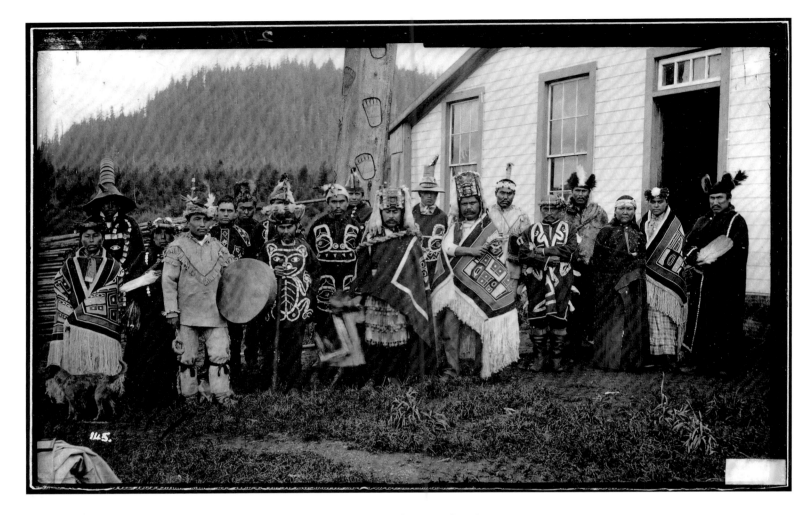

**People at the Tlingit village
of Fort Wrangle, Alaska.**
George T. Emmons, 1885.
Black-and-white recent contact print
from a dry glass-plate negative. PN 11880.

Men and women in ceremonial regalia
pose in front of Dogfish House, Fort
Wrangle. Chief Shakes stands front and
centre wearing a Chilkat robe and holding
a raven rattle in his right hand.

As with many photographs taken
during this era, the people in this group
portrait are not identified. Among the
researchers who use the photographic
collections at the Royal BC Museum are
relatives who can sometimes redress this
situation. For example, a research assistant
at the Sealaska Heritage Foundation was
able to identify her great grandfather, Chief
John Kadashan, as the man holding the
drum in the front row.

Chief Kan-oos-kul-thea (Paul David), possibly at Spences Bridge.
Valient V. Vinson (probably), 1910.
Original photograph. PN 9438.

The catalogue notes for this photograph identify Chief Kan-oos-kul-thea and add more information:

He speaks the Kutenai [Ktunaxa], Blackfoot and Salish languages and has some understanding of Okanagan, Assiniboine and Cree.

Dress: Beaded war bonnet set with tail feathers of the golden eagle and hung with beaded strings and twisted strips of ermine skins. Solidly beaded vest with flower designs. Cuffs, armlets and belt in solid beadwork. Shoulder sash of polished buffalo bones strung on thong. Beaded moccasin, and beaded blanket leggings and breech clout [cloth]. Paul is the eldest son of the noted Upper Kootenay war chief David who led many parties of his tribe out on the Plains buffalo hunting and warring.

The original photograph carries the imprint, "The King Studio, 311 Hastings St. W. Vancouver, B.C." and was probably taken by the same photographer and possibly at the same location as the photograph on page 126.

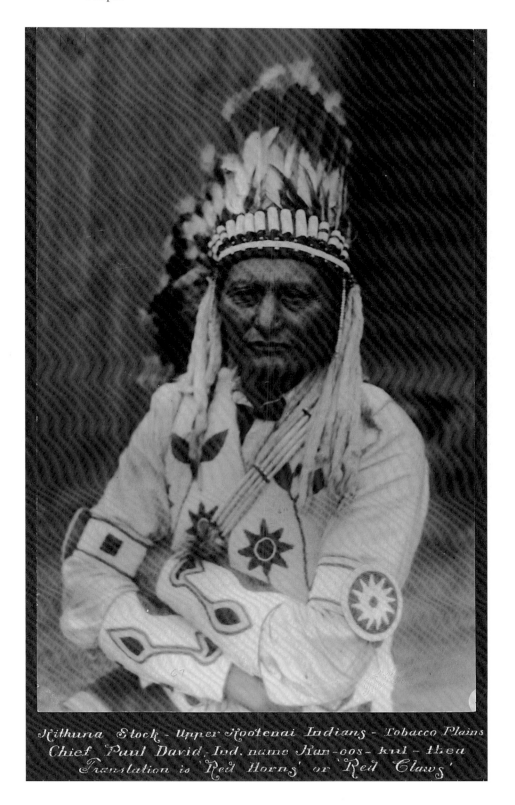

Kithuna Stock - Upper Kootenai Indians - Tobacco Plains
Chief Paul David - Ind. name Kan-oos-kul-thea
Translation is 'Red Horns' or 'Red Claws'

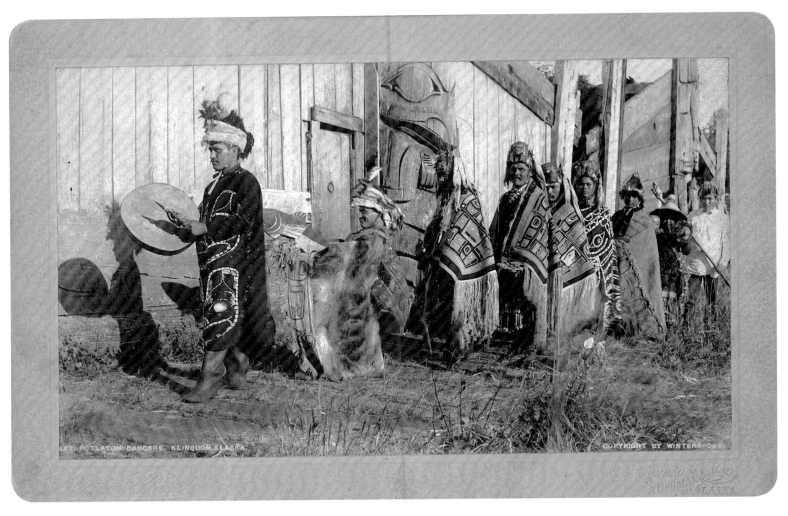

Men in ceremonial regalia at the Kaigani Haida village of Hlanqwaan (Klinkwan), Alaska.
Lloyd Winter and Percy Pond, about 1895. Boudoir card. PN 9197.

This display of ceremonial regalia may have been taken in association with the last potlatch held there before the villagers moved to Hydaburg. Other versions of this photograph can be found in the Alaska State Library and California Museum of Photography. One of these is a stereograph, taken the same day. Winter and Pond simply replaced the camera's mono lens with a stereo lens. Both were made from dry glass-plate negatives measuring 5×8 inches, a size suited for boudoir cards and stereographs.

Haida elders have identified the boy as Ben Duncan and five of the men variously as Robert Edenshaw, Matthew Collison, Edwin Scott, Eddie or Hugo Cogo and Mike George.

Images like this one are important in three ways: as historic photographs of past generations, as connective evidence associating ceremonial regalia with owners and as context for museum pieces shown in the photographs. Of the objects worn or held in this picture, six have been identified as being at the Field Museum in Chicago, one at the Glenbow Museum in Calgary, two at the Canadian Museum of Civilization in Hull, one in Osaka, Japan, and three at the Royal BC Museum.

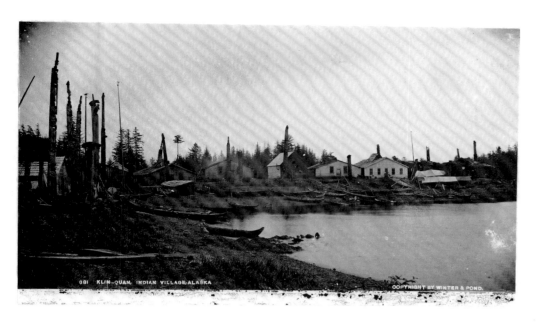

The Kaigani Haida village of Hlanqwaan (Klinkwan), Alaska.
Lloyd Winter and Percy Pond, about 1895.
Contact print from a dry glass-plate negative.
ASL-P87-0090.

Winter and Pond used the same camera to take this partial view of Hlanqwaan as they did for the photograph on the facing page.

Guides,
probably near Telegraph Creek.
Unidentified photographer, 1912.
Original card-mounted photograph.
PN 8711.

The original photograph has little information associated with it. The men in the picture were Tahltan guides hired by American big-game hunters; except for Willie Campbell (second from left), they remain unidentified. The absence of personal information and precise location depreciates the value of such photographs as historical and genealogical records.

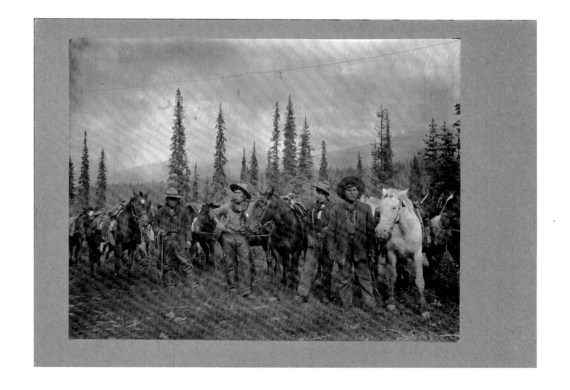

Technology

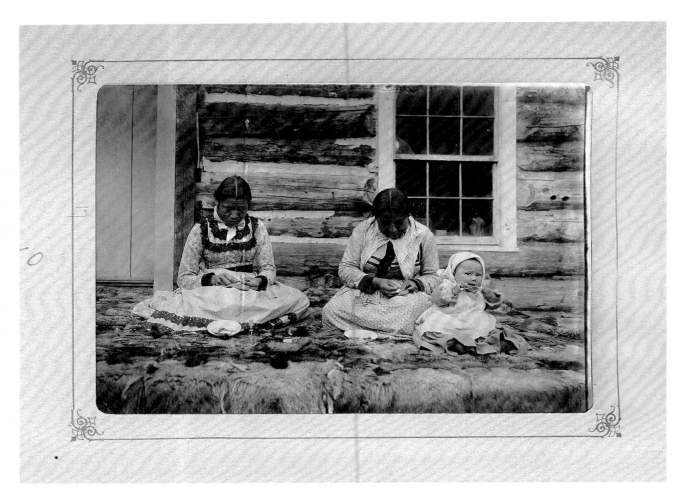

Women at the Tahltan village of Telegraph Creek.
Andrew J. Stone, about 1897.
Original photograph. BCA D-08954.

Two Tahltan women sew moccasins while sitting on pelts in front of a log house at Telegraph Creek. The two small dishes in front of them appear to contain porcupine quills.

Few photographers in this time period documented how things were made. This chapter contains scarce examples of this type of visual record.

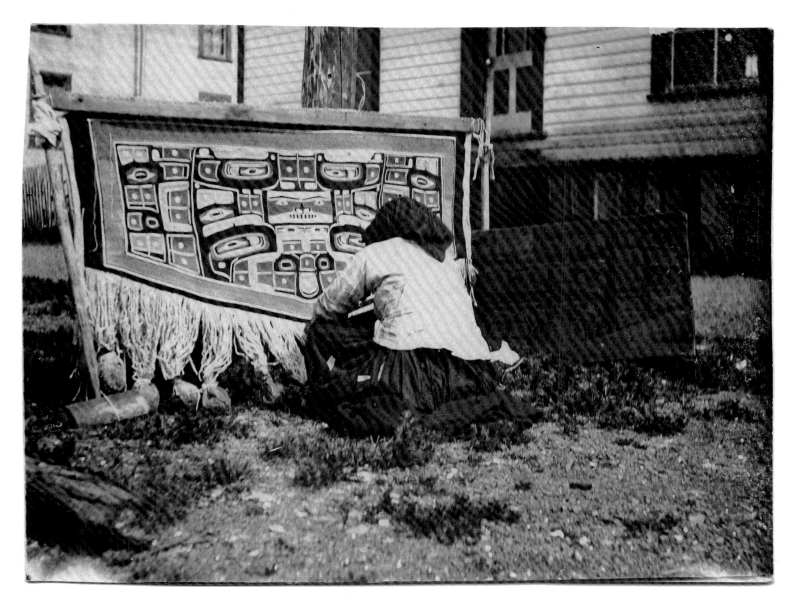

Woman weaving a Chilkat robe at Sitka, Alaska.
George T. Emmons, about 1899.
Original photograph. PN 8637.

This is one of only four photographs that I know of showing a Tlingit woman finger-weaving a Chilkat robe on a single bar loom using a pattern board as a guide. (The most spectacular of these – a stereograph by H.H. Brodeck in the collection of the Presbyterian Historical Society in Philadelphia – shows not only a partially completed robe with a pattern board above it, but a finished robe hanging above the pattern board.)

Men painted the pattern boards for Chilkat robes, showing slightly more than half of the design. Women weavers then reproduced these form-line interpretations of crest figures into a ceremonial robe made of natural and dyed mountain-goat wool and yellow-cedar bark. After completing the robe, the weaver removed the hanging strands from the skin pouches, which kept them clean; the strands serve as the robe's fringe. The Tlingit call these robes *naxein*, which means "fringe about the body".

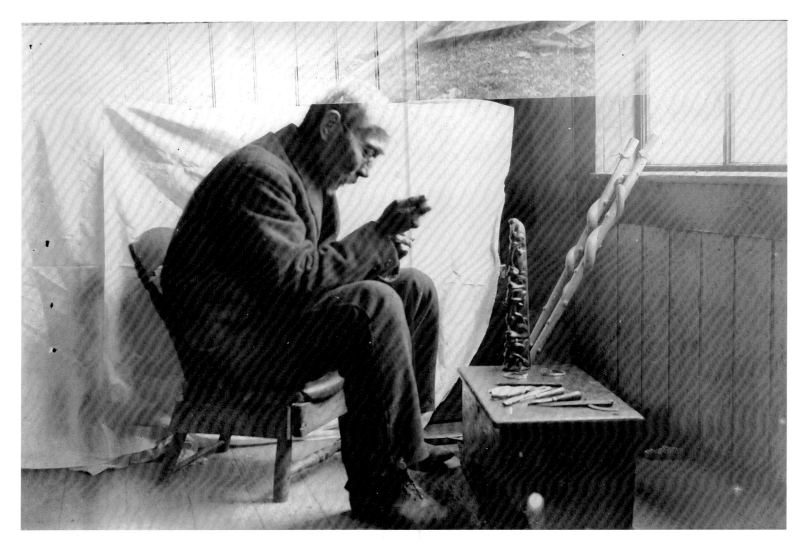

Haida carver Charles Edenshaw at the village of Rad Raci7waas (Massett).
Alfred Carmichael, 1907.
Black-and-white recent print, double exposure. PN 5168.

We cannot see what Charles Edenshaw is carving, but it could be argillite. Edenshaw was a master carver in wood, gold, silver and argillite. Before him stands an argillite model pole beside an array of tools on top of a chest. Argillite is a dense, black carbonaceous shale that Haida carvers still obtain from a quarry on Tllgaduu (Slatechuck) Creek, near Hlragilda 'Llnagaay (Skidegate). For more than a century, it has been made into pipes, bowls, plates, candlesticks, chests, Haida and non-Haida figures, and model poles for trade or sale. It is equally possible that Edenshaw is carving an ivory handle for one of the wooden walking sticks leaning against the window sill.

Initially I thought that the white sheet had been hung as a backdrop to highlight the artist's profile for this photograph. But a catalogue notation for this photograph records the recollection of Edenshaw's daughter, Nora Cogo, that her father always pinned up a white sheet around his work area to contain the dust when he carved argillite.

Edenshaw's head appears a little distorted because Alfred Carmichael exposed the negative twice.

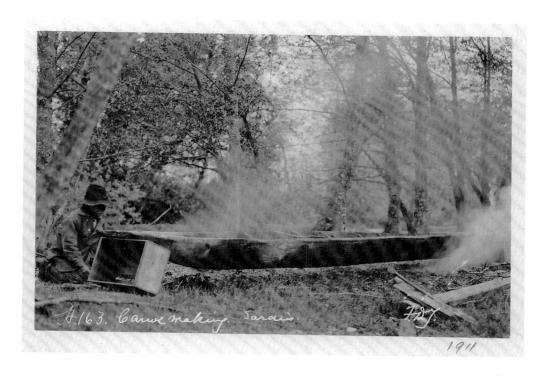

Making a river canoe at Sardis.
F. Dundas Todd, 1911.
Original photograph. PN 6200.

A Coast Salish carver fashions a dugout river canoe. Two fires appear to be burning on the ground beneath the canoe. In his 1975 report on the construction of a Nuu-chah-nulth whaling canoe, Eugene Arima observes:

> The exterior surface had been charred as early as the shaping of the bottom to cut down the reflected glare in order to see the "lumps" better for levelling. As the fine shaping of the hull proceeded, the charred surface of the sides was removed a number of times … so that the scorching had to be repeated.

Though Arima's description refers to another type of canoe, it may explain what is taking place in this photograph.

"Old Andrew camp & Tlingit hunters near Sitka, Alaska."
George T. Emmons (possibly), about 1900.
Original photograph. PN 9142.

Few photographs of hunting camps exist from this time period. The title is written in pencil on the back of the photograph. Two of the men are holding old, mid-19th-century muskets.

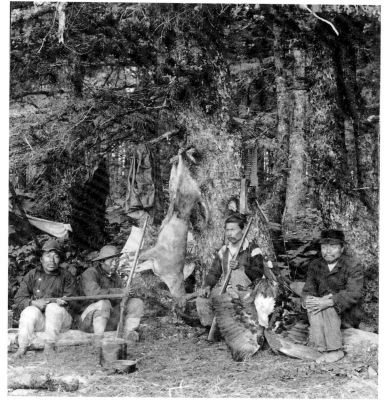

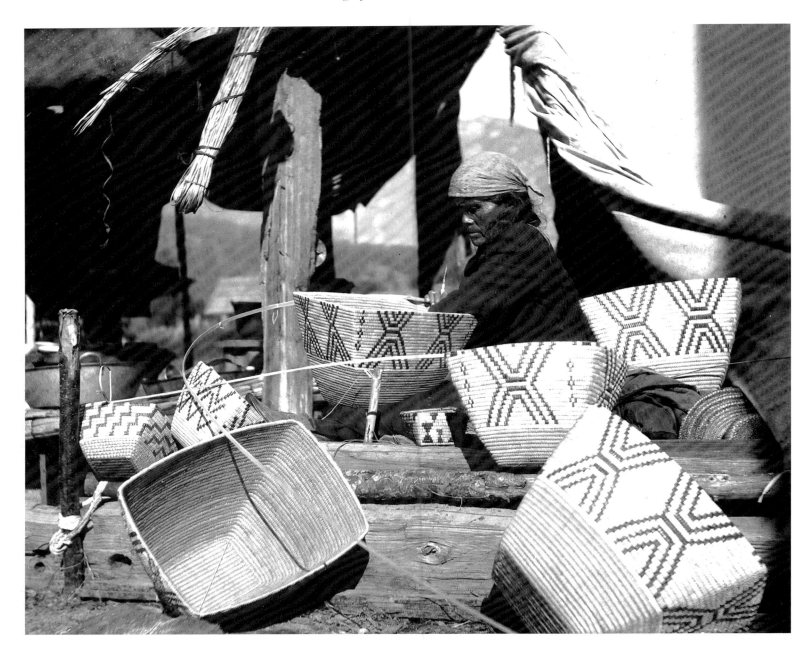

**A woman weaving
a Stl'atl'imx-type basket.**
Unknown photographer and location, 1906.
Direct duplicate negative. PN 6575.

The arrangement of the baskets suggests
that they are for sale. The sale of baskets
was an important economic activity for
First Nations women at this time.

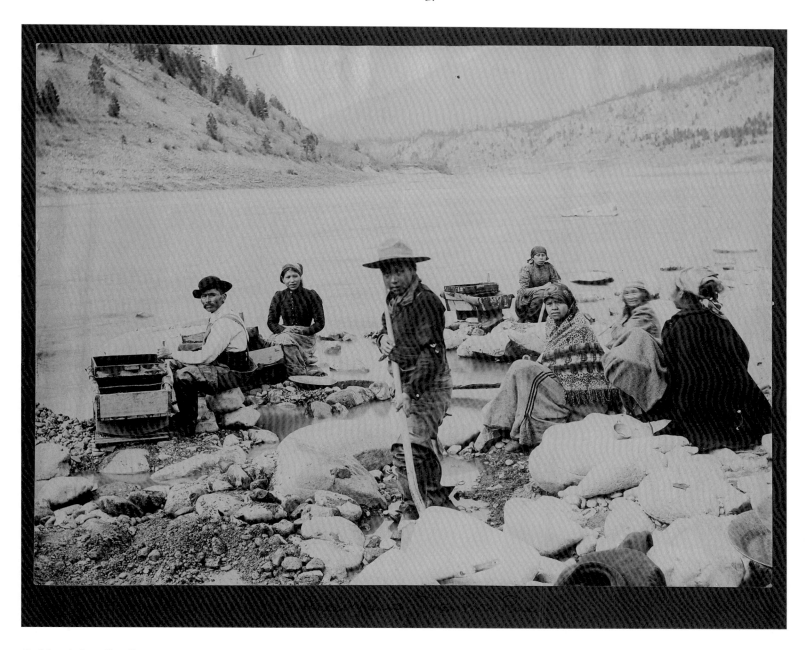

**Gold mining family
on the Thompson River, near Lytton.**
Unidentified photographer, about 1890.
Original photograph. PN 8770.

Meshk N'xetsi (Antoine McHalsie), his wife, Catherine, and her sister, Mary (far right) sit at the water's edge beside rockers used to separate gold from sand and gravel in the water. A gold pan lies at Catherine's feet. First Peoples were very much involved in a cash economy by this date. Compare this photograph of everyday life near the turn of the 20th century with Edward Curtis's images that evoked a sense of a past life. First Nations cultures were changing, not vanishing as Curtis and others mistakenly believed.

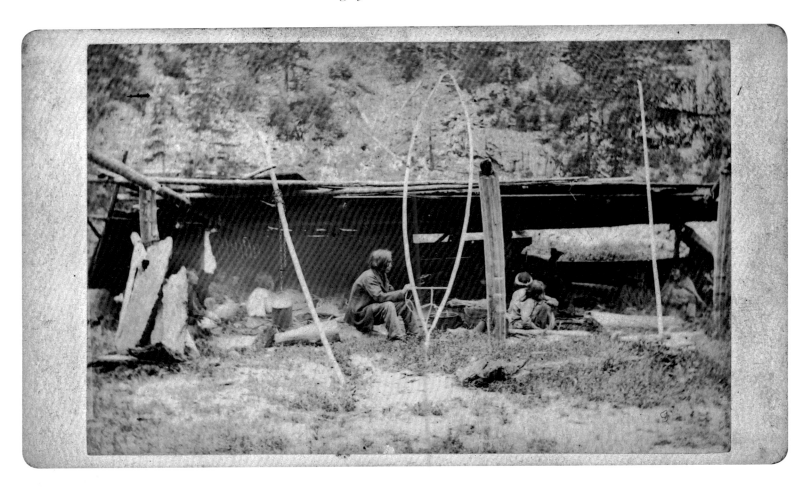

**Making a dip net,
near Hell's Gate, Fraser Canyon.**
Richard Maynard (probably), 1868.
Carte de visite. PN 5991.

This photograph documents one step in the process of making a dip-net frame. After attaching the netting and a pole, the operator will dip the net in the water, probably while standing on a fishing stage extending over the river, as shown on the facing page.

Although the back of the card bears Hannah Maynard's imprint, the photograph was probably made by her husband, Richard, when he travelled to Barkerville to photograph the Cariboo gold miners in 1868, or by Frederick Dally, who made two trips to the interior of British Columbia in 1867 and 1868. When attributing some Maynard photographs, some historians maintain that the studio images were Hannah's and the field images Richard's. But Hannah occasionally accompanied her husband on trips, such as the excursions aboard the steamer *Princess Louise* in 1879 and 1888. It is impossible to determine who created every Maynard photograph.

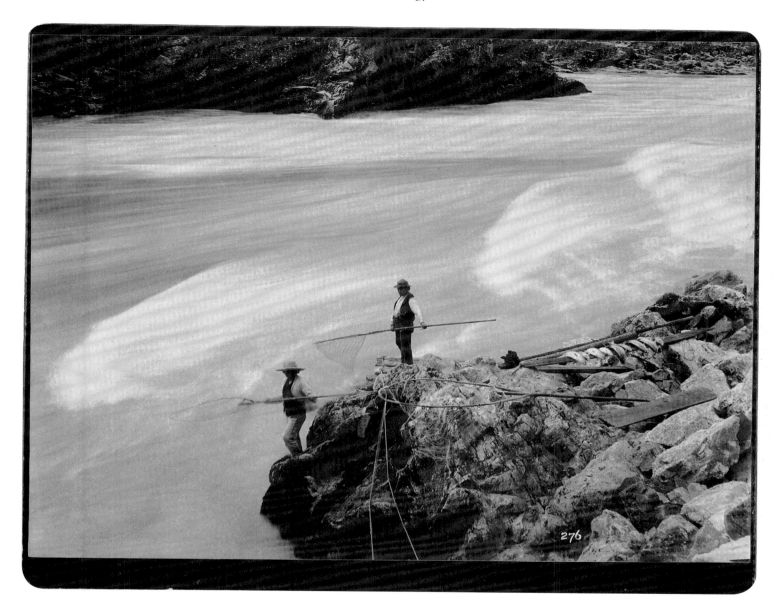

Dip netting on the Fraser River.
Charles Macmunn, about 1887.
Original card-mounted photograph.
PN 13388.

One of these First Nations fishers stands on a rough wooden plank projecting over the water. The reverse side of this card-mounted photograph bears the caption, "276 Indians fishing, view No. 1" and the imprint, "Charles Macmunn's Views of Canadian Pacific Railway, Victoria, and Surroundings, For Sale By, T.N. Hibben & Co., Booksellers and Stationers, Victoria, B.C.".

The camera's shutter speed and the slowness of the negative's emulsion contribute to the blurred texture of the fast-flowing river water. The cloud-like effect gives the image a dreamy quality instead of revealing the danger these men faced while using their dip nets.

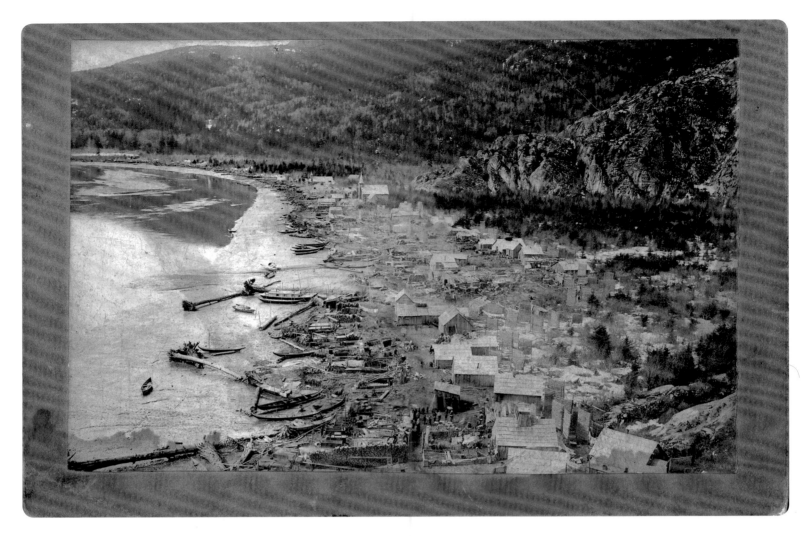

Making grease at Fishery Bay.
Benjamin A. Haldane, spring 1903.
Original card-mounted photograph.
PN 4279.

Each spring, people of the north coast gathered at Fishery Bay near the mouth of the Nass River to harvest eulachon, a species of smelt. They dried and smoked a portion of their catch, but rendered most of it into oil. Eulachon oil, also known as grease, was a valuable condiment used by coastal and interior First Peoples. It was traded into the interior of British Columbia along established routes known as "grease trails".

Northern-style canoes rest on the tidal flats, and cord wood has been stacked ready for burning to heat the water in large vats where the rendering takes place. Fifty or more drying racks snake in a line behind the cabins and smokehouses. After they have dried in the sun, the male fish are moved into the smokehouses to complete the curing process.

Eulachon processing at Fishery Bay.
Richard Maynard, spring 1884.

Richard Maynard documented the
eulachon fishery at the mouth of the Nass
River 19 years before Benjamin Haldane
took the photograph shown on the facing
page. Eulachon processing did not change
much in the intervening years. Maynard's
series of five photographs follows the order
of processing.

**1. Wooden flumes transported
water to the rendering vats.**
Original card-mounted photograph.
PN 1449.

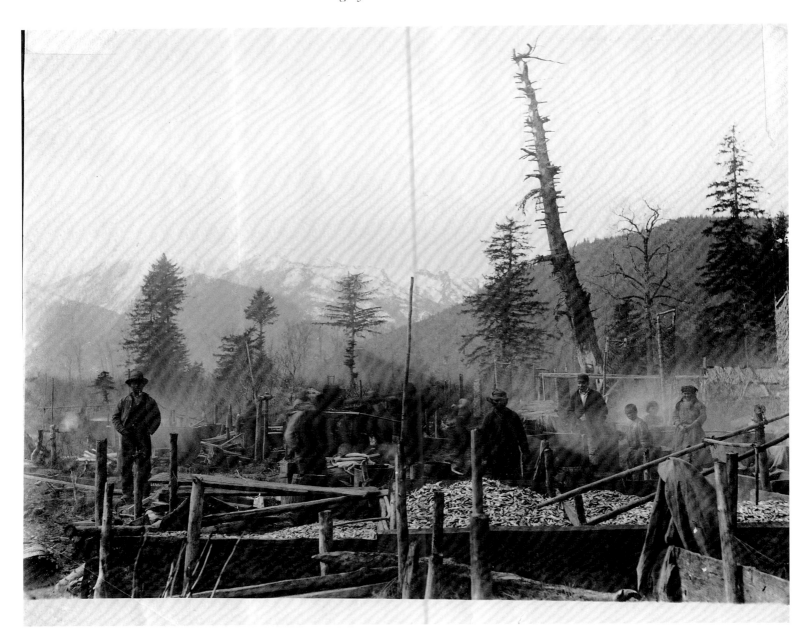

2. Surface pits.
Original photograph. PN 9360.

Made of wooden planks, the surface pits
held thousands of harvested eulachon for a
week or more until the blood drained from
their bodies.

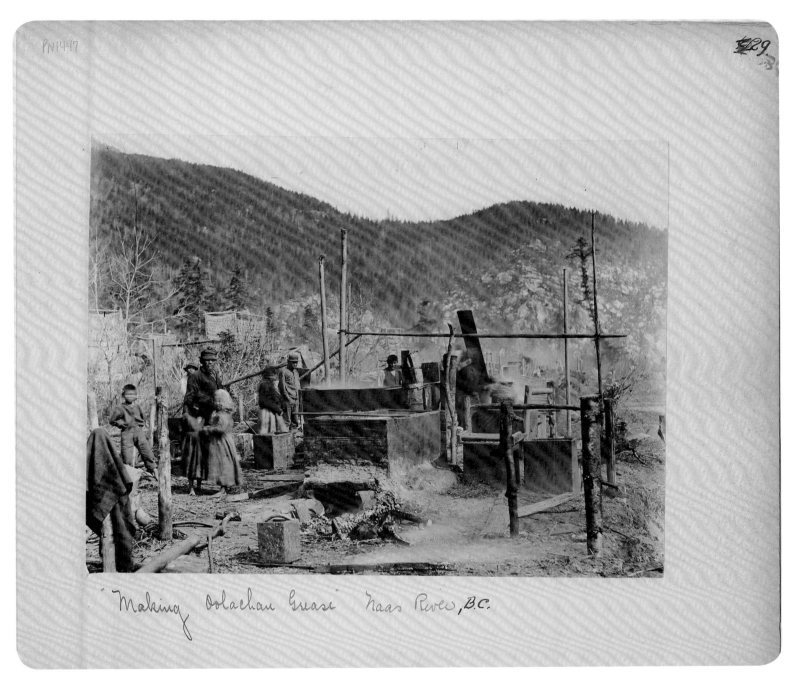

"Making Oolachan Grease" Naas River, B.C.

3. Rendering vats.
Original card-mounted photograph.
PN 1447.

The rendering vat in the centre has been set over a fire pit. In time the heat released the oil from the flesh of the ripened eulachon in the water. The oil floated to the surface, where it was removed with a scoop and placed in bent-corner boxes like the one at the left of the vat.

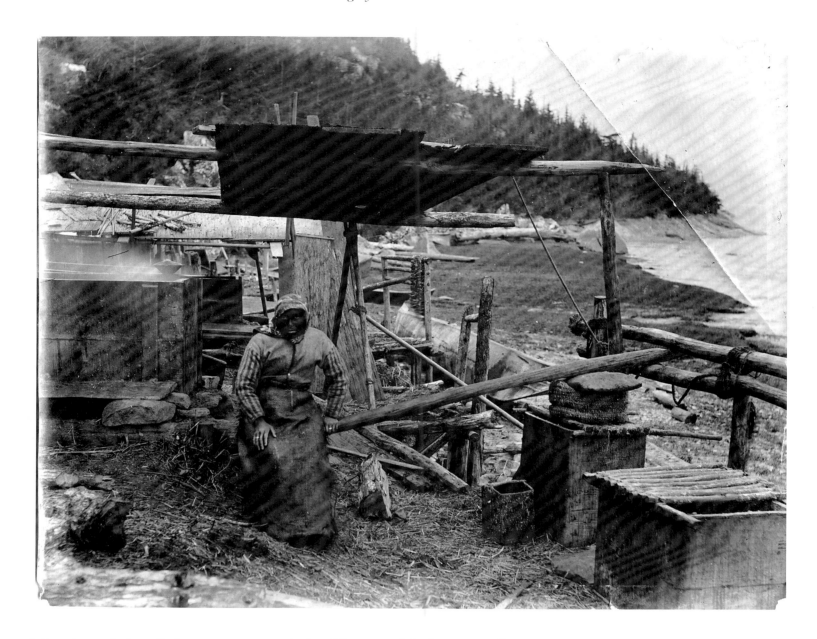

4. Pressing eulachon flesh.
Original photograph. PN 1448.

Boiling, alone, could not get all of the oil out of eulachon flesh. To get the most from their harvest, the people scooped the fish flesh from the vat into flexible spruce-root baskets. They set each basket on a small wooden platform over the top of an open water-tight bent-corner box, placed a flat rock on the basket and used a rudimentary press to squeeze the remaining oil into the box. Here, a woman sits on the lever of the press.

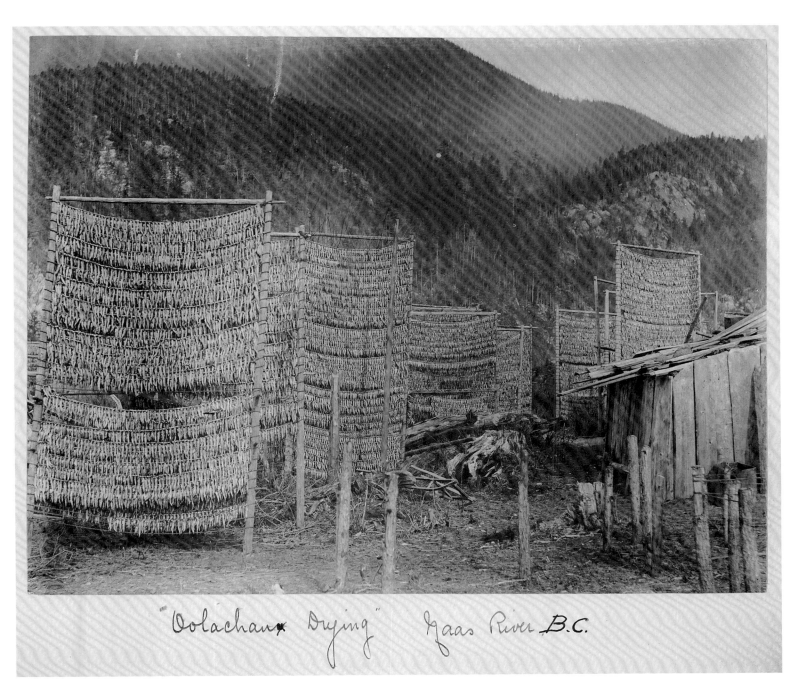

"Oolachan Drying" Naas River B.C.

5. Eulachon drying racks.
Original card-mounted photograph.
PN 5001.

Eulachon harvesters did not render all the
fish into oil. They strung some on racks to
dry them in the sun and then smoke them.
Smoked eulachons served as a staple food
throughout the year.

**A woman weaving lynx-skin strips
at the Wet'suwet'en village of Tse Kya
(Hagwilget).**
Edward Allen (attributed), 1897.
Original photograph. PN 3435.

Buildings

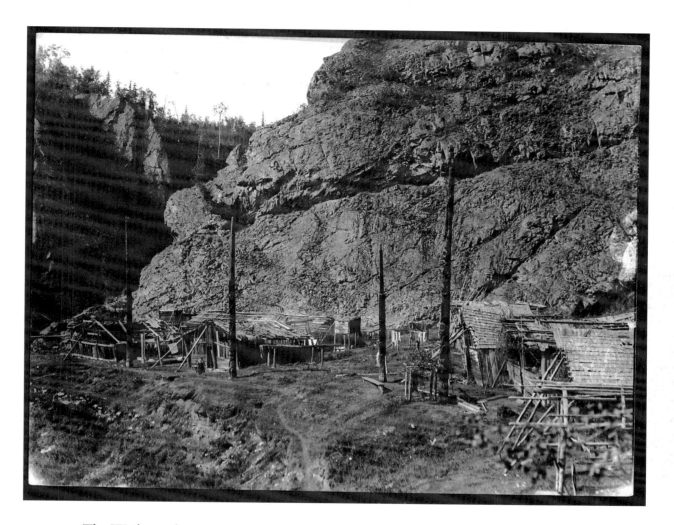

The Wet'suwet'en village of Tse Kya (Hagwilget).
John P. Babcock (possibly), about 1900.
Original photograph. PN 3399.

A woman walks along a foot path in front of the houses and poles at this Wet'suwet'en village nestled against a steep rock outcropping above the Bulkley River. Hagwilget Canyon was a productive fishing site as evidenced by the number of drying racks, the smoke houses and the food cache for storing dried salmon standing on four posts (centre).

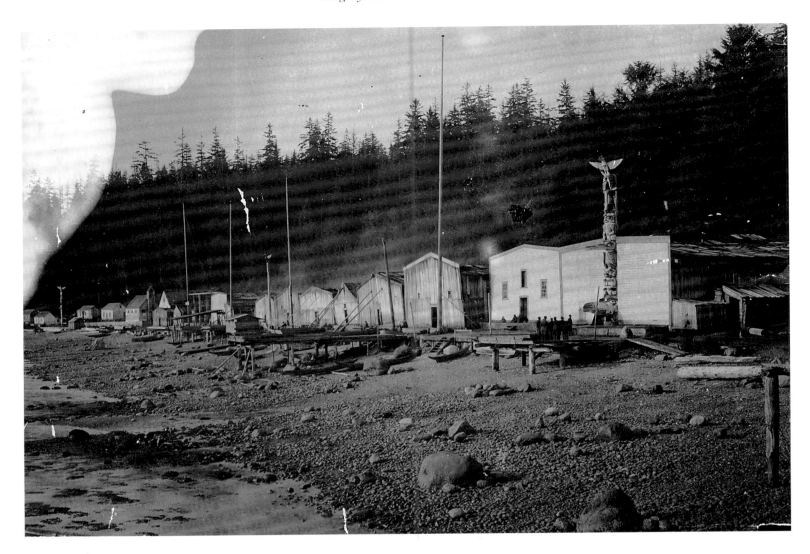

The Kwakwaka'wakw village of 'Yalis (Alert Bay).
Harlan I. Smith, 1898.
Original photograph. PN 2696.

Before 1900, photographs showing entire Kwakwaka'wakw villages were usually taken from a point on the beach. These had to be oblique views, because the houses stood close to the shoreline. Some of the houses have raised platforms, like the one shown on page 182.

Approaching the Kwakw̱ak̲a'wakw village of 'Y̲alis (Alert Bay).
Unidentified photographer 1901.
Direct duplicate negative. PN 2785.

Although probably taken from a gas-powered boat, this photograph provides a perspective of what it was like to approach a summer porch and the imposing big houses of a Kwakwa̲ka'wakw village by canoe. It is a rare example of a photograph taken at sea level and probably with a hand–held Kodak box camera. (A catalogue number has been written at the bottom of the nitrate negative.)

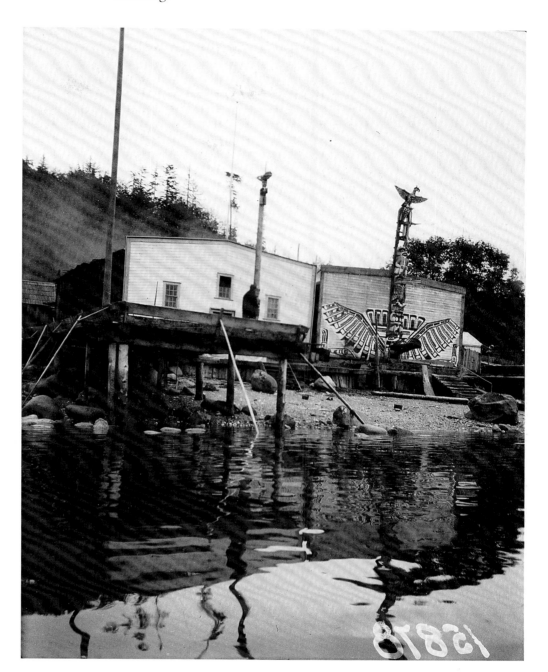

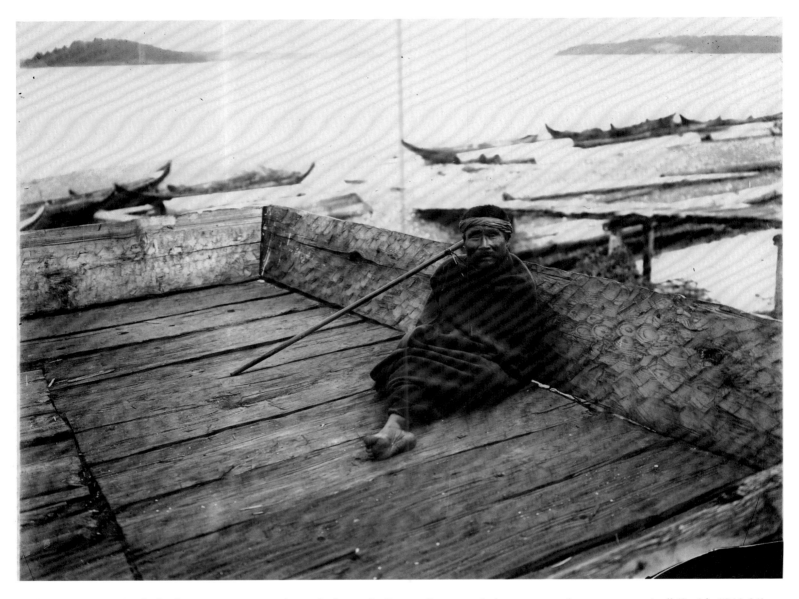

**Relaxing on a raised platform
in the Kwakwa̱ka̱'wakw village
of Tsa̱xis (Fort Rupert).**
Harlan I. Smith, 1909.
Black-and-white recent print.
AMNH 411814.

A man relaxes on a deck made of split-
cedar planks; the cedar side boards have
been roughly dressed using an elbow adze.
Common to Kwakwa̱ka̱'wakw villages,
these platforms, built on stilts, extended
over the beach and above the water (as
shown on the previous two pages). The
villagers used them in summer for social
gatherings.

Harlan Smith used a dry glass-plate
negative to take this photograph when he
visited the west coast in 1909 with mural
artist Will S. Taylor "to illustrate the home
country, characteristic occupations and
social customs of the seven great groups of
northwest coast native" (Smith 1910:31).
Smith took photographs and collected
objects to use in the Hall of Northwest
Coast Ethnology at the American Museum
of Natural History in New York. Because
Smith's photographs could capture images
only in black and white, Taylor came along
to record the colours required to produce
four mural panels for the exhibition.

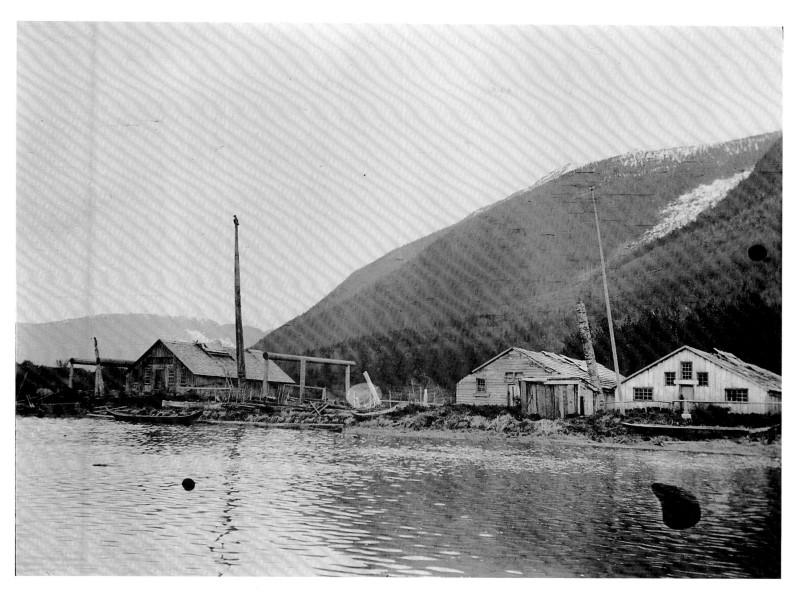

The Nisga'a village of Angidah.
Charles F. Newcombe, May 16, 1913.
Direct duplicate negative. PN 665.

Because waterways provided the most
efficient travel routes, people built inland
communities along riverbanks. To obtain
this partial view of Angidah, Charles
Newcombe took the photograph from a
boat using a hand-held camera and nitrate
negative.

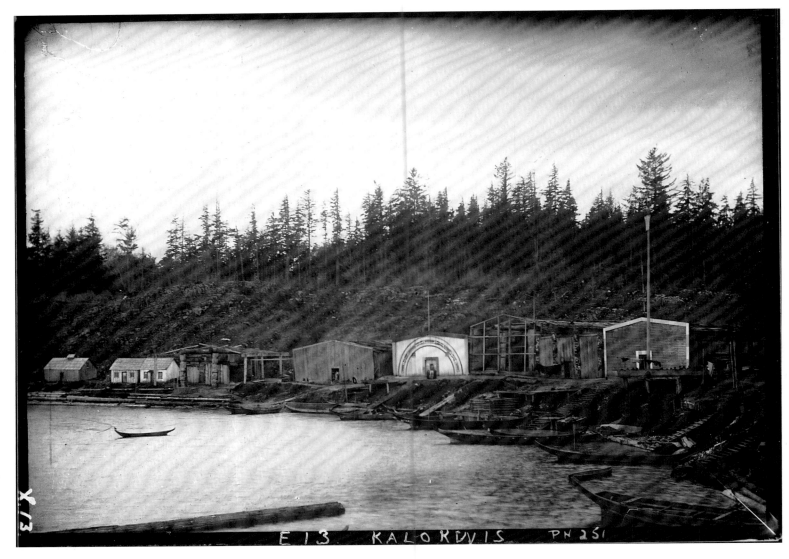

The Kwakwaka'wakw village of Kalugwis, Turnour Island.
Charles F. Newcombe, April 1, 1900. Black-and-white recent contact print from a dry glass-plate negative. PN 251.

During the early decades of the 20th century many Kwakwaka'wakw house fronts showed the influences of Euro-Canadian design and construction materials. Milled lumber replaced traditional split-cedar planking, but the essential structural elements – house posts and roof beams – remained. This photograph shows that only the fronts of the houses have changed; the sides and roofs are still made of cedar planks. The framing on the third house from the right will eventually support a new house façade.

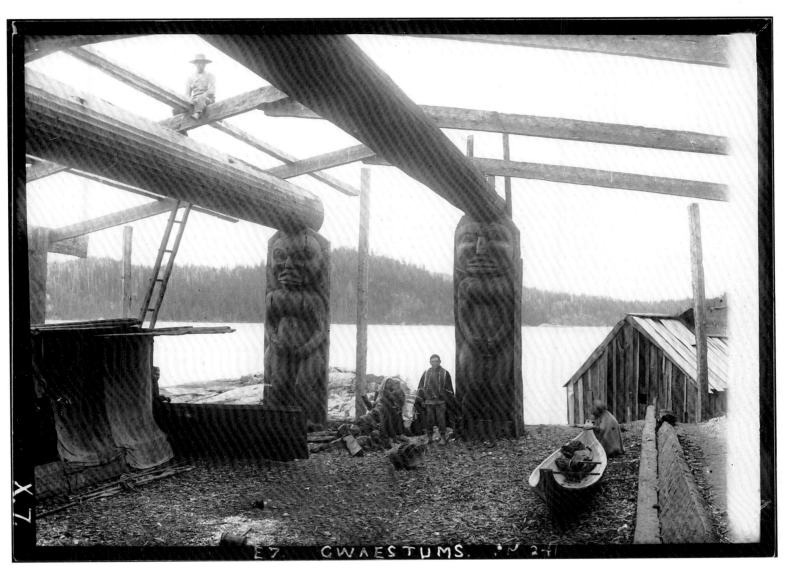

**Building a big house
in the Kwakwa̱ka'wakw village
of Gwa'yasda̱ms.**
Charles F. Newcombe, September 1900.
Black-and-white recent contact print
from a dry glass-plate negative. PN 241.

The entry in Charles Newcombe's *Register of Negatives and Lantern Slides* simply reads, "Gwa-estums, new house". This photograph shows the two fundamental structural elements of a traditional 19th-century Kwakwa̱ka'wakw house – the posts and beams. The heavy roof beams have been fluted with an elbow adze and rest on two carved inside front house posts. The rafters also appear to have been roughly dressed with an elbow adze. Split-cedar planks will eventually rest on these to make the low-gabled roof characteristic of Kwakwa̱ka'wakw houses. An unidentified man wearing a button blanket provides scale for this immense house.

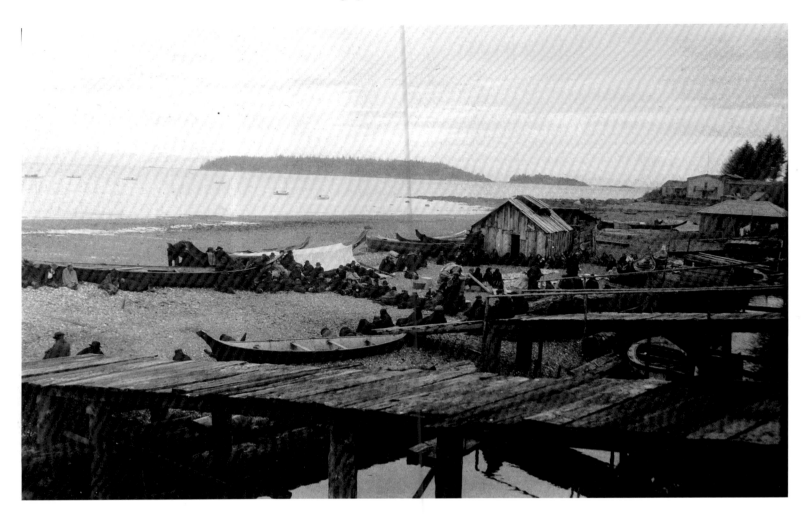

Potlatch at the Kwakwaka'wakw village of Tsaxis (Fort Rupert).
Samuel A. Barrett, 1915–16.
Nitrate negative. MPM 3651.

While on a collecting expedition, Samuel Barrett, curator of anthropology at the Milwaukee Public Museum, photographed a potlatch at Tsaxis. The large house with balcony in the far background could be the exterior of the house shown on the facing page.

Barrett used a large-format dry glass-plate negative (6½×8½ inches) to photograph the house interior, but a small nitrate negative (about 1×1½ inches) to take this photograph. Consequently, the resolution of the negative would only permit a limited enlargement before the print became too grainy to view.

Interior of a big house in Tsaxis.
Samuel A. Barrett, about 1915–16.
Black-and-white recent contact print
from a dry glass-plate negative. MPM 6527.

This house contains a blend of traditional
19th-century Kwakwaka'wakw and
20th-century Euro-Canadian architecture.
In addition to the milled lumber, framed
doors and a pane-glass window, this big
house features a staircase with a banister
leading to a second-storey balcony set
between two carved inside house posts.
Kwakwaka'wakw people often built rooms
at the back of a big house, but the Samuel
Barrett photograph on the facing page
suggests that this room may be at the front.

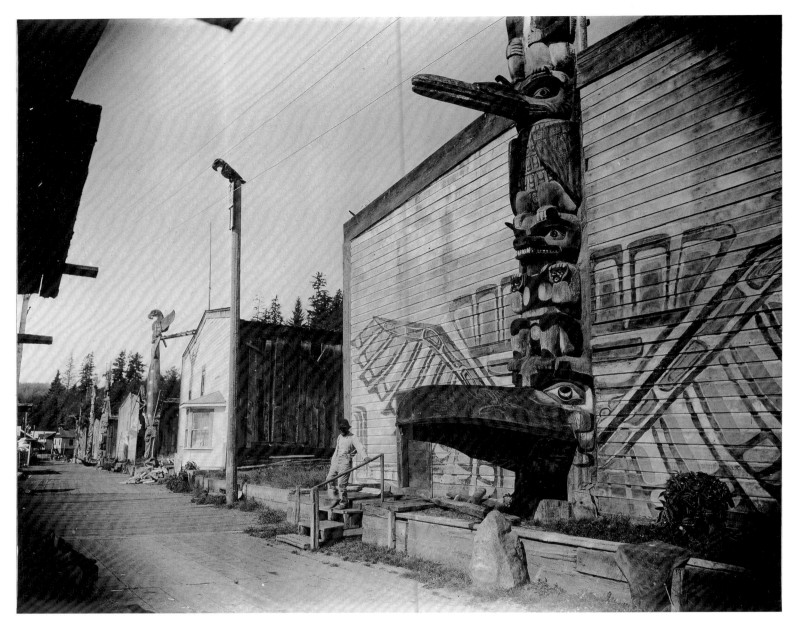

Chief Wakas' big house in the Kwakwa̱ka̱'wakw village of 'Ya̱lis (Alert Bay).
Philip Wollacott (attributed), after 1909. Black-and-white recent print. VM 1132.

The façade of Chief Wakas' house was made with milled lumber and painted with a raven design. Chief Tommy Hunt recalled that, at certain potlatches, guest chiefs had to exit this house by way of the raven's beak. According to Chief Hunt, the raven "puked" them out: at the last minute, the lower beak was dropped and the chiefs pushed outside to land on the ground in an undignified sprawl. This was a "privilege" claimed by the house owner, and although publicly embarrassed, the guest chiefs had no means of redress.

Many Kwakwa̱ka̱'wakw houses at this time had pane-glass windows, but the adjacent house has the only bay window I have seen in a house front.

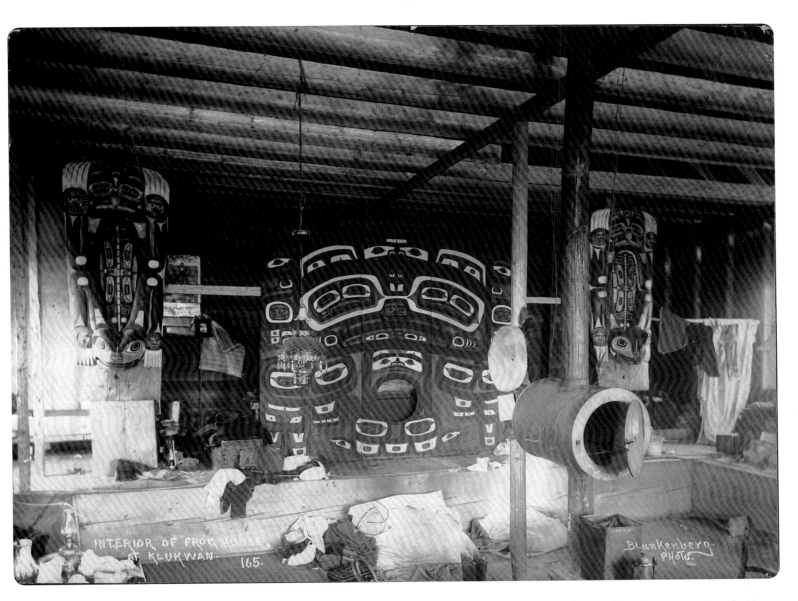

INTERIOR OF FROG HOUSE AT KLUKWAN. 165.

Blankenberg PHOTo.

Inside Frog House at the Chilkat Tlingit village of Klukwan, Alaska.
John Blankenberg, about 1900.
Original photograph. PN 1646.

This interior view of Frog House shows both the traditional material culture and contemporary retail goods present in a multi-family Tlingit house at the turn of the 20th century. The original earthen floor, excavated to a depth of about a metre, has been covered with milled timber planks. The retaining planks that form the single sleeping and storage platform are made of spruce as is the magnificently painted Raven Screen (now at the Seattle Art Museum). The carved and painted house posts on either side of the Raven Screen no longer function as supports for roof beams as they once would have.

Many store-bought goods (kerosene lamp, chest, iron stove, coffee pot, strongbox, rubber boots, wooden chair) can be seen clearly in this photograph. One item less noticeable but pertinent to the focus of this book is the small framed photograph that hangs just below the biblical poster beside the left house post. It appears to be a studio portrait taken in a likeness house of a male adult and child standing together.

**Tepee and storage platform
at Kamloops.**
Unidentified photographer, 1903.
Original photographs. PN 5282 (above),
PN 7219.

As with many historical photographs,
these have minimal documentation. Both
have only "Kamloops 1903" written in
pencil on the back. They show a mat-and-
cloth-covered double tepee and elevated
storage platform, with log cabins and St
Joseph's Roman Catholic Church in the
background.

Buildings

Acknowledgements

Foremost, I wish to acknowledge the First Peoples whose images and communities appear in this book. As well, the photographers who recorded their likenesses and the public institutions that have preserved them; without the studio and field work of the former and the responsible stewardship of the latter, little visual documentation of these living cultures would now exist.

I wish also to recognize the researchers whose published works on this subject have preceded mine: Dr Margaret Blackman, Dr George MacDonald, Dr Ira Jacknis, and especially David Mattison, not only for his significant contribution to the history of photography in British Columbia but also for reading my manuscript.

Several people at the Royal BC Museum have helped me with the preparation of the manuscript. I thank Derek Swallow, Ember Lundgren, Kelly-Ann Turkington and Dennis Duffy of the BC Archives. I also appreciate the advice and expertise of several colleagues in the Human History Section, including Dr Martha Black and Grant Keddie, curators of Ethnology and Archaeology, respectively, who also read and commented on the manuscript. A special thanks to Peter Macnair, curator emeritus in Ethnology at the RBCM, for his willingness to share his considerable knowledge and understanding of First Nations culture and for his patience responding to my endless questions.

The following people from other museums, archives and libraries have given generously of their time: Dr Andrea Laforet, Leslie Tepper and Vincent Lafond at the Canadian Museum of Civilization; Guy Tessier at Library and Archives Canada; Jim Simard, Sandra Johnston and Sean Lanksbury of the Alaska State Library, Historical Collections; Steve Henrickson at the Alaska State Museum; Sue Thorsen at Sitka National Historical Park; Steve Langdon at the University of Alaska, Anchorage; Barbara Mathé and Gregory Raml of the American Museum of Natural History; Susan Otto at the Milwaukee Public Museum; Jessica Desany at the Peabody Museum of Archaeology and Ethnology; Joan Seidl of the Vancouver Museum; Elaine Miller at the Washington State Historical Society; Alex Pezzati of the University of Pennsylvania Museum; Nina Cummings at the Field Museum; and Mark Osterman of George Eastman House.

Thanks to Robert Galois for providing me with the entry from the Clah Diaries; Chief Henry Seaweed for determining the correct sequence of four snapshots taken at the St Louis World's Fair; Quentin Ehrmann-Curat for identifying Xixanus (Bob Harris); Will and Jeanne David for drawing my attention to an early photograph of Tyee Jim; Ron Klein of Northern Light Photography for sharing his comprehensive knowledge of early Alaskan photographers; Dr Joan Schwartz at Queen's University for our discourses on Frederick Dally; and Jonathan King at the British Museum for, a decade ago, suggesting that I write this book. Thanks also to Rick Noakes, Ronald A. Greene, Leona Taylor and Uno Langmann, and to Greg Hoffman, Chet Helm's biographer, who provided background information on an aspect of the cover photograph's history.

I would also like to thank my supervisor, Dr Bob Griffin and the Royal BC Museum executive, past and present, for supporting my research work; Olive Quayle, who assisted me throughout the entire project; Chris Tyrrell for his creative and insightful approach to the design of this book; and most importantly my editor, Gerry Truscott, for his ability to untangle my ramblings so they could be understood by readers.

Finally, I acknowledge ownership of any shortcomings that may be associated with *Images from the Likeness House*.

Credits and Copyright for Photographs

All images with numbers preceded by "PN" or "BCA" reside in the collections of the Royal BC Museum: "PN" photographs in the Anthropology Audio-Visual Collection and "BCA" photographs in the British Columbia Archives.

The Royal BC Museum gratefully acknowledges the following institutions for their permission to print photographs from their collections in this book. The institution's initials precede the photograph's reference number in the caption.

AMNH: American Museum of Natural History.
ASL: Alaska State Library Historical Collection.
LAC: Library and Archives Canada.
CMC: Canadian Museum of Civilization.
FM: The Field Museum, Library Photo Archive.
MPM: Milwaukie Public Museum.
PMAE: Peabody Museum of Archaeology and Ethnology.
SITK: Sitka National Historical Park.
UPM: University of Pennsylania Museum.
VM: Vancouver Museum.
VPL: Vancouver Public Library.
WSHS: Washington State Historical Society.

Map on page 8 by Rick Pawlas, © Royal BC Museum.

Archer & Sons view camera photograph on page 134
 © Rick Noakes 2009.

Uncredited images © Royal BC Museum,
 by Kim Martin and Carlo Mocellin,
 except for PN 23910 (page 49) and PN 23880
 (page 61) by Dan Savard.

About the Author

Dan Savard has worked in the Anthropology Audio Visual Collection at the Royal BC Museum for more than 35 years, as collections manager for over 20 years. He manages a collection of historical photographs, audio records and cine film dating from the 1860s to the present that record the cultures of First Nations in British Columbia, northwestern Washington and southeastern Alaska. He has authored several academic papers and given many illustrated presentations on topics related to photography and First Peoples. This is his first book.

The Royal BC Museum

British Columbia is a big land with a unique history. As the province's museum and archives, the Royal BC Museum captures British Columbia's story and shares it with the world. It does so by collecting, preserving and interpreting millions of artifacts, specimens and documents of provincial significance, and by producing publications, exhibitions and public programs that bring the past to life in exciting, innovative and personal ways. The Royal BC Museum helps to explain what it means to be British Columbian and to define the role this province plays in the world.

The Royal BC Museum administers a unique cultural precinct in the heart of British Columbia's capital city. This site incorporates the Royal BC Museum (est. 1886), the BC Archives (est. 1894), the Netherlands Centennial Carillon, Helmcken House, St Ann's Schoolhouse and Thunderbird Park, which is home to Wawaditła (Mungo Martin House).

Although its buildings are located in Victoria, on the traditional territory of the Songhees and Esquimalt First Nations, the Royal BC Museum has a mandate to serve all citizens of the province, wherever they live. It meets this

First Nations objects in the collection of the Provincial Museum of Natural History, Victoria.
Harlan I. Smith (probably), about 1898.
Contact print from dry-plate negative.
PN 11896.

Although British Columbia's Provincial Museum of Natural History was charged with collecting anthropological material, it did not formally become the Provincial Museum of Natural History and Anthropology until 1941. The province changed the name after it established the permanent outdoor exhibition of monumental carvings, known as Thunderbird Park, on six vacant city lots in Victoria.

In 1968, the museum moved into new buildings and took a new name: the British Columbia Provincial Museum. Then, in 1987, about a century after its establishment, the museum received royal designation, becoming the Royal British Columbia Museum.

Wawadit'ła (Mungo Martin House), Thunderbird Park, Victoria, 2010. Digital image.

Kwakwaka'wakw carver Chief Nakap'ankam, Mungo Martin, built this big house, with the help of his family, completing it in 1953. It is a smaller version of a famous house that once stood in Tsaxis (Fort Rupert).

The opening ceremony, in 1953, was the first legal public potlatch held after the Canadian government removed the law against potlatching from the Indian Act. Wawadit'ła continues to be used for First Nations events with the permission of Mungo Martin's grandson, Chief Peter Knox of Fort Rupert.

mandate by: conducting and supporting field research; lending artifacts, specimens and documents to other institutions; publishing books (like this one) about BC's history and environment; producing travelling exhibitions; delivering a variety of services by phone, fax, mail and e-mail; and providing a vast array of information on its website about all of its collections and holdings.

From its inception more than 120 years ago, the Royal BC Museum has been led by people who care passionately about this province and work to fulfil its mission to preserve and share the story of British Columbia.

Find out more about the Royal BC Museum at
www.royalbcmuseum.bc.ca

References

This is the most up-to-date and complete listing of published works on the interaction between photographers and the First Peoples of the northwest coast and the interior of British Columbia from 1860 to 1920.

Alaska State Library. 2004. *Case and Draper Photographers, 1898–1920.* Juneau: Friends of the Alaska State Museum.

Arima, E., 1975. A Report on A West Coast Whaling Canoe Reconstructed at Port Renfrew, BC. *History and Archaeology* 5, Parks Canada, Ottawa.

Bant, M., and C. Hinsley. 1986. *From Site to Site.* Boston: President and Fellows of Harvard College.

Barbeau, M. 1950. *Totem Poles.* Bulletin no. 119, volume 2, Anthropological Series, no. 30 Ottawa: National Museum of Canada.

Barnett, H. 1955. *The Coast Salish of British Columbia.* Eugene: University of Oregon Press.

BC Provincial Police Veterans' Association. 1991. *Off Patrol, Memories of BC Provincial Policemen.* Surrey, BC: Heritage House.

Birrell, A. 1982. Survey Photography in British Columbia, 1858–1900. *BC Studies* 52:39-60.

Black, M. 1992. Display and Captures: Some Historic Photographs from the Northwest Coast. *American Indian Art Magazine* 18:1:68-75.

——. 1997. *A Season of Heiltsuk Art.* Vancouver: Douglas & McIntyre.

Blackman, M. 1972. *Nei:wons*, the "Monster" House of Chief Wi:ha: an Exercise in Ethnohistorical, Archaeological and Ethnological Reasoning. *Syesis* 5:211-25.

——. 1980. Posing the American Indian. *Natural History* 89:10:68-75.

——. 1981. *Window on the Past: The Photographic Ethnohistory of the Northern and Kaigani Haida.* Canadian Ethnology Service Mercury Series no. 74. Ottawa: National Museum of Man.

——. 1982. "Copying People": Northwest Coast Native Response to Early Photography. *BC Studies* 52:86-112.

——. 1984. *Tzum Seeowist* ("Face Pictures"): British Columbia Natives in Early Victoria Studios. A paper prepared for "The Photograph and the American Indian", a conference at Princeton University, September, 18-21, 1985.

——. 1986. Studio Indians: *Cartes de Visite* of Native People in British Columbia, 1862-1872, *Archivaria* 21:68-86.

——. 1992. Of "Peculiar Carvings and Architectural Devices": Photographic Ethnohistory and the Haida Indians. In *Anthropology and Photography 1860–1920* edited by Elizabeth Edwards. New Haven & London: Yale University Press.

Boas, F. 1897. The Social Organization and the Secret Societies of the Kwakiut Indians. *Report of the U.S. National Museum for 1895*, Washington, DC.

——. 1909. *The Kwakiutl of Vancouver Island.* Publications of the Jesup North Pacific Expedition 5, Memoirs of the American Museum of Natural History. New York: American Museum of Natural History.

Bogdan, R., and T. Weseloh. 2006. *Real Photo Postcard Guide: The People's Photography.* Syracuse: Syracuse University Press.

Brown, J. 1994. *Contesting Images: Photography and the World's Columbian Exposition.* Tucson: University of Arizona Press.

Browne, C. 1979. *Motion Picture Production In British Columbia: 1898–1940.* Heritage Record No. 6. Victoria: British Columbia Provincial Museum.

Buckland, G. 1980. *First Photographs: People, Places and Phenomena as Captured for the First Time by the Camera.* New York: MacMillan Publishing.

Canada, Department of Indian Affairs. 1879. *Annual Report.* Ottawa: Queen's Printer.

——. 1881. *Annual Report.* Ottawa: Queen's Printer.

——. 1901. *Annual Report.* Ottawa: King's Printer.

Carlson, K. 2005. Rethinking Dialogue and History: The King's Promise and the 1906 Aboriginal Delegation to London. *Native Studies Review* 16:2(2005):1-38.

Chambers, S. 1977. Elbridge Warren Merrill. *The Alaska Journal* 7:3:139-45.

Chittenden, N. 1884. *Official Report of the Exploration of the Queen Charlotte Islands for the Government of British Columbia.* Victoria: Government of British Columbia.

Coe, B. 1976. *The Birth of Photography: The Story of the Formative Years, 1800–1900.* New York: Taplinger.

——. 1978. *Daguerreotypes to Instant Pictures.* Gothenburg: AB Nordbok.

Coe, B., and P. Gates. 1977. *The Snapshot Photograph: The Rise of Popular Photography, 1888–1939*. London: Ash & Grant.

Coe, B., and M. Haworth-Booth. 1983. *A Guide to Early Photographic Processes*. London: V&A Publications.

Cole, D. 1982. Franz Boas and the Bella Coola in Berlin. *Northwest Anthropological Research Notes* 16:2:115-24.

——. 1985. *Captured Heritage: The Scramble for Northwest Coast Artifacts*. Seattle: University of Washington Press.

Cole, D., and B. Lockner. 1989. *The Journals of George M. Dawson: British Columbia, 1875–1878* (two volumes). Vancouver: UBC Press.

Cole, T. 1983. The Lost Art of Lantern Slides. *The Alaska Journal* 13:4:122-25.

Coleman, M. 1995. Frank La Roche: A Guide to the Klondike. *History of Photography* 19:2:143-49.

Conference of Friends of the Indians of British Columbia. 1914. *The British Columbia Indian Land Question from a Canadian Point of View*. The Witness Press.

Crosby, M. 1991. Construction of the Imaginary Indian. In *Vancouver Anthology*, edited by Stan Douglas. Vancouver: Talonbooks.

Crosby, T. 1914. *Up and Down the North Pacific Coast by Canoe and Mission Ship*. Toronto: The Missionary Society Of The Methodist Church, The Young People's Forward Movement Department.

Crownshaw, A. 1989. *Edinburgh from Old Picture Postcards*. Edinburgh: Mainstream Publishing.

Curtis, E. 1911. *The North American Indian*, vol. 7: *The Yakima. The Klickitat. Salishan Tribes of the Interior. The Kutenai*. Reprint 1970. New York: Johnson Reprint Corporation.

——. 1913. *The North American Indian*, vol. 9: *The Salishan Tribes of the Coast. The Chimakum and the Quilliute. The Willapa*. Reprint 1970. New York: Johnson Reprint Corporation.

——. 1915. *The North American Indian*, vol. 10: *The Kwakiutl*. Reprint 1970. New York: Johnson Reprint Corporation.

——. 1916. *The North American Indian*, vol. 11: *The Nootka and the Haida*. Reprint 1970. New York: Johnson Reprint Corporation.

Dally, F. n.d. Memoranda of a Trip Round Vancouver Island and Nootka Island On Board HMS *Scout*. British Columbia Archives, Dally papers, add. mss 2443, file 9.

Davis, B. 1985. *Edward S. Curtis: The Life and Times of a Shadow Catcher*. San Francisco: Chronicle Books.

Davis, G. 1904. *Metlakahtla: A True Narrative of the Red Man*. Chicago: The Ram's Horn Company.

Dawson, G. 1880. *Report on the Queen Charlotte Islands, 1878*. Montreal: Dawson Brothers.

De Laguna, F., ed. 1991. *The Tlingit Indians* by George Thornton Emmons. New York: American Museum of Natural History.

Drucker, P. 1951. *The Northern and Central Nootkan Tribes*. Bulletin 144. Washington, DC: Bureau of American Ethnology.

Duff, W. 1997. *The Indian History of British Columbia: The Impact of the White Man*. Victoria: Royal British Columbia Museum.

Emmons, G. T. 1911. *The Tahltan Indians*. Anthropological Publications 4:1. Philadelphia: The University Museum, University of Pennsylvania.

Evans, B. 1998. Catherine Russell's Recovery of the Head-Hunters. *Visual Anthropology* 11:221-42.

Evans, B., and A. Glass. n.d. *Edward Curtis Meets the Kwakwaka'wakw "In the Land of the Head Hunters"*. http://www.curtisfilm .rutgers.edu/. Rutgers, the State University of New Jersey.

Filming the Head-Hunters: How "The Vanishing Race" is Being Preserved in Moving Pictures. *Strand Magazine*, American Edition, August 1915.

Finlay, K., ed. 2004. *"A Woman's Place": Art and the Role of Women in the Cultural Formation of Victoria, BC 1850s-1920s*. Victoria: Maltwood Art Museum and Gallery.

Ford, C. 1941. *Smoke From Their Fires: The Life Of A Kwakiutl Chief*. New Haven: Yale University Press. (Reprinted 1971: Hamden, Conn.: Archon Books.)

Francis, D. 1996. *Copying People: Photographing British Columbia First Nations 1860–1940*. Saskatoon: Fifth House.

Frank, G. 2000. That's My Dinner on Display: A First Nations Reflection on Museum Culture. *BC Studies* 125/126:163-78.

Friesen (Usher), J. 1974. *William Duncan of Metlakatla: A Victorian Missionary in British Columbia*. Ottawa: National Museum of Man.

Frizot, M. 1998. *The New History of Photography*. Köln, Germany: Könemann.

Gidley, M. 1984. Edward S. Curtis Goes to the Mountain, *Pacific Northwest Quarterly* 75:4:164-70.

——. 1998. *Edward S. Curtis and the North American Indian, Incorporated*. Cambridge, UK: Cambridge University Press.

Gilbert, G. 1980. *Photography: The Early Years, A Historical Guide for Collectors*. New York: Harper & Row.

Gmelch, S. 1995. Elbridge Warren Merrill, The Tlingit of Alaska, 1899–1929. *History of Photography* 19:2:159-72.

——. 2008. *The Tlingit Encounter with Photography*. Philadelphia: University of Pennsylvania Museum of Archaeology and Anthropology.

Gosnell, R. 1897. *The Year Book of British Columbia and Manual of Provincial Information*. Victoria: Legislative Assembly.

Greenough, S., and D. Waggoner. 2007. *The Art of the American Snapshot, 1888-1978: From the Collection of Robert E. Jackson*. Washington: National Gallery of Art and Princeton University Press.

Greenwell, K. 2002. Picturing "Civilization": Missionary Narratives and the Margins of Mimicry. *BC Studies* 135:3-45.

Griffin, K. 2000. *Early Views: Historical Vignettes of Sitka National Historical Park.* Anchorage, Alaska: US Department of the Interior.

Hannavy, J. 2008. *Encyclopedia of Nineteenth-Century Photography.* New York: Routledge.

Harris, C. 2002. *Making Native Space: Colonialism, Resistance and Reserves in British Columbia.* Vancouver: UBC Press.

Henderson Publishing. 1905. *Henderson's British Columbia Gazetteer and Directory for 1905.* Vancouver: Henderson Publishing.

Henry, J.F. 1983. *Early Maritime Artists of the Pacific Northwest Coast, 1741–1841.* Seattle: University of Washington Press.

Hibben and Company, T.N. 1877. *Guide to the Province of British Columbia for 1877–78.* Victoria: T.N. Hibben & Co.

Hill, C. 1999. *Picture Postcards.* Princes Risborough, UK: Shire Publications.

Hinckley, T. 1982. *Alaskan John G. Brady: Missionary, Businessman, Judge and Governor, 1878–1918.* Miami University.

Hinsley, C. 1991. The World as Marketplace: Commodification of the Exotic at the World's Columbian Exposition, Chicago, 1893. In *Exhibiting Cultures: The Poetics and Politics of Museum Display* edited by Ivan Karp and Steven Lavine. Washington, DC: Smithsonian Institution.

Holm, B. 1983. The Vanishing Race and Other Illusions (book review). *American Indian Art Magazine* 8:3:68-73.

——. 1985. Old Photos Might not Lie, but they Fib a Lot about Color. *American Indian Art Magazine* 10:4:44-73.

Holm, B., and G. Quimby. 1980. *Edward S. Curtis in the Land of the War Canoes: A Pioneer Cinematographer in the Pacific Northwest.* Vancouver: Douglas & McIntyre.

Holm, B., and T. Vaughan. 1990. *Soft Gold: The Fur Trade and Cultural Exchange on the Northwest Coast of America.* Portland: Oregon Historical Press.

International Center of Photography. 1984. *Encyclopedia of Photography.* New York: Pound Press Books, Crown Publishers.

Inverarity, R. 1973. *Art of the Northwest Coast Indians.* Berkeley: University of California Press.

Jacknis, I. 1984. Franz Boas and Photography. *Visual Communication* 10:1: 2-60.

——. 1991. George Hunt, Collector of Indian Specimens. In *Chiefly Feasts: The Enduring Kwakiutl Potlatch*, edited by A. Jonaitis. Seattle: University of Washington Press.

——. 1992. George Hunt, Kwakiutl Photographer. In *Anthropology and Photography 1860–1920*, edited by E. Edwards. New Haven and London: Yale University Press.

——. 2000. Visualizing Kwakwaka'wakw Tradition: The Films of William Heick, 1951–63. *BC Studies* 125/126:99-146.

Jessup, L. 1999. Tin Cans and Machinery: Saving the Sagas and Other Stuff. *Visual Anthropology* 12:49-86.

——. 2001. J.S. Watson, Jr: Nass River Indians (1927–28). *Unseen Cinema: Early American Avant-Garde Film 1893-1941*, edited by Bruce Posner. New York: Black Thistle Press.

Johnson, T., ed. 1998. *Spirit Capture: Photographs from the National Museum of the American Indian.* Washington, DC: Smithsonian Institution Press.

Jonaitis, A. 1991. *Chiefly Feasts: The Enduring Kwakiutl Potlatch.* New York: American Museum of Natural History.

Kasaan Haida Heritage Foundation. n.d. http://www.kavilco.com /pages/khhfchiefskowal.html.

Keddie, G. 1991. Victoria's Early Hospital Properties. *Discovery* 19:3:4-5.

——. 2003. *Songhees Pictorial: A History of the Songhees People as seen by Outsiders, 1790–1912.* Victoria: Royal BC Museum.

Kendall, L., B. Mathe and T.R. Miller. 1997. *Drawing Shadows to Stone: The Photography of the Jesup North Pacific Expedition, 1897–1902.* Vancouver: Douglas & McIntyre.

Kopas, C. 1970. *Bella Coola.* Vancouver: Mitchell Press.

Kreis, K. 1992. "Indians" on Old Picture Postcards. *European Review Of Native American Studies* 6:1:39-48.

Kuhnlein, H., and N. Turner. 1991. *Traditional Plant Foods of Canadian Indigenous Peoples: Nutrition, Botany and Use.* Amsterdam: Gordon and Breach.

LaViolette, F. 1961. *The Struggle For Survival.* Toronto: University of Toronto Press.

Leeson, B. 1914. Photographing Brother "'Lo". *Camera Craft* 14:10:489-94.

Leggat, R. 1999. A History of Photography from its Beginnings till the 1920s. http://www.rleggat.com/photohistory/welcome .html.

Low, J. 1982. Dr Charles Frederick Newcombe. *The Beaver* 62:4:32-39.

Lyman, C. 1982. *The Vanishing Race and Other Illusions: Photographs of Indians by Edward S. Curtis.* Washington, DC: Smithsonian Institution Press.

MacDonald, G. 1983. *Haida Monumental Art: Villages of the Queen Charlotte Islands.* Vancouver: UBC Press.

MacDonald, J. 1985. *From Ceremonial Objects to Curios: Power Exchange at Port Simpson and Metlakatla.* Ottawa: National Library of Canada, Canadian Theses Service.

Macnair, P. 1971. Descriptive Notes on the Kwakiutl Manufacture of Eulachon Oil. *Syesis* 4:169-77.

——. 1982. The Northwest Coast Collections: The Legacy of a Living Culture. *Field Museum of Natural History Bulletin* 53:4: 3-9.

Macnair, P., A. Augaitis, N. Collison, R. Davidson, B. Reid and others. 2006. *Raven Travelling: Two Centuries of Haida Art.* Vancouver: Vancouver Art Gallery.

Macnair, P., and A. Hoover. 2002. *The Magic Leaves: A History of Haida Argillite Carving.* Victoria: Royal BC Museum.

Macnair, P., and J. Stewart. 1999. *To the Totem Forests, Emily Carr and Contemporaries Interpret Coastal Villages.* Victoria: Art Gallery of Greater Victoria.

Makepeace, A. 2002. *Edward Curtis, Coming To Light.* Washington, DC: National Geographic Society.

Mallandaine, E. 1874. *First Victoria Directory: Fifth Issue and British Columbia Guide, 1874.* Victoria: E. Mallandaine.

Maring and Blake. 1904. *Alaska Totem Poles.* Seattle: The Alaska Steamship Company.

Marino, C. 1998. *The Remarkable Carlo Gentile: Pioneer Italian Photographer of the American Frontier.* Nevada City: Carl Mautz.

Marr, C. 1989. Taken Pictures: On Interpreting Native American Photographs of the Southern Northwest Coast. *Pacific Northwest Quarterly* 80:2:52-61.

——. 1990. Photographers and their Subjects on the Southern Northwest Coast: Motivations and Responses. *Arctic Anthropology* 27:2:13-26.

Marr, C., L. Colfax and R. Monroe. 1987. *Portrait in Time: Photographs of the Makah by Samuel G. Morse, 1896–1903.* Neah Bay, WA: Makah Cultural and Research Center, with the Washington State Historical Society.

Martin, J., and A. Colbeck. 1989. *Handtinting Photographs: Materials, Techniques and Special Effects.* Cincinnati: North Light Books.

Massey, W. 1894. *The World's Fair through a Camera and How I Made My Pictures.* Toronto: William Briggs.

Mattison, D. 1982. Sweet Old Tunes, part 2. *Brass International* 10:3.

——. 1985. Richard Maynard: Photographer of Victoria, BC. *History of Photography* 9:109-29.

——. 1986. *Eyes of a City, Early Vancouver Photographers 1868–1900.* Occasional Paper 3. Vancouver City Archives.

——. 1987. A Fair Wind Blowing: Richard Maynard's Tours on HMS *Boxer*, 1873–1874. *Photographic Canadiana* 12:4:2-5.

——. 1999-2007 *Camera Workers: The British Columbia, Alaska and Yukon Photographic Directory, 1858–1950.* http://members.shaw.ca/bchistorian/cw1858-1950.html

——. 2003. What about Rappertie?, Victoria *Times-Colonist*, 12 January 2003 (p. D11).

Mattison, D., and D. Savard. 1992. The Northwest Pacific Coast: Photographic Voyages 1866–81. *History of Photography* 16:268-88.

Mayne, R. 1862. *Four Years in British Columbia and Vancouver Island.* London: John Murray.

McCord Museum. n.d. *The Magic Lantern.* http://www.mccord-museum.qc.ca/en/keys/virtualexhibits/magiclantern/

Meehan, J. 1990. *Panoramic Photography.* New York: Amphoto.

Milburn, M. 1986. Louis Shotridge and the Objects of Everlasting Esteem. In *Raven's Journey: The World of Alaska's Native People* edited by Susan Kaplan and Kristin Barsness. Philadelphia: University Museum of Archaeology and Anthropology.

Miles, G. 2003. *James Swan, Cha-tic of the Northwest Coast: Drawings and Watercolors from the Franz and Kathryn Stenzel Collection of Western American Art.* New Haven: Yale University.

Monroe, R. 1982. The Earliest Pacific Northwest Indian Photograph (ca 1860). In *Three Classic American Photographs* (pamphlet). University of Exeter (UK), American Arts Documentation Centre.

Moosang, F. 1999. *First Son: Portraits by C.D. Hoy.* Vancouver: Presentation House Gallery and Arsenal Pulp Press.

Morris, R. 1994. *New Worlds from Fragments: Film, Ethnography and the Representation of Northwest Coast Cultures.* Boulder, Colorado: Westview Press.

Nicola Valley Museum Archives Association. 1995. *Teit Times*, vol. 1 (Summer 1995).

Orvell, M. 2003. *American Photography.* Oxford, UK: Oxford University Press.

Parham, R. 1996. Benjamin Haldane and the Portraits of a People. *Alaska History* 11:1:37-45.

Postman, J. 2001. Controversial Novel Spurs New Interest in Turner. Review of James Wilson's book, *The Dark Clue.* Victoria *Times-Colonist*, December 2, 2001.

Pritchard, A. 1996. *Vancouver Island Letters of Edmund Hope Verney, 1862–65.* Vancouver: UBC Press.

Pruecel, R., and L. Williams. 2005. The Centennial Potlatch. *Expedition* 47:2:9-19.

Public Broadcasting Service. 1999. Wet-Plate Photography. In *American Experience.* http://www.pbs.org/wgbh/amex/eastman/sfeature/wetplate_step1.html.

Raibmon, P. 2000. Theatres of Contact: The Kwakwaka'wakw meet Colonialism in British Columbia and at the Chicago World's Fair. *The Canadian Historical Review* 81:2:157-90.

——. 2005. *Authentic Indians: Episodes of Encounter from the Late-Nineteenth-Century Northwest Coast.* Durham and London: Duke University Press.

Ray, G. 2008. *The Wide World Magazine, Wide World Brotherhood and Newnes: It's a Wide, Wide, Wide, Wide World!!!* http://www.collectingbooksandmagazines.com/wide.html.

Riley, L., ed. 1988. *Marius Barbeau's Photographic Collection: The Nass River.* Canadian Ethnology Service Mercury Series, no. 109. Hull, Quebec: Canadian Museum of Civilization.

Ritzenthaler, R., and L. Parsons. 1966. *The Samuel A Barrett Collection: Masks of the Northwest Coast.* Publications in Primitive Art 2. Milwaukee Public Museum.

Royal Commission on Indian Affairs. 1916. *Royal Commission on Indian Affairs*, vols 1-4. Victoria: Acme Press.

Russell, C. 1999. *Experimental Ethnography: The Work of Film in the Age of Video.* Durham, NC: Duke University Press.

Sandweiss, M., ed. 1991. *Photography In Nineteenth-Century America.* Fort Worth, Texas: Amon Carter Museum.

Savard, D. 2003. "To do a Moving Picture Thing ..." Cine Film and the Northwest Coast 1910–1930. Unpublished paper presented at the Association of Moving Image Archivists Conference 2003, Vancouver, BC. BC Archives file V2003:04.

——. 2005. Changing Images: Photographic Collections of First Peoples of the Pacific Northwest Held in the Royal British Columbia Museum, 1860–1920. *BC Studies* 145:55-96.

Scherer, J. 1990. Repository Sources of Northwest Coast Indian Photographs. *Arctic Anthropology* 27:2:40-50.

Schwartz, J. 1982. *The Past in Focus: Photography and British Columbia, 1858–1914. BC Studies* 52 (Special Issue).

Sexton, T. 1980. Double Takes: Stereographs by H.H. Brodeck. *The Alaska Journal* 10:3:18-21.

——. 1982. The Images of Charles H. Ryder. *The Alaska Journal* 12:3:32-41.

Sherwood, J. 2004. *Surveying Northern British Columbia: A Photojournal of Frank Swannell.* Prince George, BC: Catlin Press.

——. 2007a. *Surveying Central British Columbia: A Photojournal of Frank Swannell, 1920–28.* Victoria: Royal BC Museum.

——. 2007b. Report on Visit to Library and Archives Canada. Unpublished.

Silversides, B. 1994. *The Face Pullers: Photographing Native Canadians 1871-1939.* Saskatoon: Fifth House.

Slemmons, R. 1989. *Shadowy Evidence: The Photography of Edward S. Curtis and His Contemporaries.* Seattle Art Museum.

Smith, D. 2000. *A Tour of Duty in the Pacific Northwest: E.A. Porcher and HMS* Sparrowhawk, *1865–1868.* Fairbanks: University of Alaska Press.

Smith, H. 1910. A Visit to the Indian Tribes of the Northwest Coast. *The American Museum Journal* 10:2:31-42.

——. 1914. A Peaceful Indian Uprising. *The Southern Workman* (Hampton, Virginia) February: 78-86.

Smith, J. 1902. The Man Who Would Be Chief. *The Wide World Magazine* (London) October: 571-76.

Solnit, R. 2003. *River Of Shadows: Eadweard Muybridge and the Technological Wild West.* New York: Viking Penguin.

Spira, S. 2005. *The History of Photography as Seen Through the Spira Collection.* New York: Aperture.

Steinhart, A. 1979. *The Postal History of the Post Card in Canada, 1871–1911.* Toronto: Mission Press.

Stewart, H. 1977. *Indian Fishing: Early Methods on the Northwest Coast.* North Vancouver: J.J. Douglas.

——. 1984. *Cedar: Tree of Life to the Northwest Coast Indians.* Vancouver: Douglas & McIntyre.

Sturtevant, W. 1974. *Boxes and Bowls: Decorated Containers by Nineteenth-Century Haida, Tlingit, Bella Bella and Tsimshian Indian Artists.* Washington, DC: Smithsonian Institution Press.

Suttles, W. 1992. The Halkomelem *Sxwayxwey. American Indian Art Magazine* 8:1:56-65.

Suttles, W., and W. Sturtevant. 1990. *Handbook of North American Indians,* vol. 7: *Northwest Coast.* Washington, DC: Smithsonian Institution.

Swanton, J. 1905. *Contributions to the Ethnology of the Haida.* Publications of the Jesup North Pacific Expedition 5, Memoir of the American Museum of Natural History. New York: American Museum of Natural History.

Tate, C. 1929. Thrilling Story of Missionary Adventure and Success: An Autobiographical Sketch of Nearly Sixty Years Labor Among Indian Tribes of B.C. *The Western Recorder* 5:3 (September).

Tate, C. 1930. A Story of Missionary Adventure: An Autobiographical Sketch of Nearly Sixty Years Labour Among Indian Tribes of British Columbia. Part 5. *The Western Recorder* (January).

Teit, J. 1900. *The Thompson Indians Of British Columbia,* Memoir of the American Museum of Natural History, vol. 1, part 4. New York: American Museum of Natural History.

Tepper, L., ed. 1987. *The Interior Salish Tribes of British Columbia: A Photographic Collection.* Canadian Ethnology Service Mercury Series Paper No. 111. Hull, Quebec: Canadian Museum of Civilization.

——. 1991. *The Bella Coola Valley: Harlan I. Smith's Fieldwork Photographs, 1920–1924.* Canadian Ethnology Service Mercury Series 123. Hull, Quecec: Canadian Museum of Civilization.

Thomas, A. 1978. *The Expanding Eye: Photography and the Nineteenth-Century Mind.* London: Croom Helm.

——. 1982. Photography of the Indian: Concept and Practice on the Northwest Coast. *BC Studies* 52:61-85.

Thompson, J. 2007. *Recording Their Story: James Teit and the Tahltan.* Gatineau, Quebec: Canadian Museum of Civilization.

Turner, N.J. 1998. *Plant Technology of First Peoples in British Columbia.* Vancouver: UBC Press; Victoria: Royal BC Museum (2007 reprint).

Updike, J. 2007. Visual Trophies: The Art of Snapshots. *The New Yorker,* vol. 83, December 2007.

Usher, J. 1974. *William Duncan of Metlakatla: A Victorian Missionary in British Columbia.* Publications in History, no. 5. Ottawa: National Museum of Man.

Van Kirk, S. 1997. Tracing the Fortunes of Five Founding Families of Victoria. *BC Studies* 115/116:148-79.

Varley, C. 1979. *Edward Curtis in the Collection of the Edmonton Art Gallery.* Edmonton Art Gallery.

Veillette, J., and G. White. 1977. *Early Indian Village Churches: Wooden Frontier Architecture in British Columbia.* Vancouver: UBC Press.

Verhoeff, N. 2007. Moving Indians: Deconstructing the *Other* in Moving Images (1895–1915). *European Review of Native American Studies* 21:1:39-47.

Walens, S. 1978. *The Kwakiutl of Vancouver Island*. Film review. *American Anthropologist* 10:1:204.

Waterman, T. 1920. *The Whaling Equipment of The Makah Indians.* University of Washington Publications in Anthropology, vol.1, no.1.

Webster, G. 2001. *Dzawadi. Anthropologica* 43:1:37-41.

Whymper, F. 1868. *Travel and Adventure in the Territory of Alaska, Formerly Russian America – Now Ceded to the United States – and in Various Other Parts of the North Pacific.* London: John Murray.

Wickwire, W. 1994. To See Ourselves as the Other's Other: Nlaka'pamus Contact Narratives. *Canadian Historical Review* 75:1:1-20.

Williams, C. 2003. *Framing the West: Race, Gender and the Photographic Frontier in the Pacific Northwest.* New York: Oxford University Press.

Wright, R. 2001. *Northern Haida Master Carvers.* Vancouver: Douglas & McIntyre.

Wyatt, V. 1987. Alaskan Indian Wage Earners in the 19th Century: Economic Choices and Ethnic Identity on Southeast Alaska's Frontier. *Pacific Quarterly* 78:1-2:43-49.

——. 1989. *Images from the Inside Passage: An Alaskan Portrait by Winter and Pond.* Vancouver: Douglas & McIntyre.

——. 1991. Interpreting the Balance of Power: A Case Study of Photographer and Subject in Images of Native Americans. *Exposure* 28:3: 23-33.

Zimmerly, D. 1974. *Museocinematography: Ethnographic Film Programs of the National Museum of Man, 1913–1973.* Ethnology Division Mercury Series, no. 11. Ottawa: National Museums of Canada.

Index